WILLIAM H. JACKSON

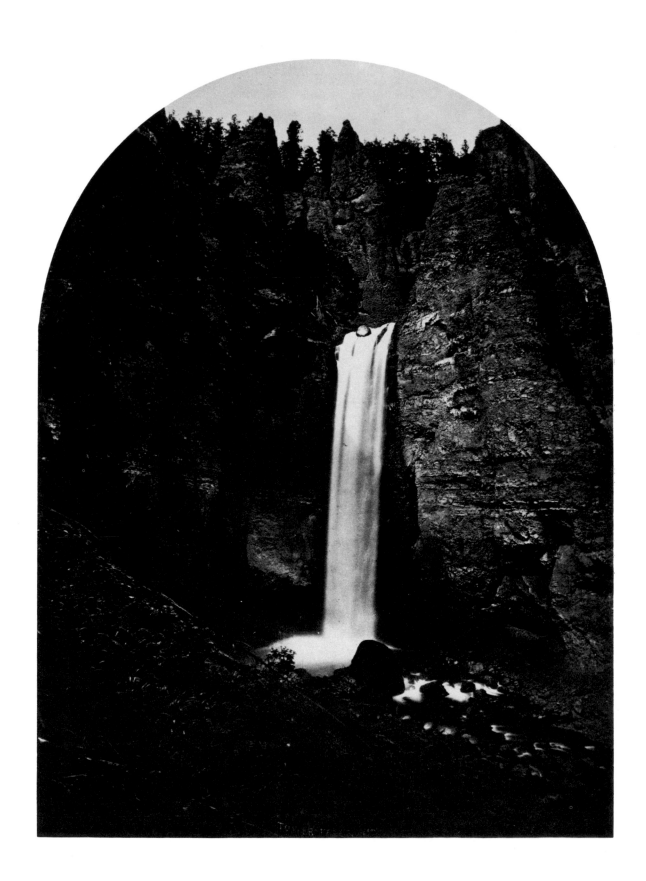

WILLIAM H. JACKSON

By BEAUMONT NEWHALL & DIANA E. EDKINS

With a Critical Essay by WILLIAM L. BROECKER

MORGAN & MORGAN

AMON CARTER MUSEUM, FORT WORTH

© 1974 by the Amon Carter Museum of Western Art,
Fort Worth, Texas

All rights reserved in all countries.
No part of this book may be reproduced or translated
in any form, including microfiling, without written
permission from the authors and publishers.

Published in cooperation with the
Amon Carter Museum of Western Art
by Morgan & Morgan, Inc.
145 Palisade Street
Dobbs Ferry, New York 10522

International Standard Book Number 0-87100-045-8
Library of Congress Catalog Card Number 73-89076
Printed in the United States of America

LIST OF PHOTOGRAPHS

The source of photographs used for reproduction is given in parentheses after the title. The following abbreviations are used:

A.C.M. Amon Carter Museum of Western Art
S.H.S.C. State Historical Society of Colorado

PREFACE

In 1971, Mitchell Wilder, Director of the Amon Carter Museum of Western Art, Forth Worth, Texas, asked us to compile a book to accompany a retrospective exhibition of the work of William Henry Jackson, pioneer photographer of the American West. Through his enthusiastic backing, we were able to visit the principal collections of Jackson's work. We examined thousands of negatives and prints in order to make a selection that would reveal Jackson not only as a visual historian and documentarian, but as one of the most gifted and perceptive 19th-century photographers. He belonged to that small band of adventuresome men who carried their cumbersome cameras and equipment into the wilderness and showed the world, in convincing, straightforward photographs, the very look of the land and the Indians before the coming of modern civilization. To Jackson, "field photography," as he called it, was a challenge and a way of life; his affinity to the natural scene and his extraordinary rapport with Indians led to the production of grandiose landscapes and compelling portraits, which won for him international acclaim.

In the choice of photographs and in their sequencing, we have been guided by esthetic feeling rather than strict chronology. While Jackson's early work has been seen more often and is, therefore, better known than his post-1878 work, a substantial representation from the latter period has been selected for inclusion.

Jackson was a prolific writer, as well as photographer; his autobiography, *Time Exposure,* is a vivid account of his adventures. Rather than attempting to write a biography, we have provided a short introduction, a concise chronology, and an extensive bibliography.

For their help and their suggestions, we thank the staff of the Amon Carter Museum of Western Art, especially Ron Tyler, Curator of History, and Mrs. Marjorie Morey, Curator of Photography Collections; Terry Mangan of the State Historical Society of Colorado, Denver, and Mrs. Enid Thompson, formerly with the Society; Jim Davis of the Denver Public Library and Alys Freeze, formerly there; Archibald Hannah, Director of the Western Americana Collection of the Beinecke Library, Yale University, New Haven, Connecticut; John Szarkowski, Director of the Department of Photography, The Museum of Modern Art, New York City; Alan Fern, Milton Kaplan and Jerry Kearns of the Library of Congress; Robert Sobieszek of The International Museum of Photography at George Eastman House, Rochester, New York; the Bancroft Library, University of California at Berkeley; Miss Nell Carico of the United States Geological Survey; the Bureau of American Ethnology of the National Archives; Mr. Myron Wood; Lee D. Witkin of the Witkin Gallery, New York City; Peter C. Bunnell, Director of the Princeton University Art Museum, Princeton, New Jersey; and Eugene R. Zepp of the Print Department at the Boston Public Library, Boston, Massachusetts.

Beaumont Newhall
Diana E. Edkins

INTRODUCTION

William Henry Jackson began his long career as a photographer of the American West just after the close of the Civil War, when a reunited America began the systematic exploration of the vast areas of the country between the Missouri River and the Sierra Nevada range. During the years from 1870 to 1878, he was official photographer to the United States Geological and Geographic Survey of the Territories, one of several semi-military expeditions organized by the Department of the Interior to gather, in great detail, data about the unknown, uncharted, and little understood West. He traveled overland with geologists, topographers, surveyors, ethnologists, archaeologists, naturalists and other specialists, often under great hardship. The photographs that he, and his colleagues on similar surveys, brought back to the East showed America the very look of the land and of the Indians who dwelt there. As *The New York Times* wrote on April 27, 1875, in a story about the Survey, "While only a select few can appreciate the discoveries of the geologists or the exact measurements of the topographers, everyone can understand a picture. . . ."

Mastery of the photographic process, physical stamina to withstand the rigor of travel in the wilderness, zeal for exploring the unknown, love for the outdoor life — these were the qualifications of the Survey photographer. Jackson possessed them all.

Born in 1843, he was brought up with a love for pictures. His mother, who was something of a painter, gave him lessons, and as a teenager he was already earning money painting window screens, theatrical backdrops and political posters. Upon graduation from school in Troy, New York, where his family was then living, he got a job in a photographic gallery as retoucher and colorist. This experience led to a better position in the gallery of Frank Mowry, in the neighboring city of Rutland, Vermont.

Jackson's budding professional career as an artist was interrupted by the outbreak of the Civil War. On August 18, 1862, he enlisted in the Twelfth Vermont Infantry, Company K. His military service was brief; he saw no combat and spent most of his time, with the approval of his commanding officer, sketching camp life and the fortifications around Washington, which it was the duty of the company to guard. Within a year, at the expiration of his enlistment, he was back in Vermont at his old job in the Mowry Gallery and later moved from Rutland to Burlington to work in yet another photographic studio. He had fallen in love and was engaged to be married in June, 1866. Somehow, in April, the couple had a falling out and the engagement was broken. Bitterly disappointed, Jackson impetuously quit his job and left for New York City.

There he chanced to meet a fellow veteran of Company K, who was planning to go West with a friend and mine for silver in the Montana Territory. Jackson joined them. They traveled by rail to St. Joseph, Missouri, where they signed up as bullwhackers for a wagon train bound from Nebraska City to Montana.

Twenty-five heavy wagons, each drawn by 12 oxen, comprised the typical overland wagon train of the time. Each team was driven by a bullwhacker, so named because he controlled the oxen with an 18-foot whip, the bullwhack. Every day at dawn the oxen were rounded up and yoked and, by five A.M., the train was on its way. At ten A.M. came a breakfast stop and the animals were set loose to graze till two in the afternoon when the teams were readied for the second drive, which ended at sunset. And so it went, at a rate of about 15 miles a day, across Nebraska, following the North Platte, across Wyoming, following the Sweetwater. They forced their oxen to ford rivers. To cross the Rocky Mountains they had to "double team"—alternating 24 animals to a wagon— yoking, unyoking, back tracing, and then yoking again. Their route was to take them to the southwest corner of Wyoming and then north to Montana.

But by now Jackson's dream of silver mining had vanished. He was homesick, his companions had left him, and he felt that the quickest way to return East was first to head for California. He left the Montana-bound train and joined a Mormon one, headed from South Pass to Salt Lake City; the trip, although only some 150 miles, proved to be even more difficult, for it was now winter. At times, 36 oxen had to be yoked to a single wagon in order to pull it through the mud and snow, and Jackson's own wagon, loaded with almost five tons of freight, had to be abandoned. From Salt Lake City, he went to Los Angeles, this time as a passenger for he had earned some money and his family had also sent funds. Finding no suitable work in California, he headed East in May on another strenuous trip: driving a string of 200 wild horses to the railhead of Julesburg, Wyoming, for transportation in cattle cars to Omaha, Nebraska.

In 1867, Omaha was the center of Union Pacific Railroad operations in the construction of the transcontinental line, and a boom town. Jackson decided to settle there. He secured employment in one of the photographic galleries in town and soon, with the help of capital sent by his father, he and his brother, Edward, established the "Jackson Brothers, Photographers" portrait studio. But indoor work bored him. He determined to photograph the countryside and Indian life along the route of the newly-opened Pacific Railroad.

One of the earliest photographs we have of him at work (page 134) shows him standing in front of a tent which served as a darkroom, preparing a wet plate. The collodion process, which was then universal, was awkward and difficult. The photographer had to make his own sensitive plates in the field and process them on the spot. In a portable darkroom—usually a tent or a wagon fitted out for the purpose—he coated a glass plate with collodion, a viscous solution of nitrocellulose to which a halide salt such as potassium iodide had been added. While the coating was still tacky, the plate was plunged into a solution of silver nitrate; within minutes, light-sensitive silver salts were formed in suspension in the collodion coating. The plate, while wet, was put into a light-tight holder and immediately exposed in the camera, which stood waiting on its tripod, already focused upon the scene. Without delay the photographer dashed back to the darktent and developed the latent image before the sensitive coating had dried. He then fixed and washed the plate.

On this first trip along the rails in 1869, Jackson carried two cameras: one for 8- by 10-inch negatives, the other for stereoscopic pictures. He said that the whole equipment—glass plates, chemicals, silver bath, developing tray, fixing tray, washing tray, bottles, vials and drying racks—weighed a ton.

With a companion, he first went west to Promontory Point, then back east through Corinne, Ogden, Uinta, Salt Lake City, Weber Canyon, Echo Canyon and Wasatch, traveling by hand car, freight trains and locomotives with all this gear for three months. He was elated when, on the basis of this work, he received an order from New York to supply ten thousand stereoscopic photographs of the country. These card photographs, produced with a twin-lens camera, were then exceedingly popular; viewed through a special hand-held instrument, they gave startling illusions of three dimensions. The vast distances of the West, the rugged terrain of mountains and canyons, the dense forests and sparse plains, so unfamiliar to the East, became believable through these three-dimensional pictures.

In addition to these expeditions, Jackson was busily recording Indians in his Omaha gallery, where he posed them somewhat incongruously amid papier-mâché rocks and artificial foliage.

In July, 1870, Ferdinand Vandiveer Hayden, geologist-in-charge of the Geological and Geographic Survey of the Territories, visited Jackson in his Omaha studio, saw his pictures of the country along the Union Pacific Railroad and of the Indians, and invited him to join the forthcoming expedition to the Wyoming and Utah Territories. Hayden could offer Jackson only his keep during the trip and the right to whatever negatives he made. Jackson accepted. Thus began an association that lasted for eight highly-productive years.

Jackson's position with the Survey became salaried in 1871. As a government employee, he now divided his time between field trips each summer and printing and cataloging his negatives

in Washington during the winter months. Considering the difficulties of field photography at that time, his production was staggering: he listed 2000 negatives in the *Descriptive Catalogue of the Photographs of the U.S. Geological Survey of the Territories for the Years 1869-1875, Inclusive.* Hayden stressed the importance of the photographs in his annual reports, praising the truthfulness of the "uncompromising lens" and the value of the documents to geologists, ethnographers and archaeologists. The photographs were substitutes for personal inspections of the almost inaccessible areas of the West.

The most spectacular use of Jackson's photographs as evidence was of those taken in the Yellowstone area. Hayden had heard tales of this extraordinary region, with its hot springs and geysers, and set the exploration of it as the goal of the 1871 expedition. The resulting photographs became extremely popular. Drawings from them were widely reproduced by wood engravings in the illustrated press. Copies of original prints were made available to members of Congress and played an important part in convincing them to pass the bill creating Yellowstone as our first national park in 1872.

On the 1873 expedition in the Colorado region, Jackson resolved to locate, and to photograph for the first time, the Mountain of the Holy Cross, a 14,000-foot peak that had become legendary because, under certain weather conditions, snow filled the fissures at its summit to outline a perfect cross. He first discovered it through binoculars at too great a distance to photograph. Further exploration, guided by the somewhat vague advice from mountain men, led him to believe that his best camera stance would be the summit of Notch Mountain, northeast of the Mountain of the Holy Cross and approximately the same elevation. The party found the going rough; so steep and overgrown with thick brush was the trail that pack animals could not be used for the last 1,500 feet of the climb. Three men lugged a hundred pounds of photographic gear to the peak. Before noon, Jackson exposed eight plates: one with the 11- by 14-inch camera, the others with the 5 by 8. He processed them on the spot.

The photographs became as legendary as the mountain itself. Jackson won seven medals for the ones exhibited at the Philadelphia Centennial Exposition in 1876. Henry Wadsworth Longfellow hung one of Jackson's prints on the wall beside a portrait of his deceased wife, and was inspired to write the poem "The Cross of Snow," which closes with the stanza:

> *There is a mountain in the distant West*
> *That, sun-defying, in its deep ravines*
> *Displays a cross of snow upon its side.*
> *Such is the cross I wear upon my breast*
> *These eighteen years, through all the changing scenes*
> *And seasons, changeless since the day she died.*

Each season, Jackson brought larger cameras to the field; he found that the vast landscapes demanded as big pictures as possible. In those days, enlarging was possible, but hardly practical. It took all afternoon to make a single print in a mammoth "solar camera" mounted on the gallery roof and constantly trained on the sun by an apprentice. The results did not compare with contact prints. If large prints of the highest quality and in quantity were needed, the negatives had to be equally large. In 1875, Jackson took a 20- by 24-inch camera to the Rocky Mountains. With its tripod and plate holder, it was a full load for one pack mule. Such oversize cameras were far from unique, but had seldom been used under such trying conditions, and Jackson's photographs elicited the wonder of the photographic world.

In addition to taking these grand landscapes, Jackson discovered, photographed and sketched ancient Indian cliff dwellings in the Southwest. He was proud that his work was recognized by archaeologists, and wrote a scholarly "Notice of the Ancient Ruins in Arizona and Utah Lying About the Rio San Juan" for the *Bulletin* of the U.S. Geological Survey. He was also placed in charge

of the Survey's elaborate exhibition at the 1876 Centennial Exposition. This comprised large transparencies, Indian artifacts, and beautiful scale models of pueblos and ruins that Jackson had painstakingly constructed from his photographs and notes. Hayden considered the importance of the exhibition warranted Jackson's continuous presence that year to give background on the exhibits and answer visitor's questions.

The following year proved disastrous photographically. Jackson had an opportunity to accompany a friend, the Reverend Sheldon Jackson, on a trip to the Southwest missions established by the Presbyterian Church. Hayden encouraged him to go. Knowing that he would be traveling lightly, Jackson imported from England a supply of Warnerke's "sensitive negative tissue," supplied in bands. This new product, introduced in 1875, was a predecessor of roll film. After years of experimentation, it had been found possible to produce a collodion emulsion which would retain its sensitivity while dry, and could be processed long after exposure. Collodion dry plates began to be manufactured in England, but were never popular as their light sensitivity was relatively low, requiring exposures three times greater than that of the wet process. Furthermore, they were expensive. Leon Warnerke, a Russian living in England, conceived the idea of coating paper with this collidio-bromide emulsion; after processing, the coating was stripped from its paper base, dried and mounted on glass to produce a negative which could be printed by conventional means. He supplied the paper in rolls, sufficient for a hundred exposures, to be used in a simple roll holder which could be attached to any camera. Jackson was delighted at the prospect of traveling with only an 8- by 10-inch camera, a tripod, a roll holder and a few rolls of "sensitive tissue"—all of which could be comfortably carried on his back.

The trip began at Santa Fe, New Mexico. They went to the Laguna and Acoma pueblos, to Fort Defiance where ten thousand Indians were assembled, and to the ancient ruins in the Canyon de Chelly. At San Ysidro, Jackson left his missionary friend and went on to visit the ruins at the Chaco Canyon. He made 400 exposures. When he developed the "sensitive tissue," not one image appeared.

Jackson's last field trip as a government photographer was in 1878. The following year, Congress curtailed appropriations and the Hayden Survey was merged with others to form the present U.S. Geological Survey. He moved from Washington to Denver and opened a studio there specializing in landscape work.

In 1881, he received his first railroad job since his own work work along the Union Pacific line. The Denver & Rio Grande Railway Company commissioned him to take a series of views along the route of that narrow-gauge line, the longest in the world. His spectacular panoramas, often printed from three or more, 18- by 22-inch slightly-overlapping negatives, soon brought Jackson orders from other railroads throughout the United States, Canada and Mexico, and for the next decade this specialty was his chief business. He was now using dry plates and film exclusively. With the substitution of gelatin for collodion, dependable dry plates were now on the market; their advantage over the old hand-coated collodion plates was that exposures were reduced by a sixtieth. No longer chained to a portable darktent, Jackson could now increase his production greatly. His business prospered and, in 1883-84, he incorporated with Walter F. Crosby, an amateur photographer, as the W.H. Jackson Photograph and Publishing Company. As this new title indicates, books now became of importance to Jackson. For the World's Columbian Exposition in Chicago in 1893, he produced albums of one hundred 11- by 14-inch original photographic prints which he sold at $1,000 each. His *Wonder Places. . . The Most Perfect Pictures of Magnificent Scenes in the Rocky Mountains* (1894) brought him great praise. It was a book without words, relying for its effect on the photographs alone.

The last major photographic expedition undertaken by Jackson was a trip halfway around the world with the World Transporation Commission in 1894. He took the job after securing an agreement from *Harper's Weekly* that they would pay $100 a page for pictures supplied by him of landscapes and the everyday life of the people. The Commission, headed by Major Joseph Pangborn, publicity

man for the Baltimore & Ohio Railroad, sailed to England in September. By November they were in Cairo. India was next, and then Australia, New Zealand, the East Indies, China and Japan. From Vladivostok, Jackson crossed Russia by sleigh and the Trans-Siberian Railroad. He arrived home in March, 1895.

Jackson now became increasingly involved with publishing photographs, and built up a huge library. It is not clear which photographs were taken by him and which by cameramen in his employ.

In 1897, he became a salaried director of the Photochrom Company, a subsidiary of the Detroit Publishing Company. The company specialized in printing color lithographs of famous paintings and crudely hand-colored photographic landscapes and city views. Jackson said that the annual output was seven million prints a year. To push sales, the company converted a private railroad car into a traveling exhibition gallery and, in the summer of 1902, Jackson toured the Southwest aboard the "California Special." This was the peak of the company's success. In 1924, it collapsed, and Jackson sold his interest and moved to Washington. Eventually, all of the 40,000 negatives that had cost him so much effort were acquired from the Detroit Publishing Company by Henry Ford and deposited in the Edison Institute in Dearborn, Michigan.

Jackson spent the remaining years of his long life painting and as research secretary of the Oregon Trail Association. He was commissioned in 1936 by the Department of the Interior to paint murals for its new building, showing scenes from the great Surveys of the West with which he had been associated. The job was shortlived because of lack of funds, but Jackson produced some thirty paintings. He also wrote his autobiography, *Time Exposure*, which was published in 1940. It was regenerative, bringing him the renewed admiration of the photographic world. The annual, *U.S. Camera 1941*, published an excellent biographical essay by Hartley Howe with 39 illustrations, including drawings and paintings as well as photographs. Ansel Adams selected several of Jackson's spectacular prints for the exhibition, "Photographers of the Civil War and the American Frontier," which he directed for The Museum of Modern Art in 1942, and which marked the first time that a major art museum had featured Jackson's photographs, along with those of his contemporaries— Timothy H. O'Sullivan, Alexander Gardner, Ben Wittick and other pioneer photographers of the West. Jackson was the honored guest at the preview. As he stood before one of the largest pictures in the show, a superb 20- by 24-inch print, he said, "That's a pretty good picture, Mr. Adams. Who took it?"

"You did, Mr. Jackson!"

"Why so I did," the old man replied. "But I can do better now and in color, with this," he chuckled, pulling from his hip pocket a miniature camera. "And no need for a string of mules!"

Only shortly after this recognition of his work, following injuries he had suffered from a fall, Jackson died on June 30, 1942—less than a year before his one-hundredth birthday.

Beaumont Newhall

THE PHOTOGRAPHS OF WILLIAM H. JACKSON

William Henry Jackson is an unequaled phenomenon in the growth and development of photography, and in America's experience of learning about herself and the world. The amazing variety and scope of his life and career are detailed in the *Chronology*, pages 135-150. There, one can begin to comprehend the enormous output and the prodigious energy of the man. The quality of his achievement becomes evident in viewing his pictures, for no matter how badly he has sometimes been served in the past by poor presentation, the honesty and clarity of his vision remain, and the best of his pictures stand as the definitive images of the scenes they show us. The advent, then, of a major exhibition of his work, and of a book of high-quality reproductions, provides a new and valuable opportunity to appreciate his accomplishments.

A life span of ninety-nine years is remarkable; Jackson's was unique in that it almost exactly paralleled the first century of photography. The daguerreotype, and the Talbotype (the first negative-positive process, little used in the U.S.), were made public in 1839 and 1840; Jackson was born in 1843. By the time he began photographing professionally, photography had progressed to the wet collodion process, which yielded a glass plate negative of excellent quality. Prints were made by placing the negative in contact with sensitized paper to obtain a same-size image; giant pictures, of which Jackson was a master, required giant negatives. Enlarging lay in the future; when it became practical, Jackson eagerly seized upon it, as he did upon each technical improvement that would advance his work. Virtually all the developments in photography with which we are so familiar occurred during his lifetime, excepting only the most recent, such as the Polaroid Land process and xerographic reproduction.

The invention of the wet plate process in 1851 inspired photographers to take to the field as never before, and a great wave of recording the physical reality of nature swept the world. Previously, studio portraiture had comprised easily three-quarters of photography's output. Portraiture did not diminish, but in the second half of the 19th century, photographing the world accounted for most of the phenomenal growth of the medium.

Given the huge amount of equipment and materials that had to be transported, and the cumbersome nature of the process, it is amazing that the wet plate went everywhere: up mountains, down mineshafts, into caverns and catacombs, across deserts, off to the Tropics and the Arctic. In Europe, Roger Fenton went off to record the war in the steaming Crimea, in 1855. Adolphe Braun and the Bisson Frères climbed the Alps. Felice Beato, Francis Frith and others went into the Middle East, North Africa, and Egypt. John Thomson went to Asia for a decade, then returned to further document life in the streets of London. There were many others like them.

In the United States, the post-Civil War years, with their accelerated development and expansion, saw a resumption of government and railroad company surveys to explore and map the territories west of the Mississippi in great detail. For the first time, they used photography to document much of what was notable. It was just such surveys that provided the major opportunity and the foundation of Jackson's career.

He was not alone in this. A great number of photographers who had gained experience in field work during the Civil War, and others who had gone west earlier, joined surveys and expeditions or otherwise explored and recorded the West, Panama, and newly-purchased Alaska. In addition to William Henry Jackson, they included Timothy H. O'Sullivan, Alexander Gardner, Alfred Hart, Andrew Russell, Carlton E. Watkins, Eadweard Muybridge, and John Hillers among others.

The output of these photographers was documentary: pictures were taken for the express purpose of recording the actuality of what the camera saw. That they were also often images of great

beauty is a tribute both to the subject itself, and to the sensitivity of the photographer and his ability to capture natural beauty in a straightforward photograph, with clear vision and direct technique.

A very different picture-making tradition grew alongside that of documenting the natural world. Starting in England with Oscar Rejlander and Henry Peach Robinson, in 1857 and 1858, a significant number of photographers had become concerned about Art. They frequently tortured the medium and themselves in an effort to create "Fine Art," which to them meant photographs that looked, in subject and manner, like academic paintings. These Pictorialists were primarily concerned that the beauty of the made image, and the "artistic" skill of its making, should be appreciated. This led them to employ highly-manipulative, controlled and artificial methods, including making composite prints and paste-ups; casting, costuming and staging apparent genre scenes; and devising ways to imitate the surface appearance of oils, watercolors, pastels, charcoal and crayon drawings, and the like.

In addition, the Pictorialists wanted to be sure that the sentimental-moral-melodramatic content of the picture was admired. To insure this, they generally assigned explicit or symbolically simplistic titles to their works. The viewer, by reading the label, could be absolutely certain of what he was to see in the image and what he was to feel about it.

Between the Pictorialists and the documentarians of nature, there arose in the 1880s, the Naturalists, led by Peter Henry Emerson. In direct reaction against the artificial excesses of Pictorialism, they emphasized making beautiful pictures of natural subjects in their natural surroundings, without artifice. Their goal, however, also was Art, which would result from being true to Nature, and that was to be achieved by using the medium to duplicate the impression the photographer had of the subject. They thus attempted to be truthful, impressionistic and interpretive all at the same time. Their manner of image-making was, in fact, largely romantic, and often their concern with the beauty of the final image surpassed their concern for the subject. As a result, their output is much closer to that of the Pictorialists than to that of the photographers of Jackson's vein, who dealt with reality in terms of the full technical capacity of photography: overall clarity, sharpness in depth, the recording of greater detail than the eye perceived.

The photographers who turned to the documentary recording of Nature made the subject preeminent. It was what the thing photographed had to say for itself that they wanted to show. The function of technique was simply to reveal the subject as clearly, emphatically and effectively as possible, without distortion or personal interpretation. In this attitude are the wellsprings of the great tradition of "straight" photography, the unmanipulated procedure of finding the strongest way of making a picture which lets the subject say what it has to say, rather than what the photographer has to say about it.

The great bulk of Jackson's work, and certainly his best pictures, are in this tradition: the direct response to the natural scene and the direct recording of it. But Jackson was also an economic realist and, when necessary, he turned to pasting-up and hand-coloring in order to achieve a more salable image. However, his impulse was largely commercial and, in that, very different from the artistic aspirations of Pictorialism.

The best-known work of Jackson comes primarily from his initial period, 1868-1879 when he first photographed in the vicinities of Omaha and Cheyenne, and then, most importantly, on the successive Hayden Surveys of the geography and geology of the Western states. From this period come the famed Yellowstone views, important studies of Southwest Indian tribes, vast panoramas of mountain ranges, and documentation of the ruins of lost cities of ancient tribes.

Within this decade of work, Jackson moved rapidly from competent view-taking to a mastery of landscape. The clarity of his pictures improved, the adjustment of the edges of the frame to the subject became more precise, the images became internally more unified. Whatever his talent for composition at the beginning (the evidence of his sketches in those years is not very reassuring; aside from their awkward draftsmanship, they tend to be loosely, even diffidently organized), he undoubtedly

learned a great deal from the artist, Thomas Moran, about selecting viewpoint as a means of organizing the subject within the picture area. Jackson himself noted this influence (see *Chronology, 1871*). There was an interaction between the image-making of the two men over a long period, with Moran using Jackson's photographs as material for later paintings (see *Chronology, 1892*). Many other artists drew upon Jackson images as source material for paintings. A particularly interesting example using the photograph of the Taos Pueblo, page 57, is detailed by Van Deren Coke in *The Painter and the Photograph* (University of New Mexico Press, 1972).

During this first decade, Jackson also became something of a skilled photo-geographer and -topographer, and a documentary ethnographer and archaeologist. He was quick to see and understand the possible scientific importance of the material he encountered, but without losing sight of its commercial potential. He was, after all, a photographer whose business was to sell prints—the only way any photographer of the time made a living, for practical methods of faithful mass reproduction were 15 to 20 years off. A great deal of his stereograph production capitalized on the opportunities provided by the Survey field trips and, in later years, many of these early images were reworked for commercial purposes.

The photographs from Jackson's Denver and railroad period, roughly 1879-1896, are somewhat less well-known as a group, but there are many famous photographs among them. His production was vast during this time—as indeed it was at other periods, but now he needed a greater volume to sell from because he no longer had government support for his work. As a result, he seems to have photographed everything visible from a given camera location before moving on to the next spot; consequently, the percentage of memorable pictures seems a smaller part of the total output. There were repeated assignments from virtually all the railroads in the West during these years, enabling Jackson to travel extensively and compile further documentation of the places, the inhabitants, and the natural wonders of California, Mexico, and the developing Western states and territories.

Apparently it was during this period that Jackson began adding a significant amount of hand-work and over-painting to improve some of his pictures for reproduction. (Crude halftones became common just after 1880; great improvements were made in the succeeding decade.) Later, he would virtually create pictures with after-work, but now he retouched to strengthen detail, provide emphasis and clarity, to blend or subdue distant backgrounds.

Jackson was a direct recorder of the natural scene, but when it came to selling his pictures, his appreciation of the direct image was not that of a purist. Clarity and a sense of visual completeness made a picture more appealing to a viewer, and Jackson obviously felt it a part of the task to add those qualities when required, by whatever means necessary. Such an attitude must have come quite naturally to one who had begun in photography as a retoucher and colorist, and who had learned to sketch and paint before learning to take photographs.

The third photographic period of Jackson's career comprises uncounted thousands of images, including those from his foreign tour with the World Transportation Commission, and two-and-a-half decades with the Photochrom Company. Jackson traveled the U.S. more widely than ever before during these years, and his largely unknown work in the East and the Caribbean is one of the results.

Many pictures from this period became familiar because they were so widely reproduced, or so widely distributed as Photochrom prints or as stock photographs from the Detroit Photographic Company. However, the pictures were known anonymously rather than as the work of William Henry Jackson, despite the fact that his name was usually included on the pictures he had produced; audiences see content, not credits.

Many previous pictures were reused now, Jackson hand-coloring them and supervising the preparation of the several lithographic plates required to reproduce each as a full-color Photochrom print. Cosmetic work was performed on old and new pictures alike. An image might be up-dated by painting a contemporary hat and necktie on a figure in an earlier photograph (Fir Tree, page 123); others would be the result of composite paste-up and paint-in work (Saltair Pavilion, page 124: several

bathers have been pasted in, the pavilion roof and details have been strengthened, the waving flags and banners added, and the sky improved).

Jackson also returned to the areas of many of his earlier Western pictures to provide new images for Photochrom reproduction. When the company failed in 1924, he turned to using his photographs, and his memories, to provide source material for the paintings and murals which were the major work of his last quarter-century.

The great majority of Jackson's photographs are, first and foremost, straightforward documentary records. Their lack of artifice is their strength, and their effective simplicity of statement has made them the images by which we recognize the old, unspoiled West. Time and again he was there first, and was by far the best. In much of his work, Jackson pointed his camera at everything in a seemingly rapid-fire, shoot-everything fashion. Such pictures provided complete coverage, while the subject provided the beauty that evokes our wonder or awe. But Jackson's way of showing the subject is the essential, if unobtrusive, factor.

There is also a great number of pictures in which Jackson obviously took more time to see the subject and make it into an image that provokes attention. There is a strange-world feeling about a single figure in the vapors of a hot spring, or a group silhouetted under a vast overhang. The little mechanical men quarrying stone, or the formal portrait of two palm trees are images which we see as on the borders of the surreal. It is a quality of seeing that the photographer brought to the subject that makes such pictures notable. Their feeling is quite different from the inherent eeriness of ruined San Francisco or the naturally fantastic grotesqueries of volcanically-active topography.

Of a different order of experience is the impact of his panoramic views and broad vistas. In these he displayed a great mastery of communicating the sweep and vast scale of the subject. The very large plate or film size he used whenever possible added greatly to the effect of such pictures. In the resultant large prints, the viewer is confronted with an image of such great size and amazing detail that exploring its content becomes an experience in time as well as in vision.

Compared with some of his contemporaries in the 1870s and 80s, Jackson was objective and neutral. The pictures of Carlton E. Watkins, for example, were frequently taken with much more of an eye to pictorial beauty. Timothy H. O'Sullivan's best photographs have a greater sense of consciously-intended graphic impact. Jackson's greatest pictures are uncomplicated, if overwhelming; they are direct, convincing. In them there is no interpretation; there is strong showing. For all his energy, his varied activities, and his enormous output, it is in the grand Western vistas that Jackson's reputation as a master of photography is secure.

William L. Broecker

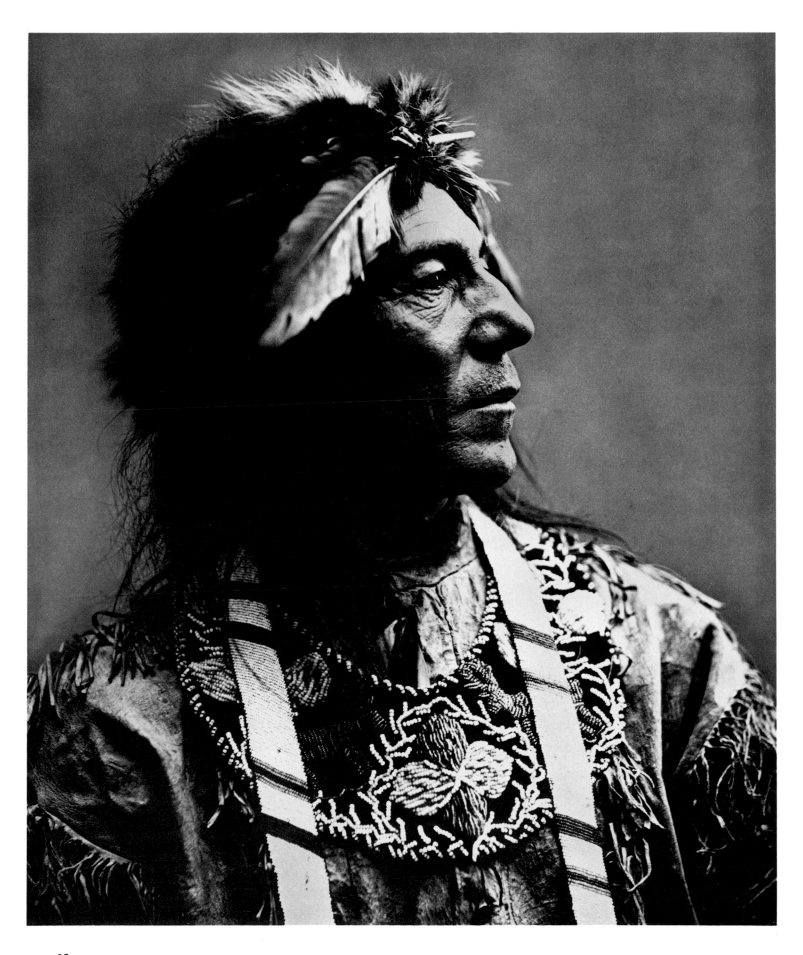

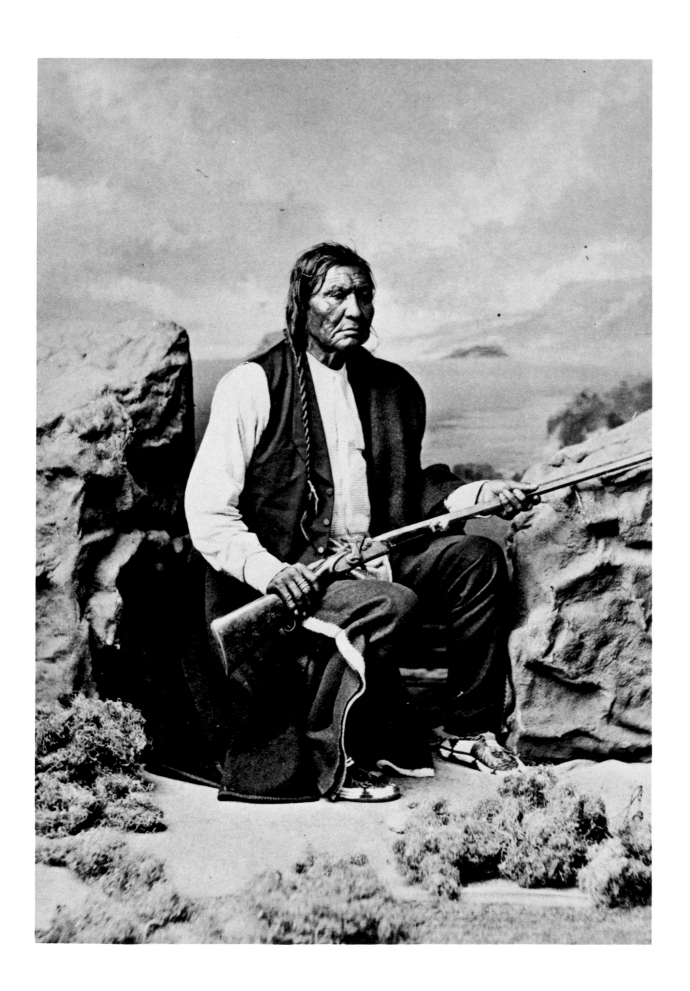

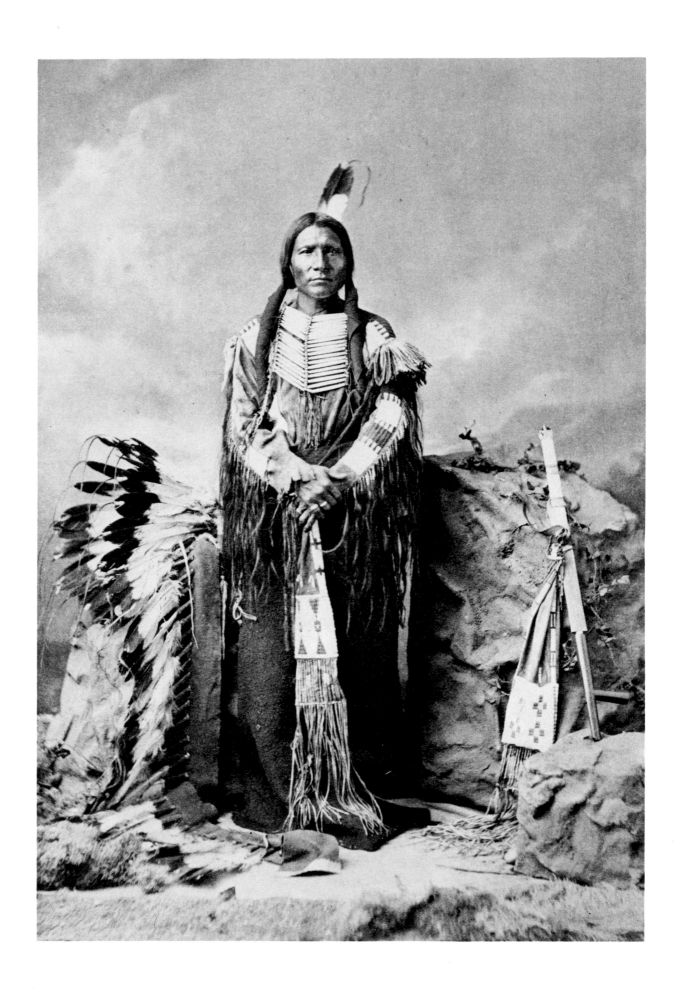

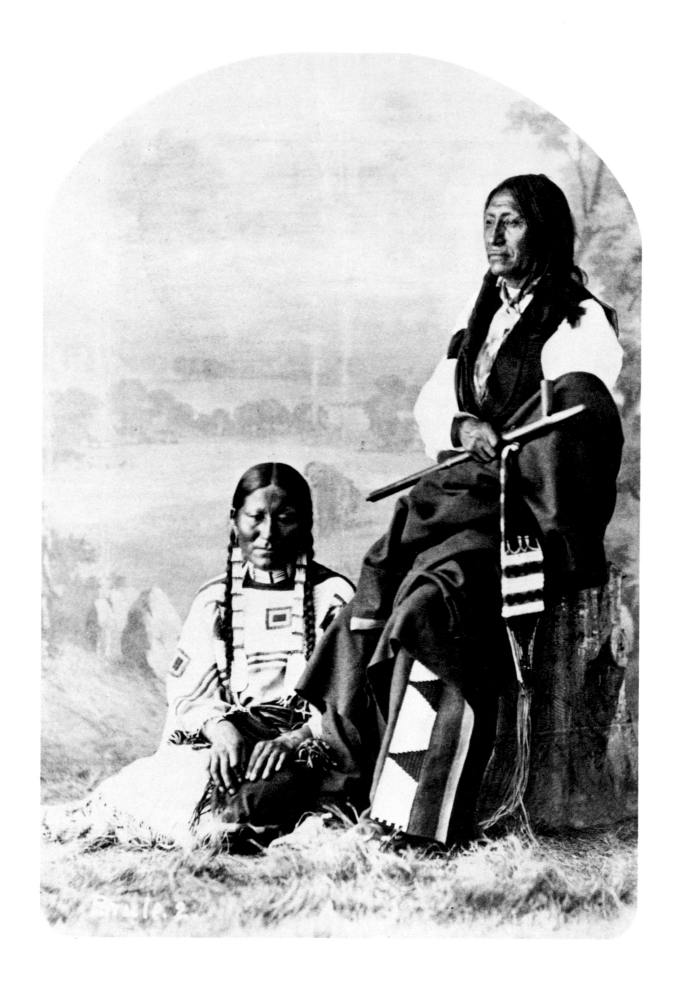

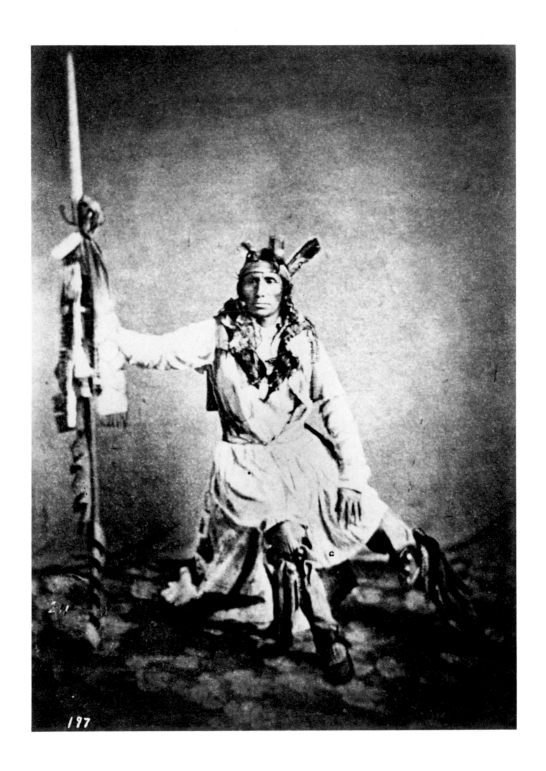

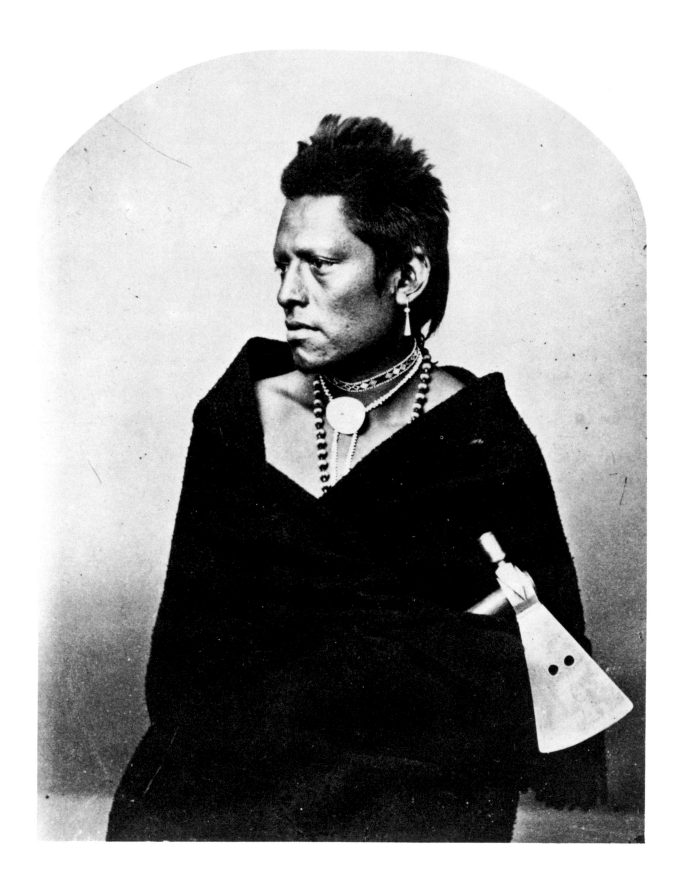

30

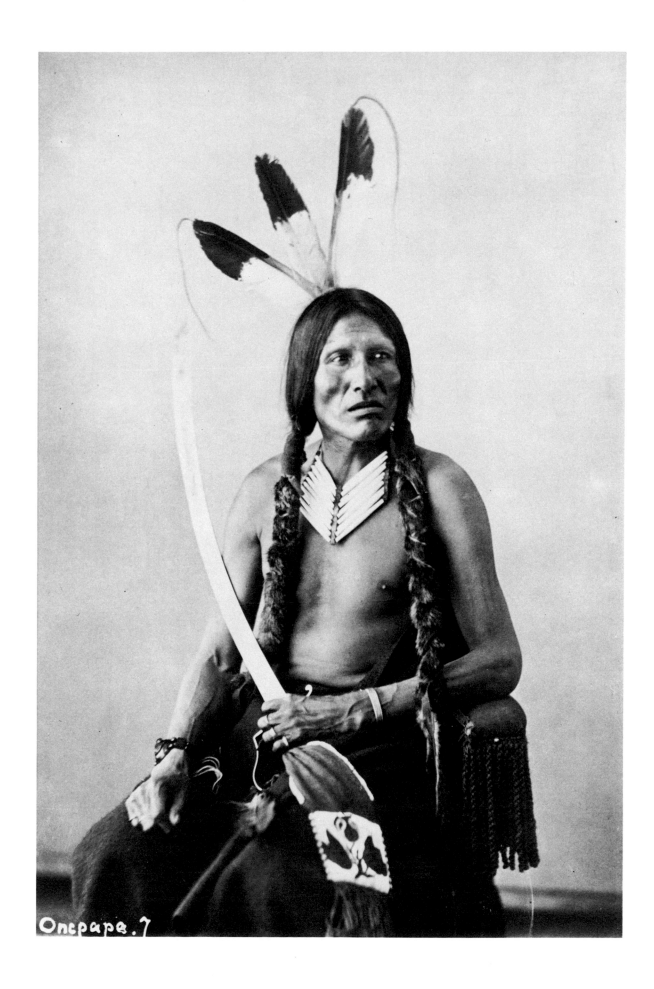

Oncpapa. 7

31

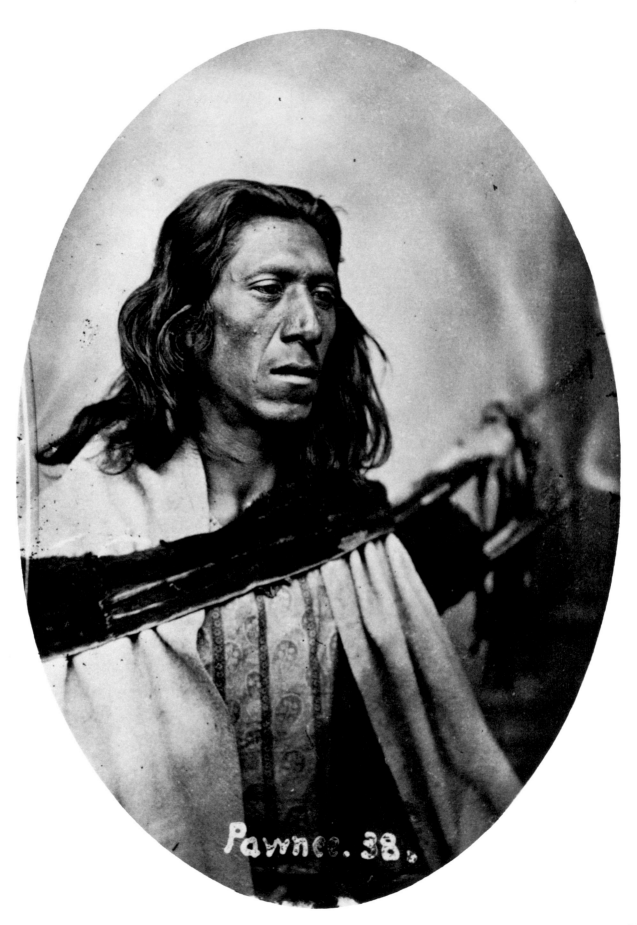

Pawnee. 38.

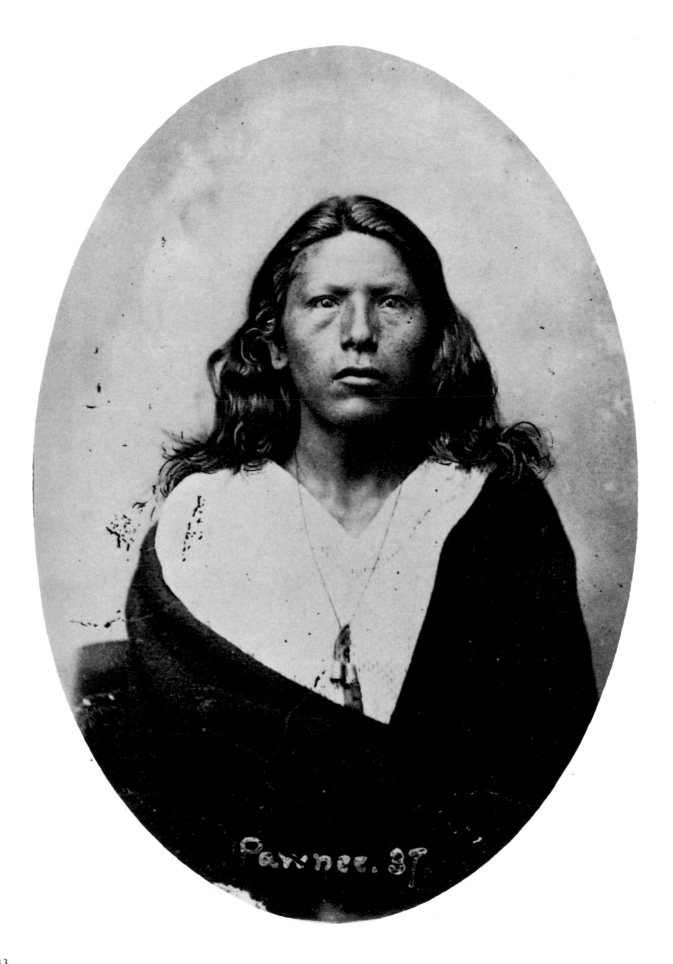

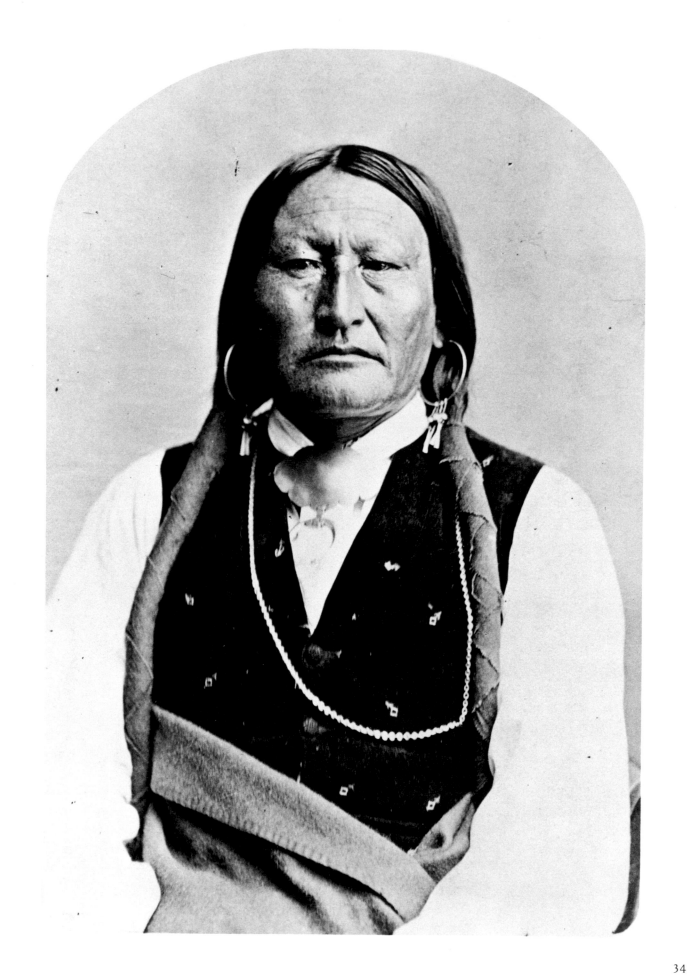

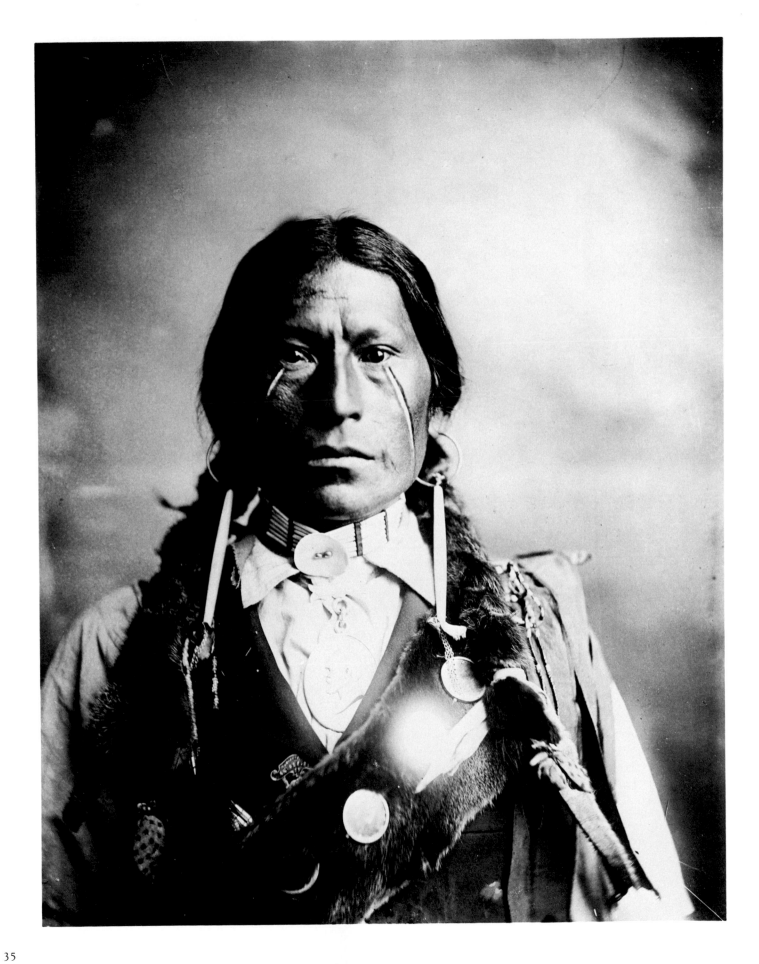

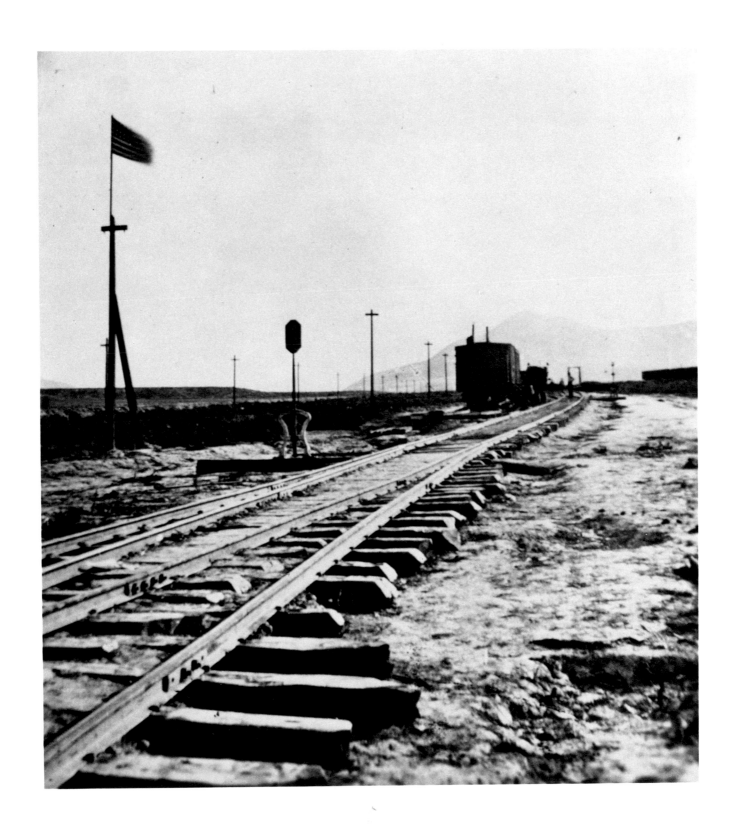

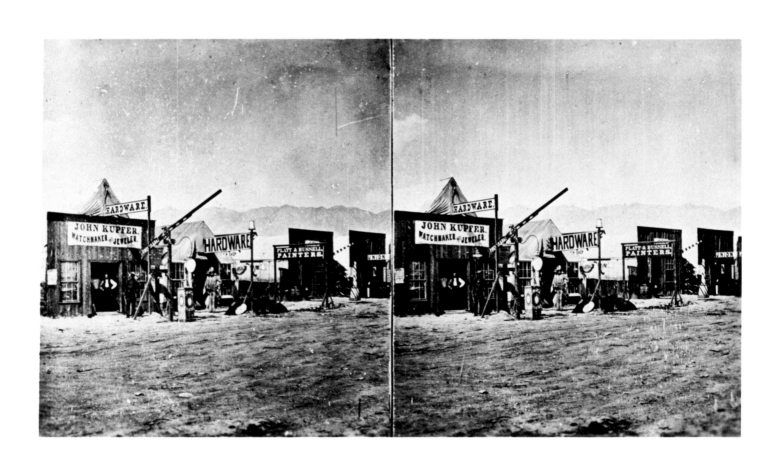

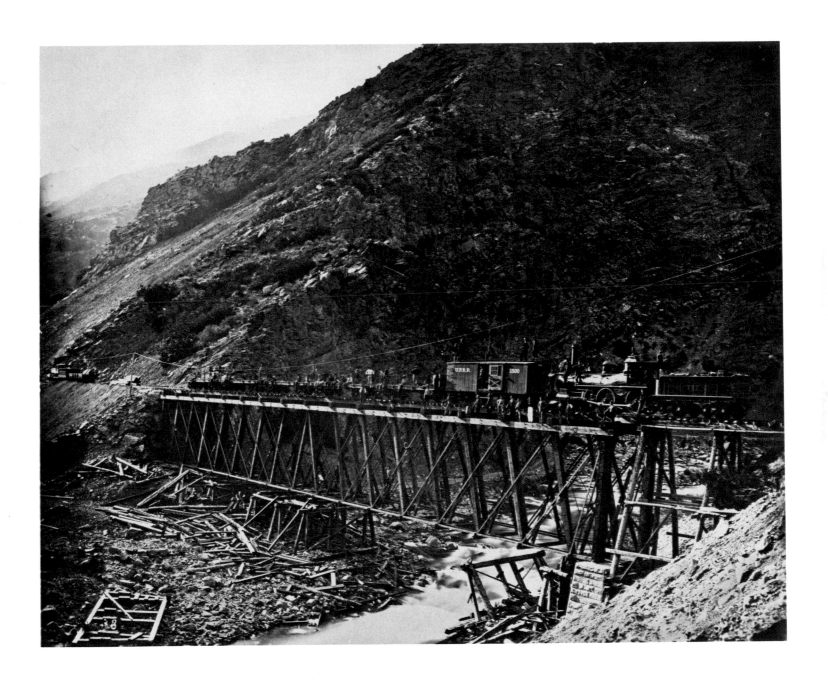

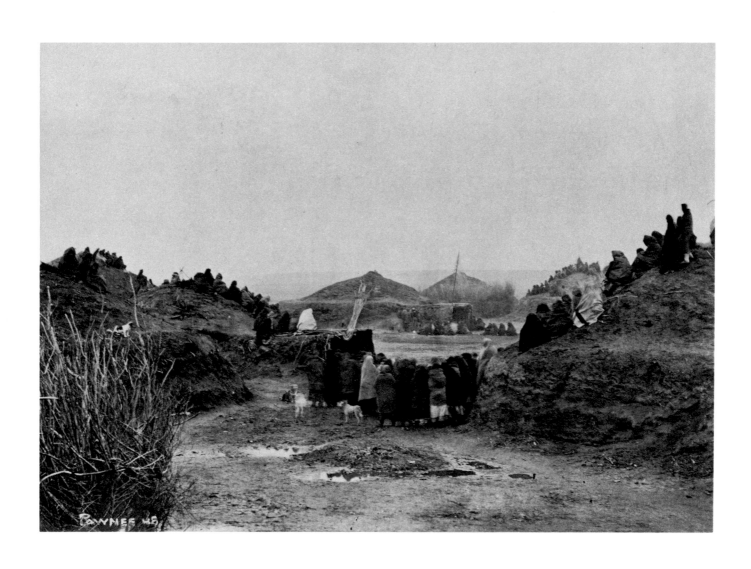

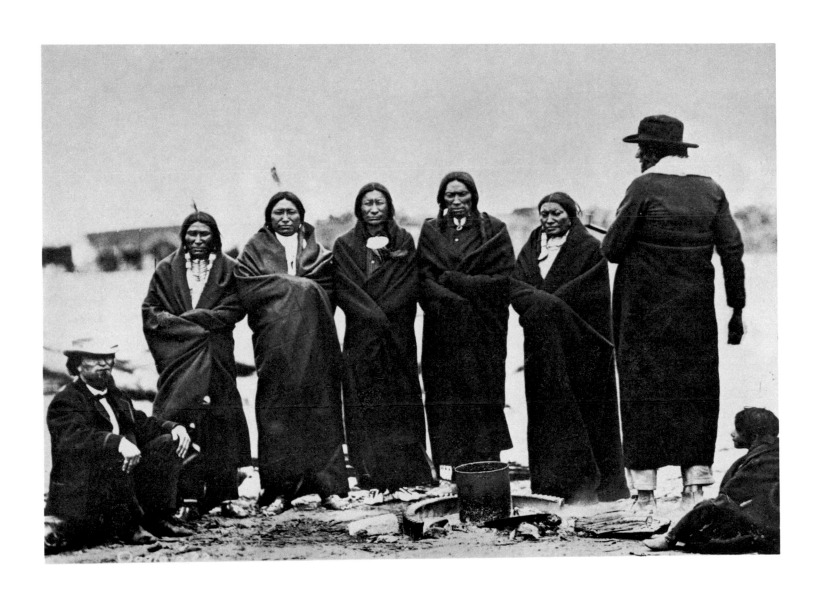

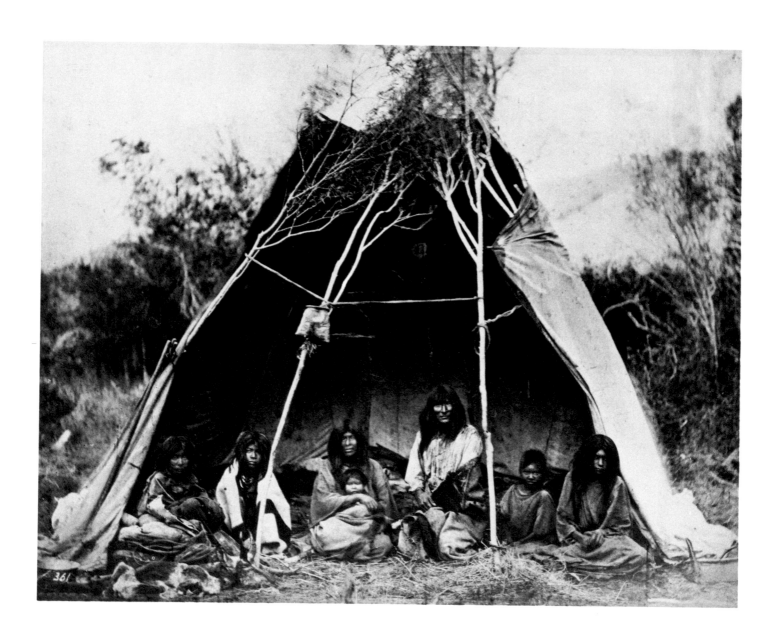

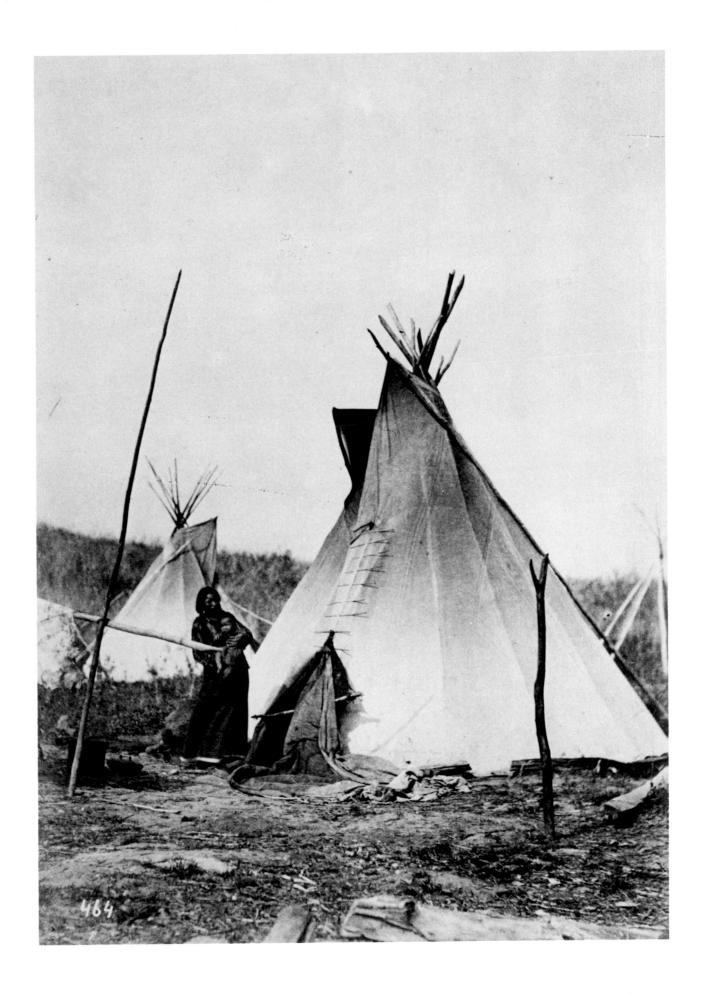

464

43

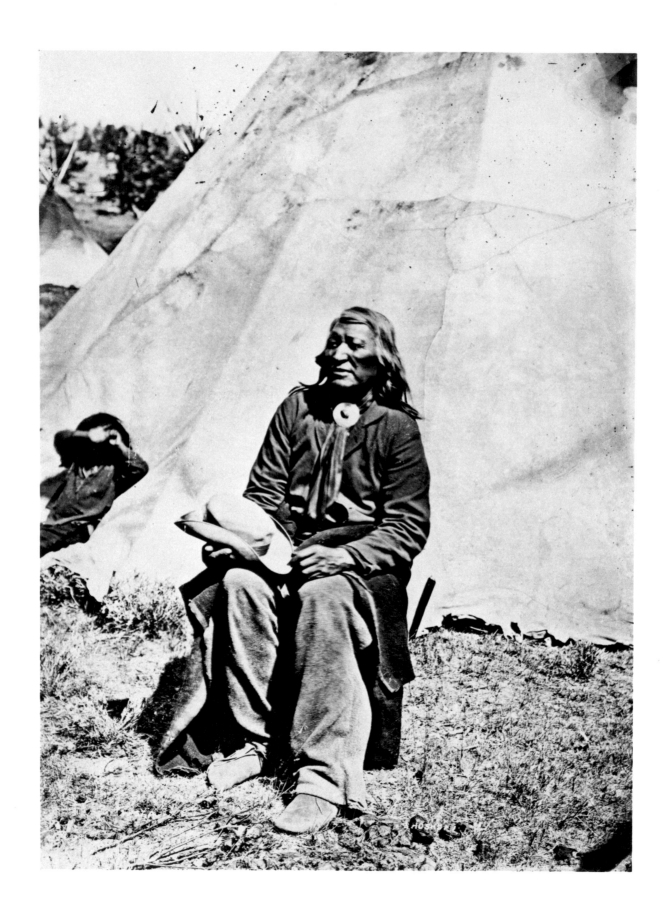

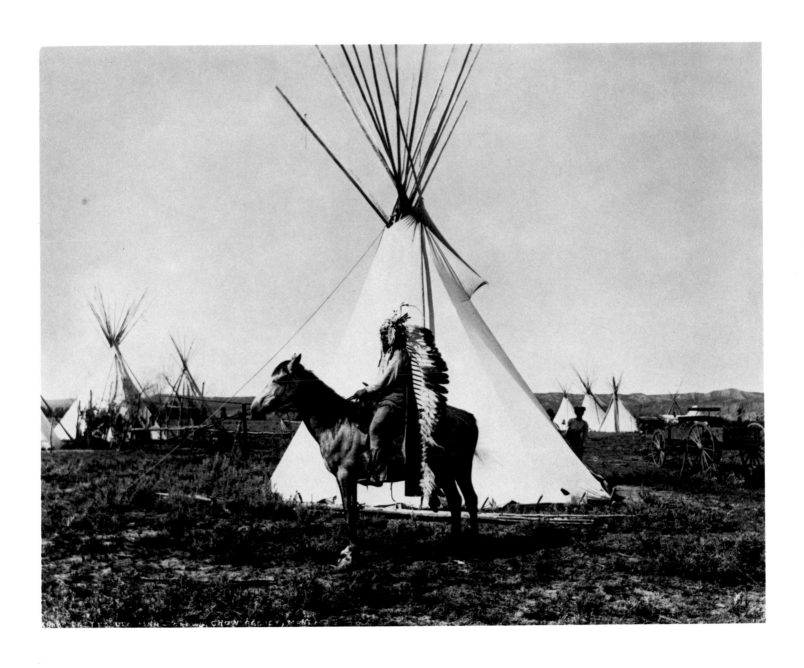

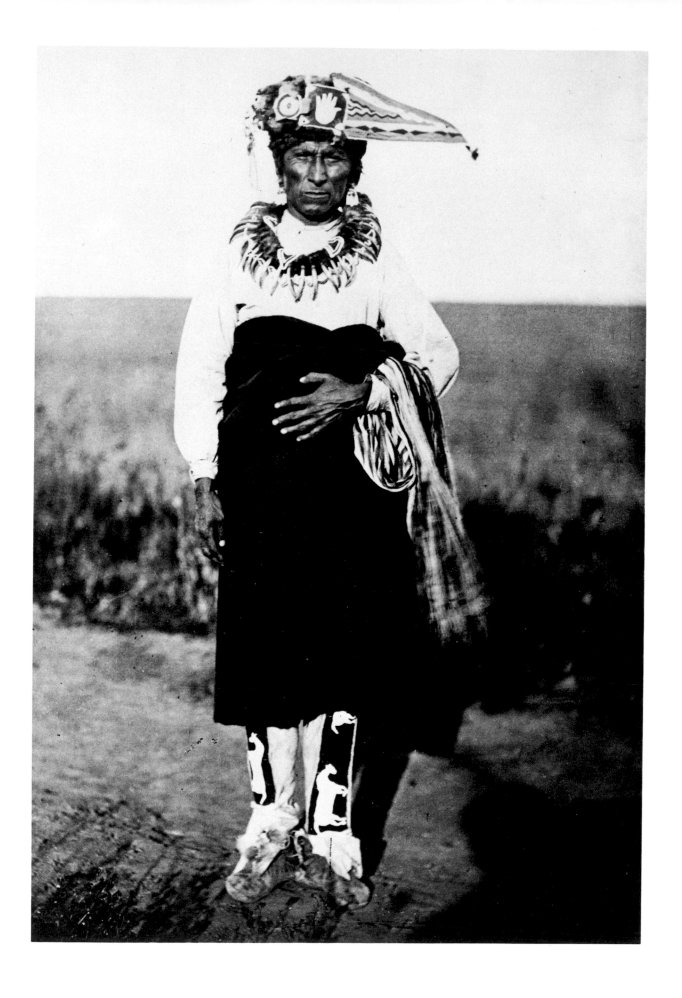

46

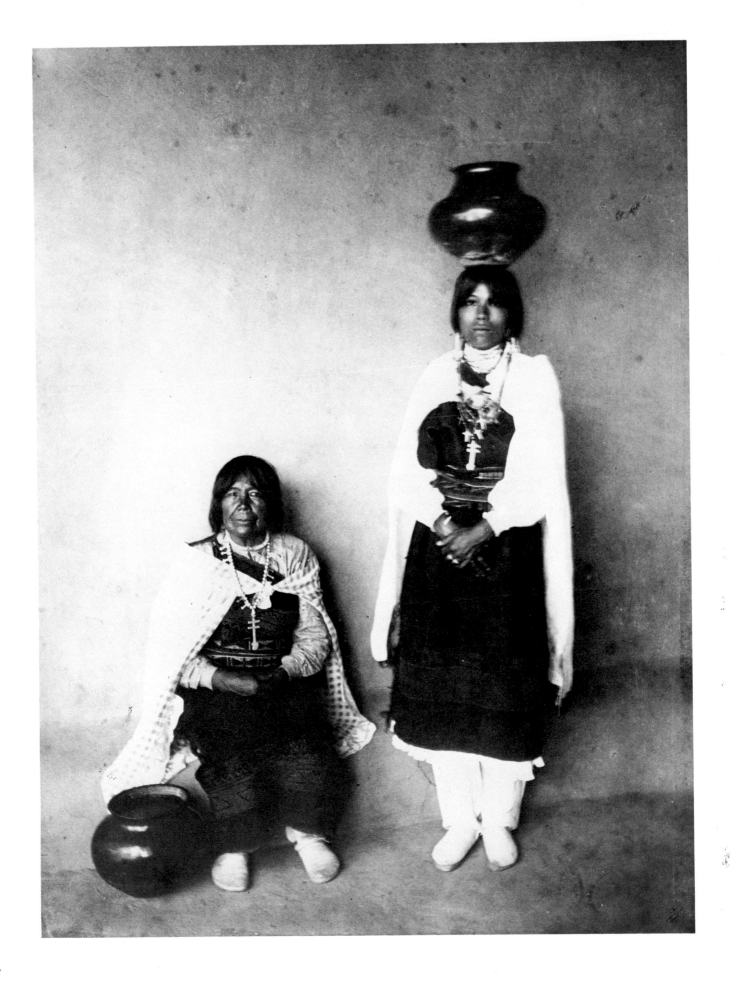

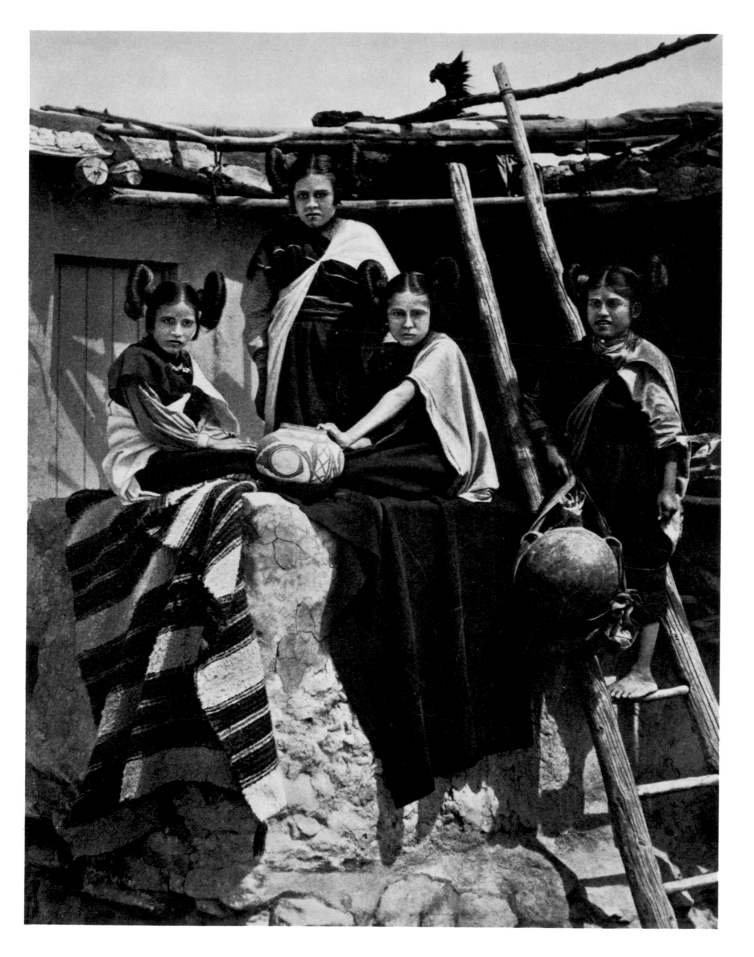

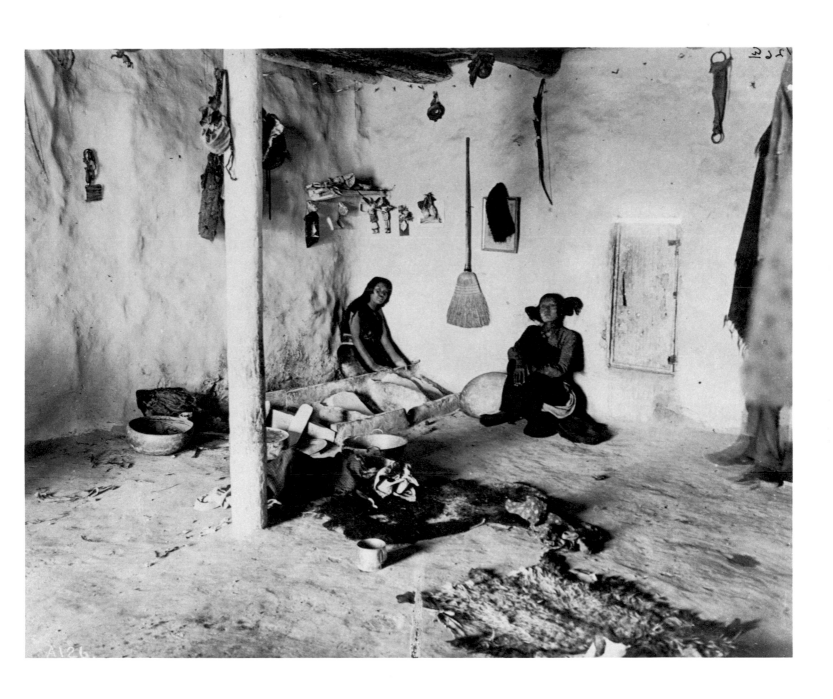

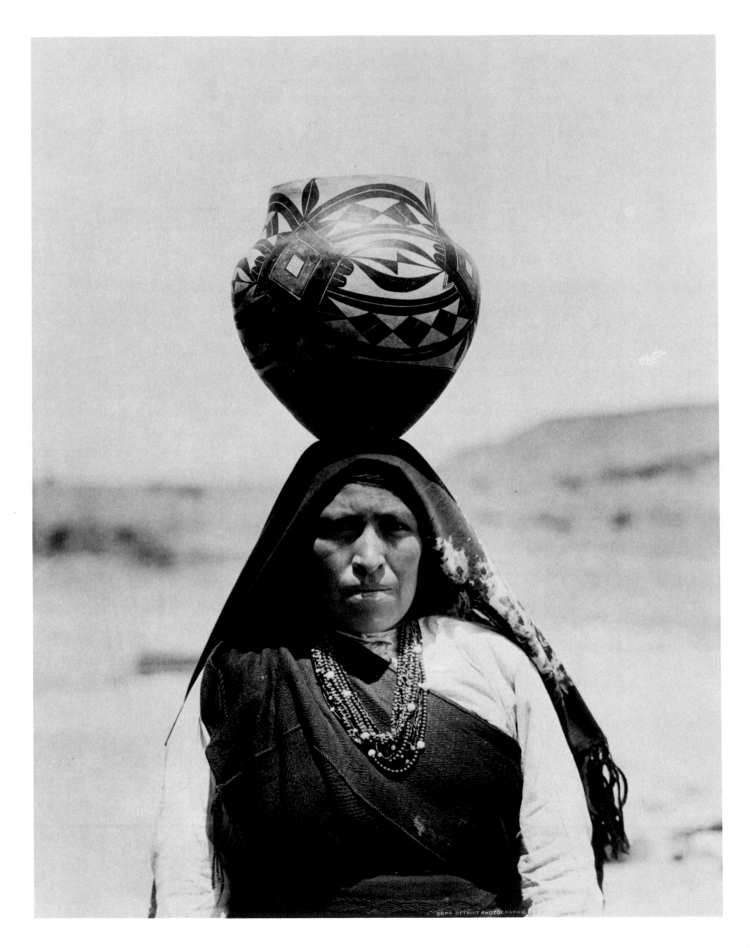

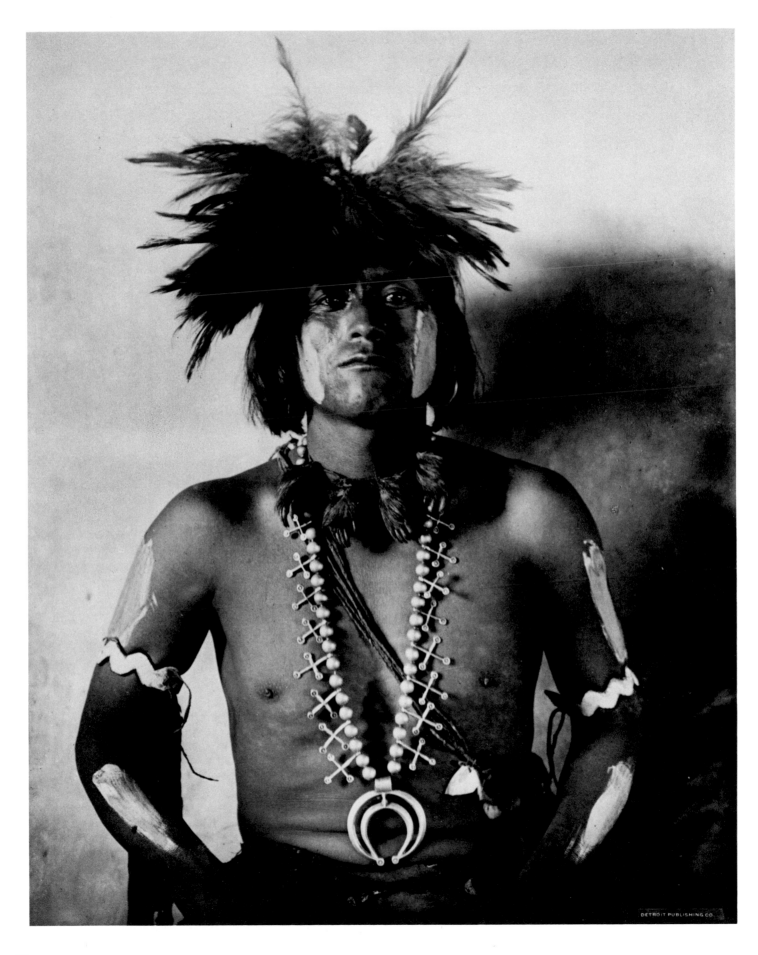

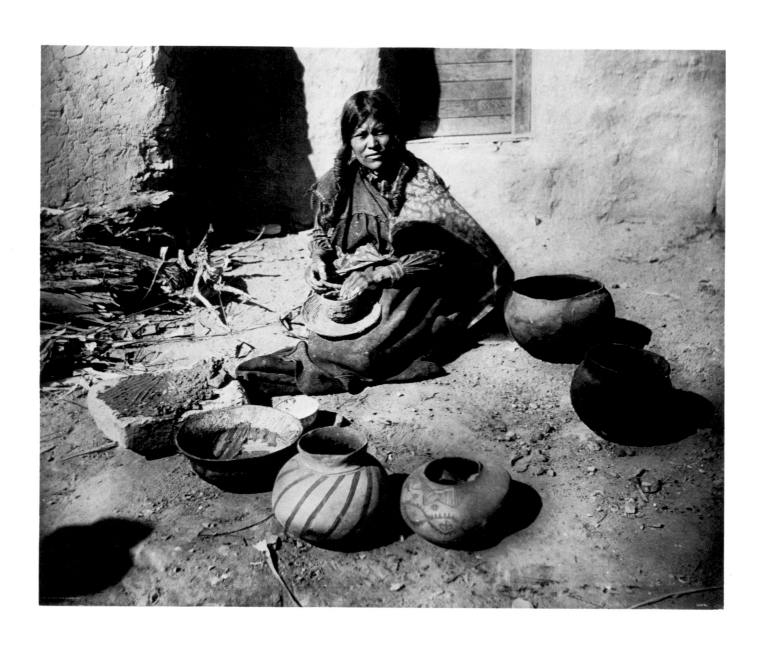

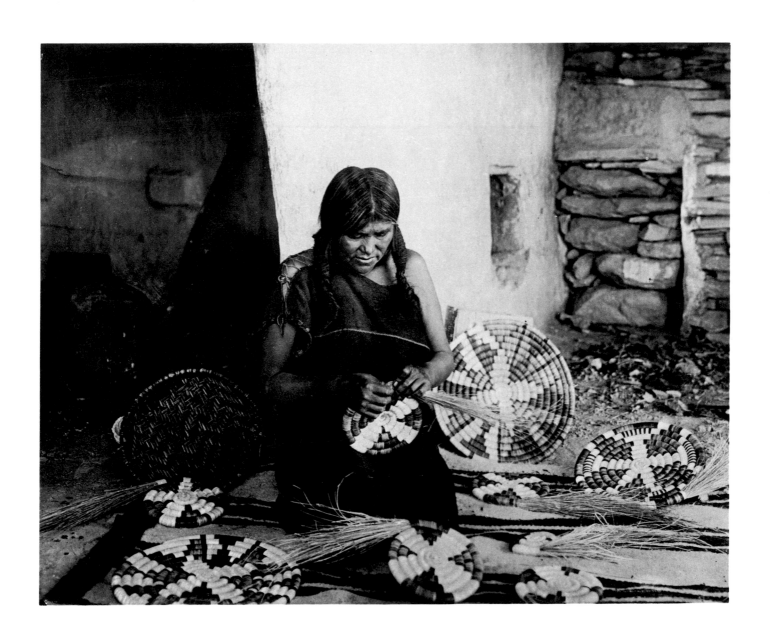

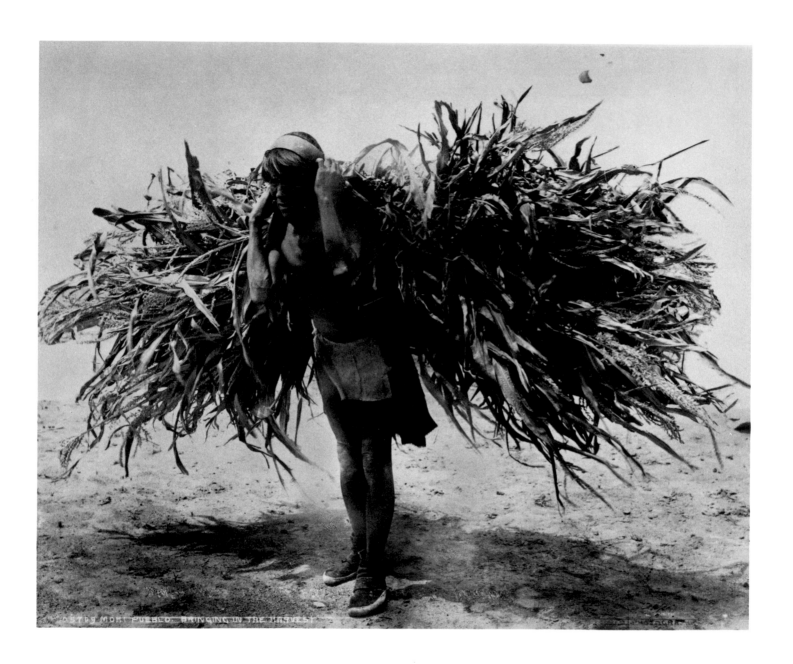

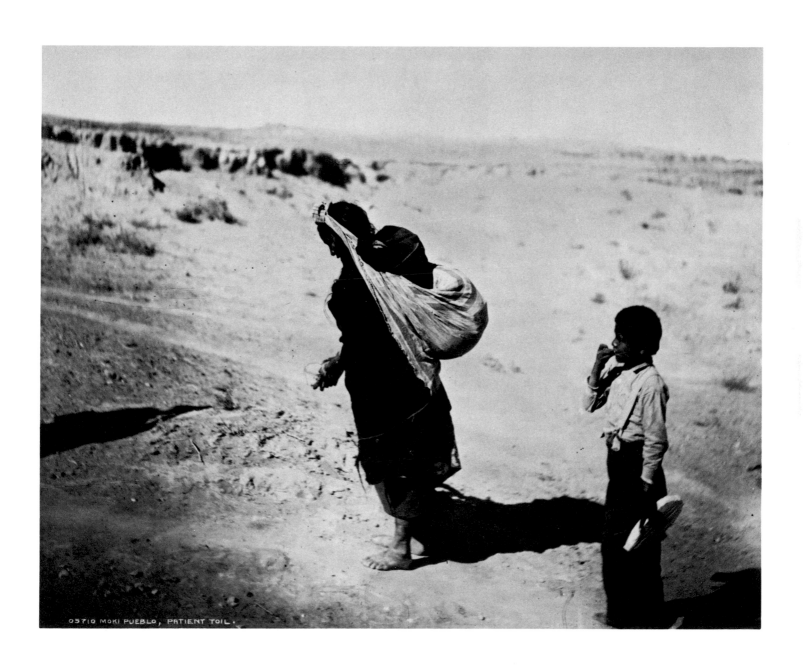

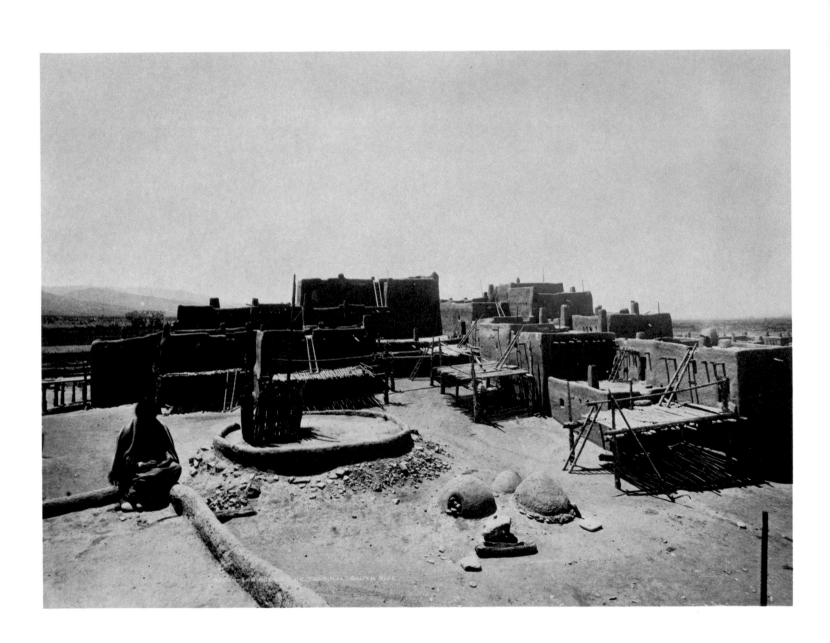

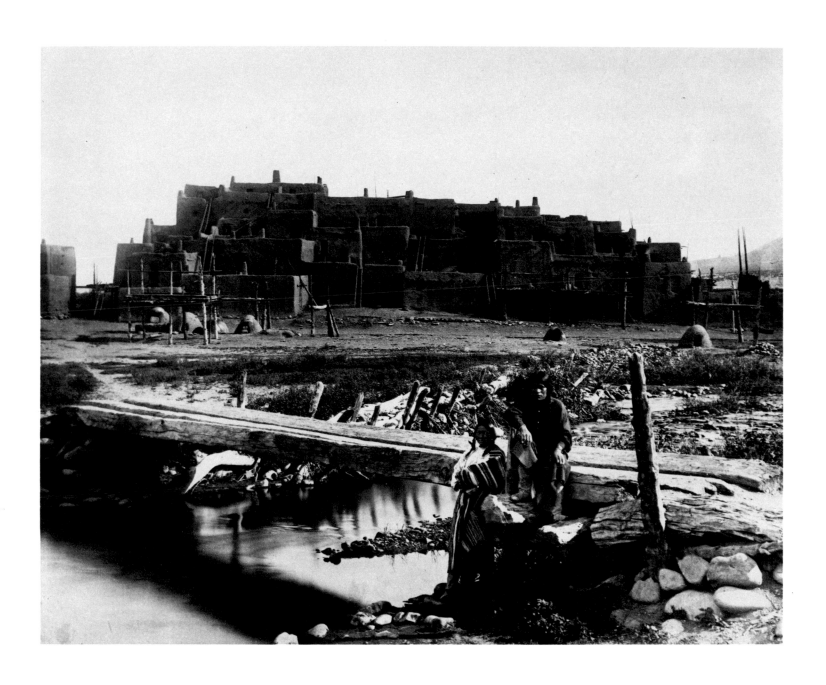

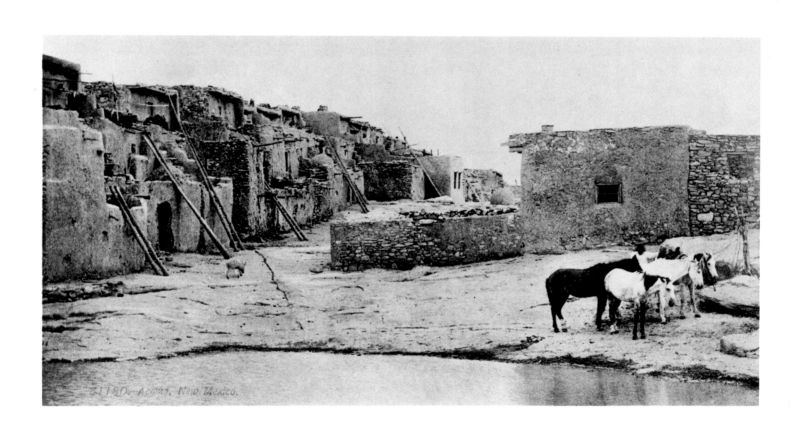

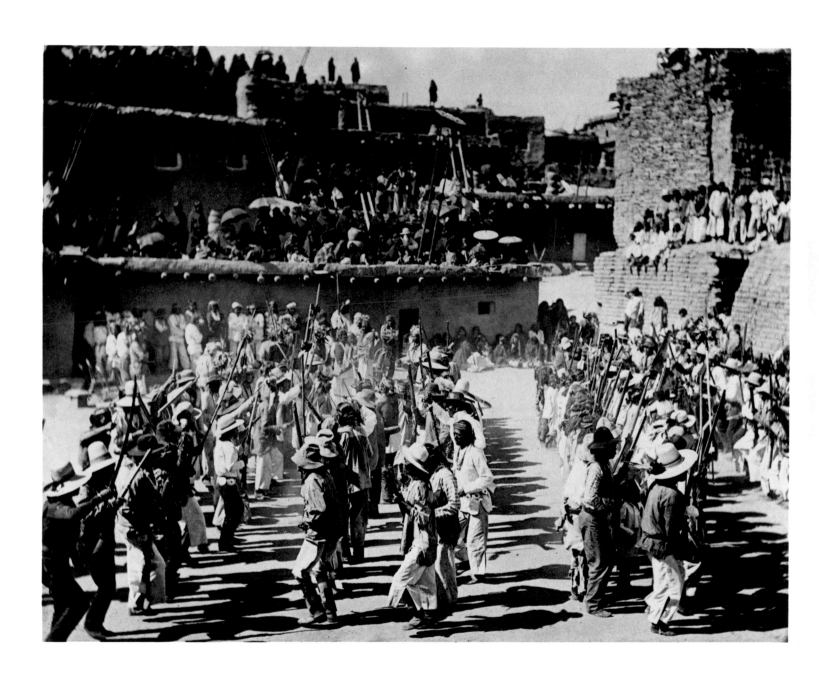

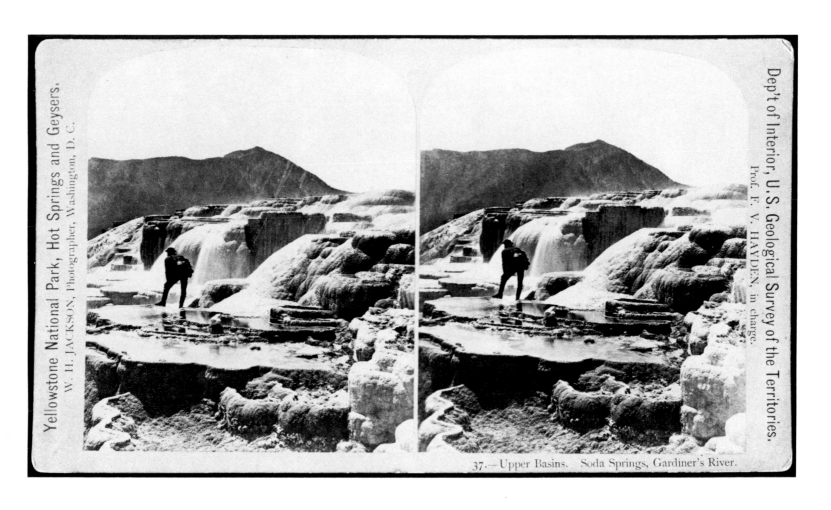

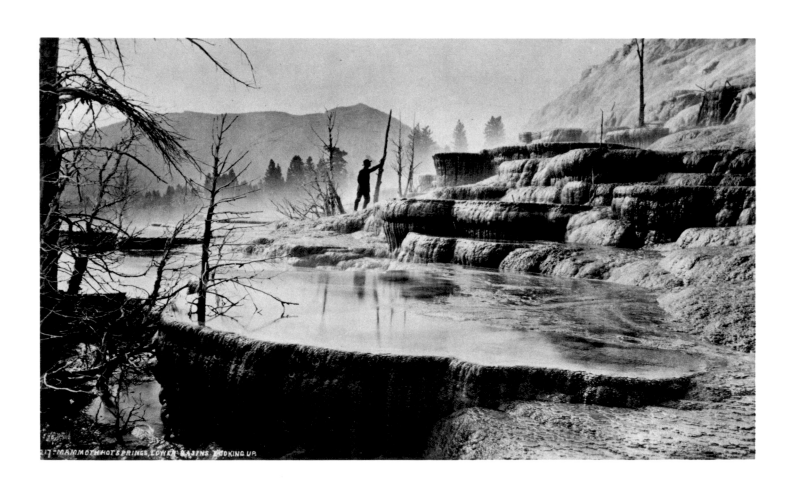

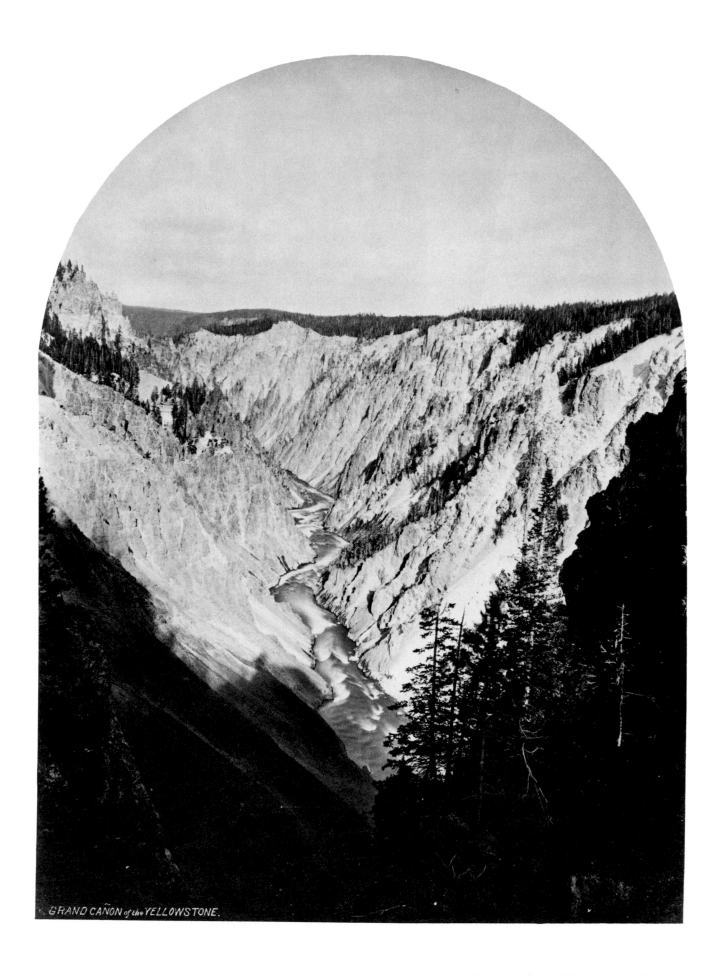

GRAND CAÑON of the YELLOWSTONE.

63

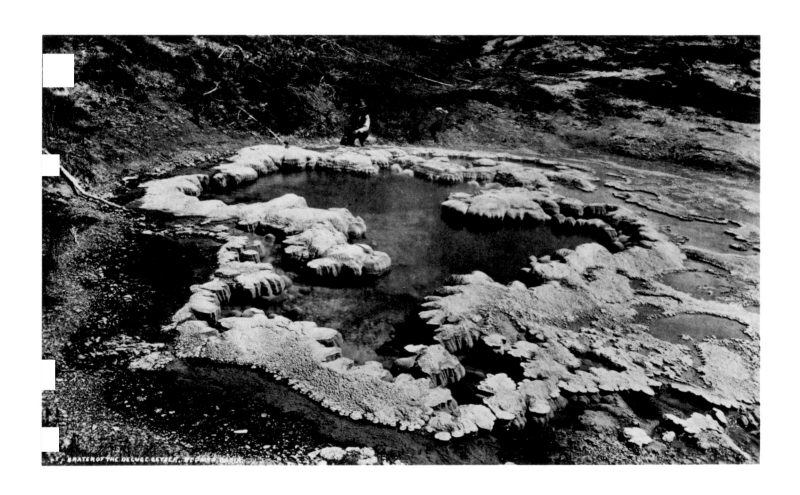

CRATER OF THE DELUGE GEYSER, UPPER BASIN

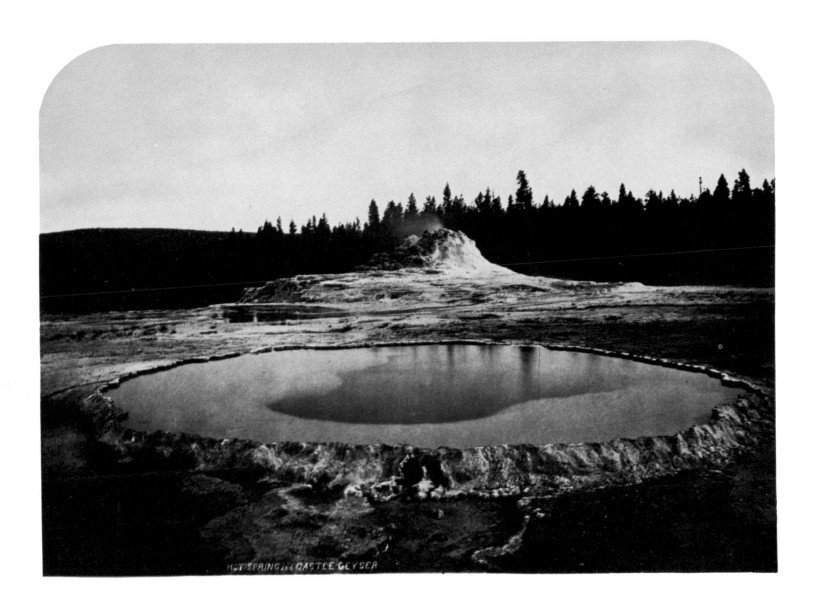

HOT SPRING AND CASTLE GEYSER

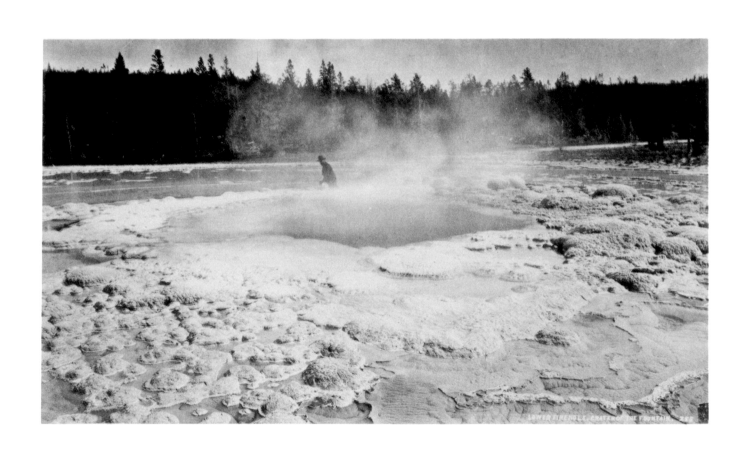

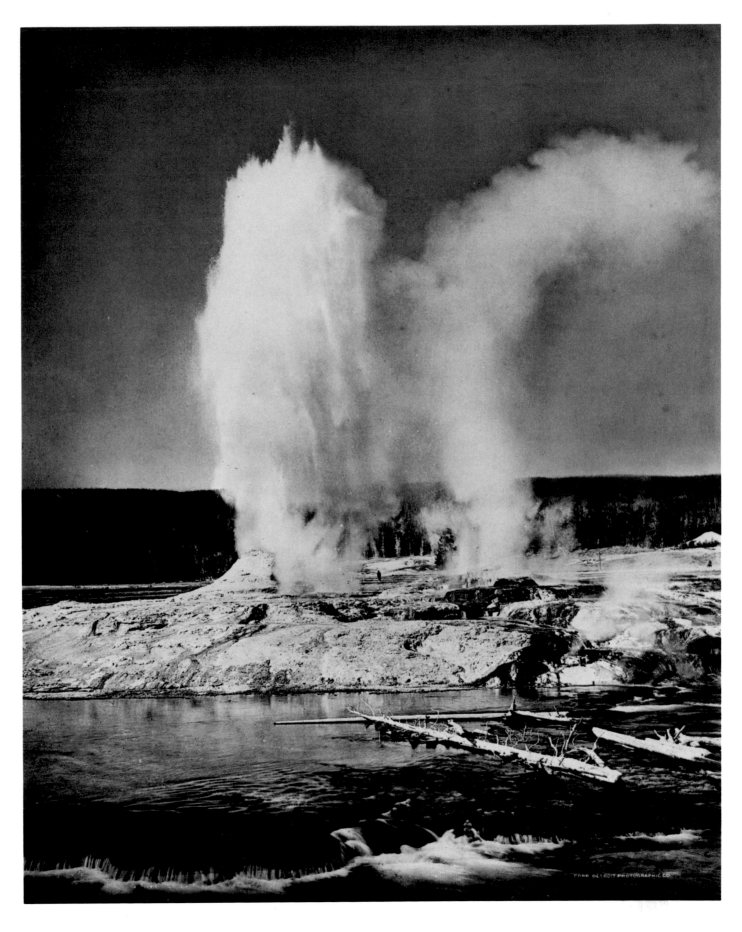

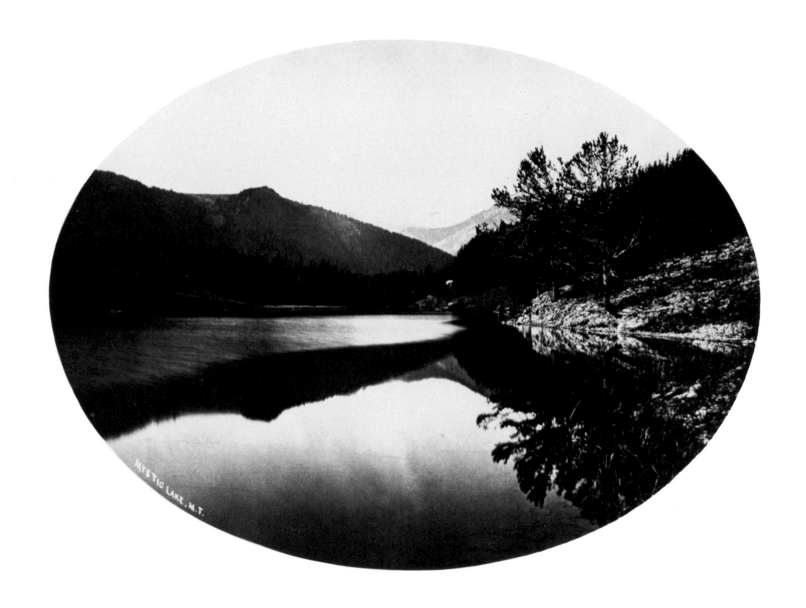

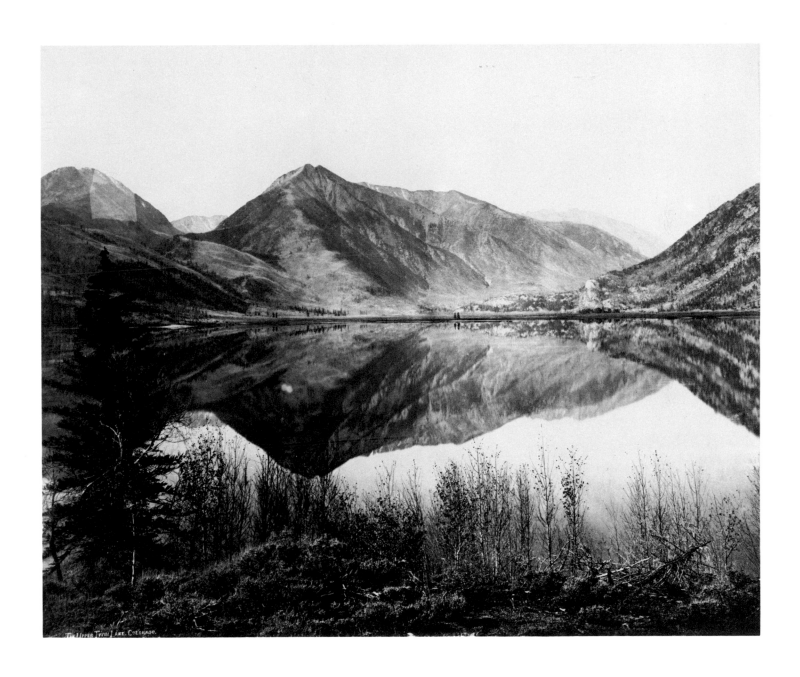

The Upper Twin Lake, Colorado.

69

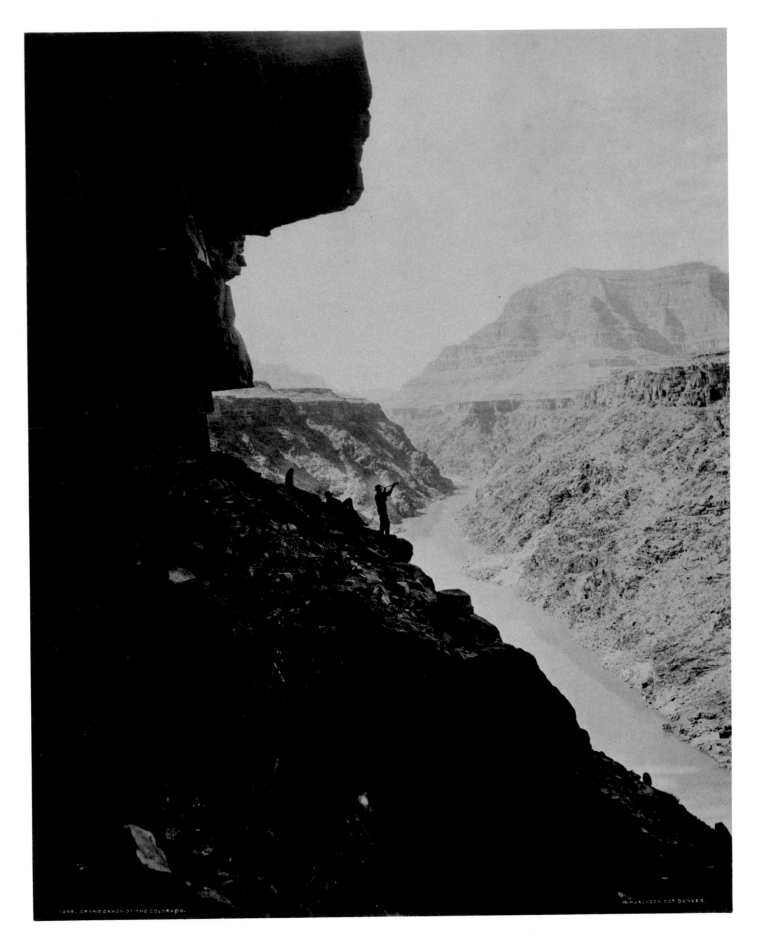

1069. GRAND CANON OF THE COLORADO.

W.H. JACKSON & CO. DENVER.

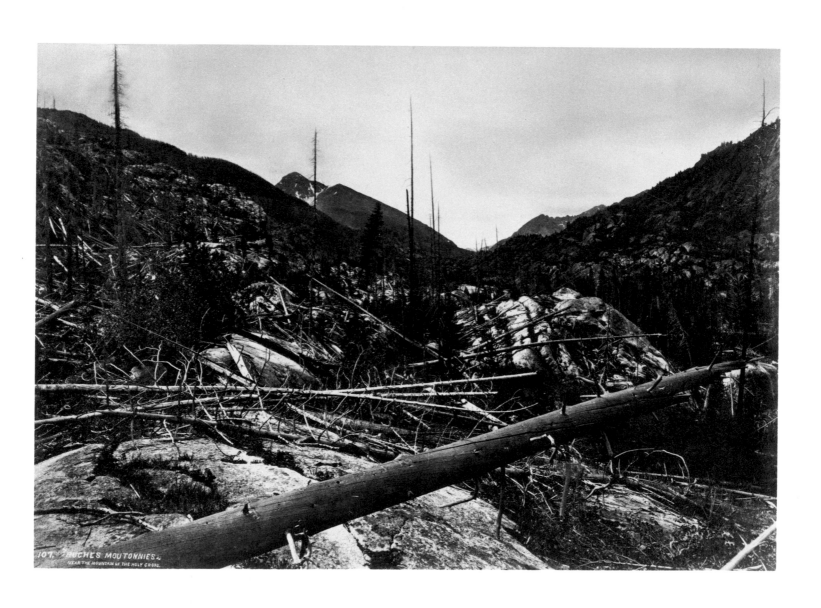

107. ROCHES MOUTONNIES.
NEAR THE MOUNTAIN OF THE HOLY CROSS.

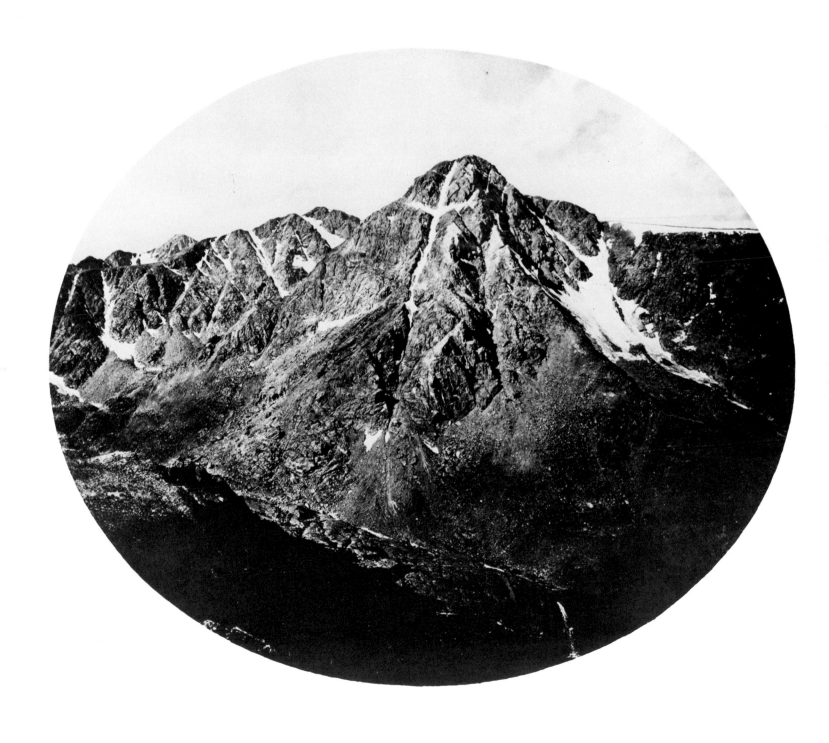

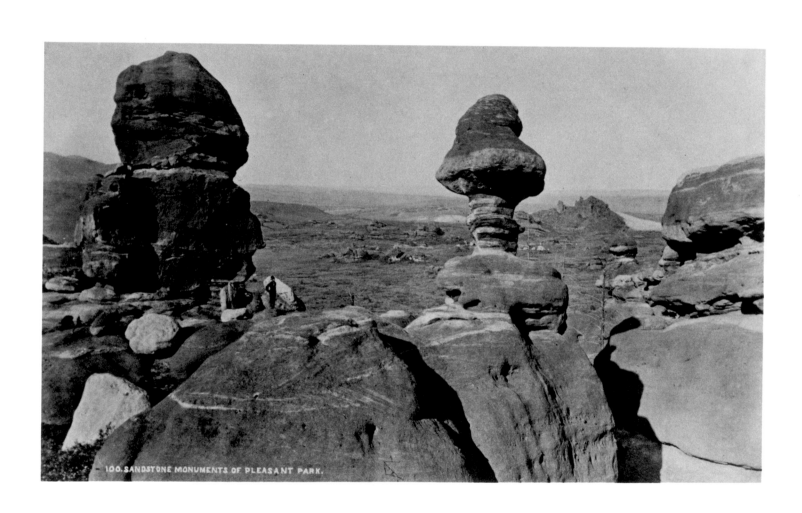

100. SANDSTONE MONUMENTS OF PLEASANT PARK.

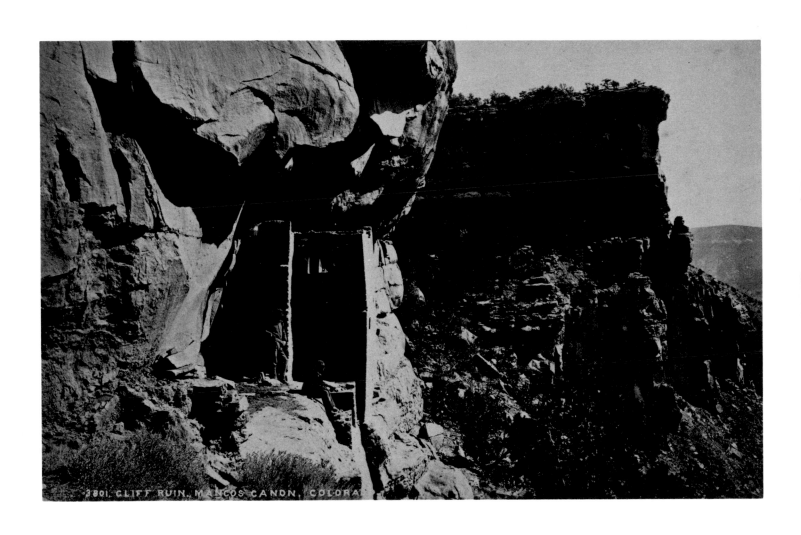

3801. CLIFF RUIN. MANCOS CANON, COLORADO

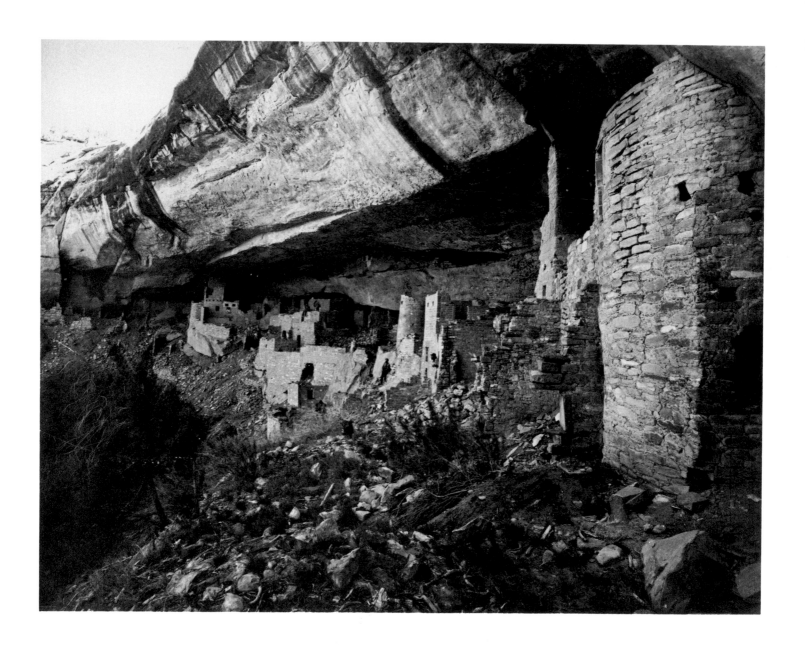

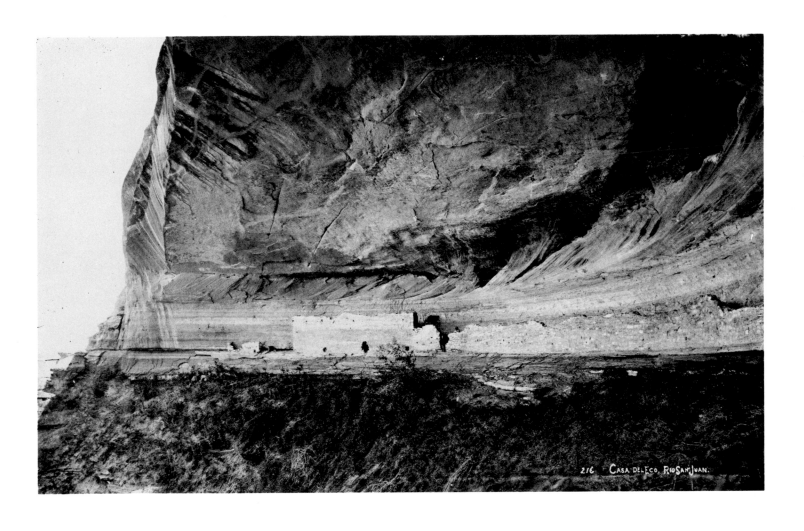

216. CASA DEL ECO, RIO SAN JUAN.

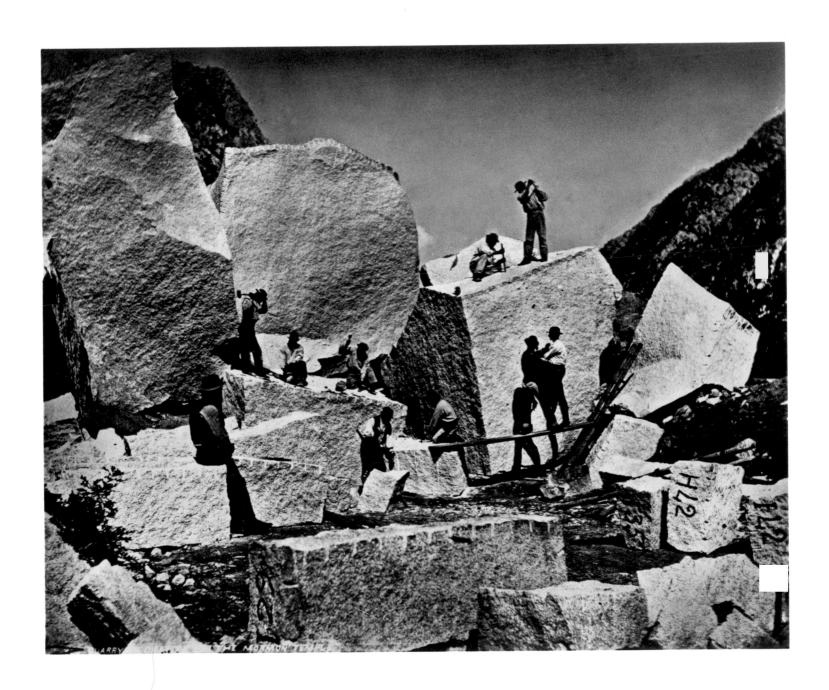

QUARRY ... THE MORMON TEMPLE

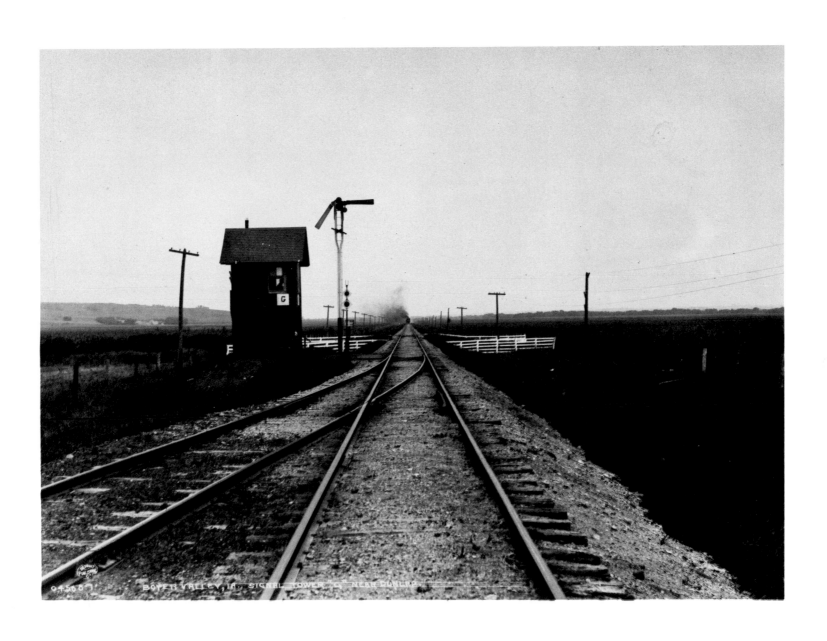

BOYER VALLEY, IA, SIGNAL TOWER "G" NEAR DUNLAP

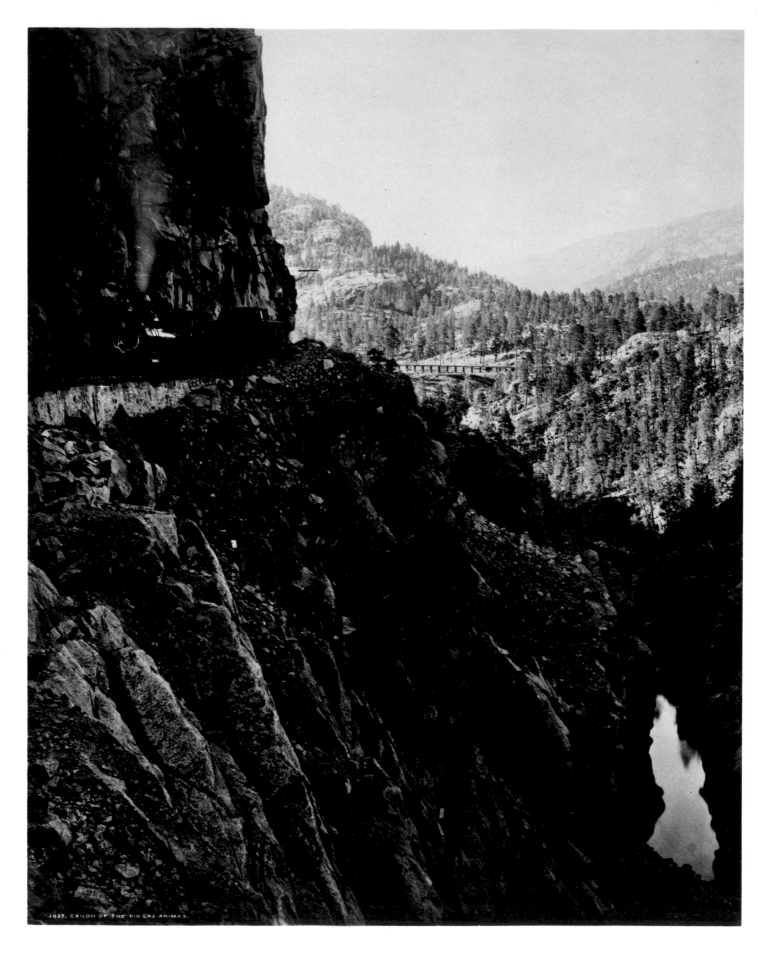

1037. CANON OF THE RIO LAS ANIMAS.

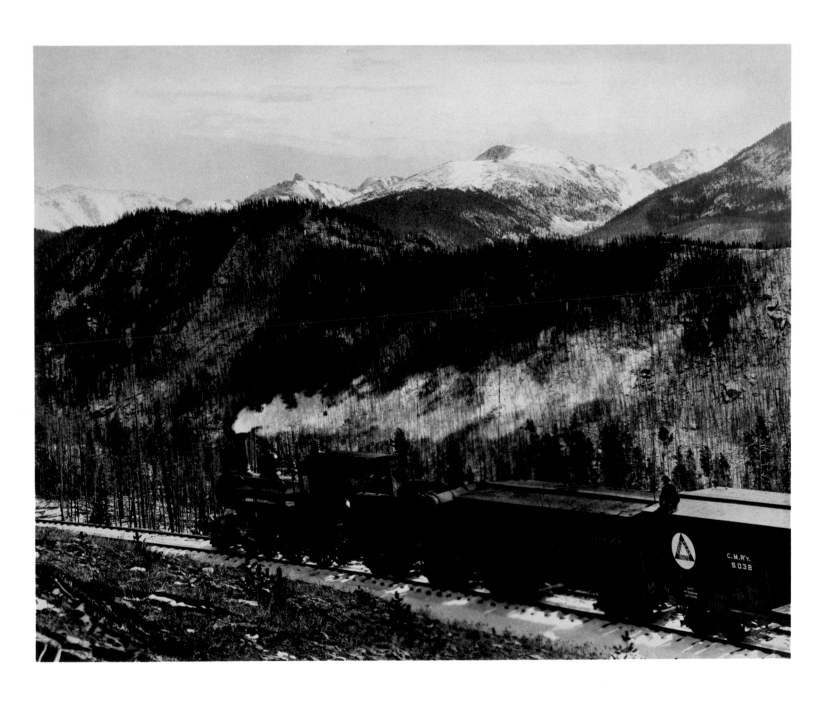

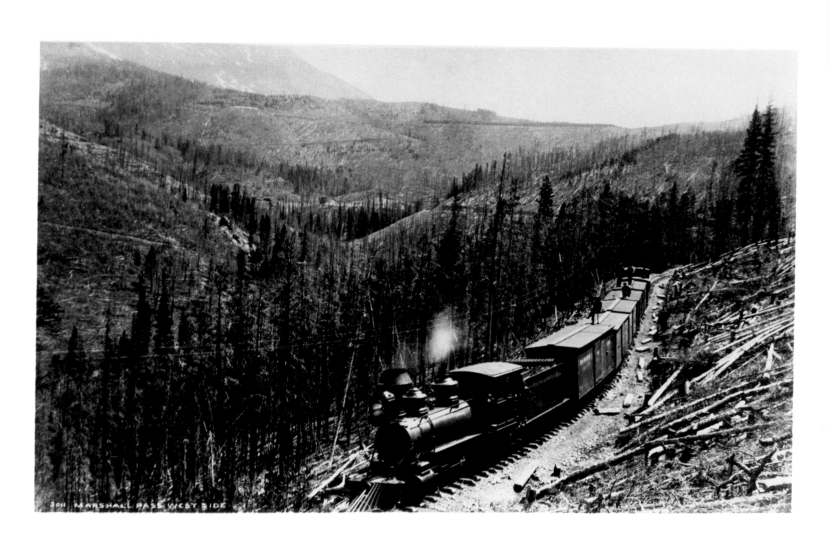

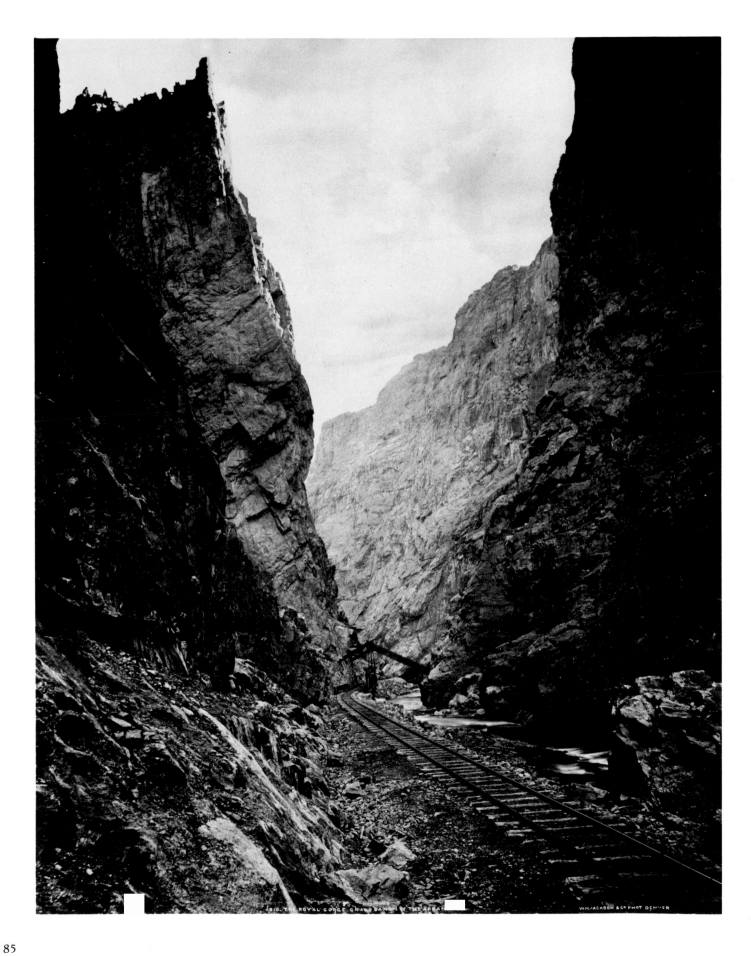

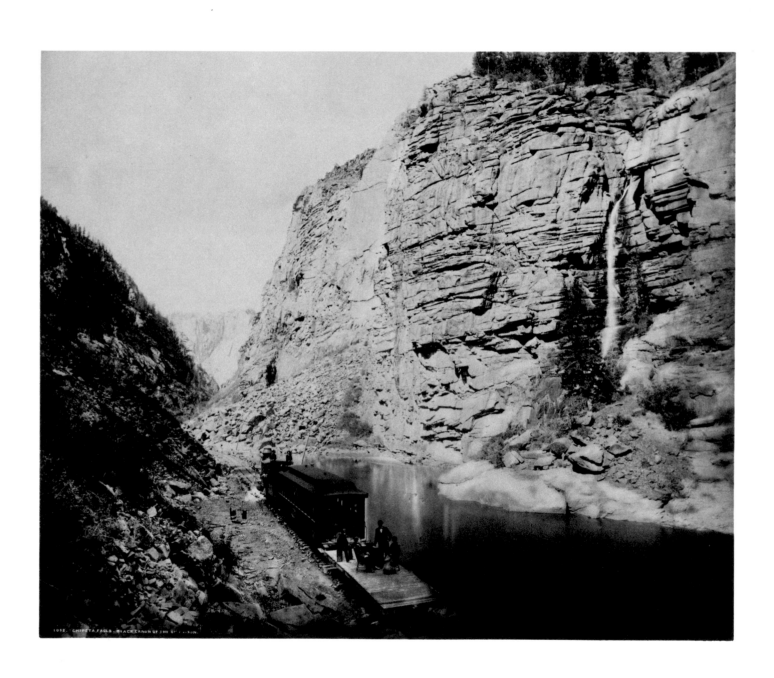

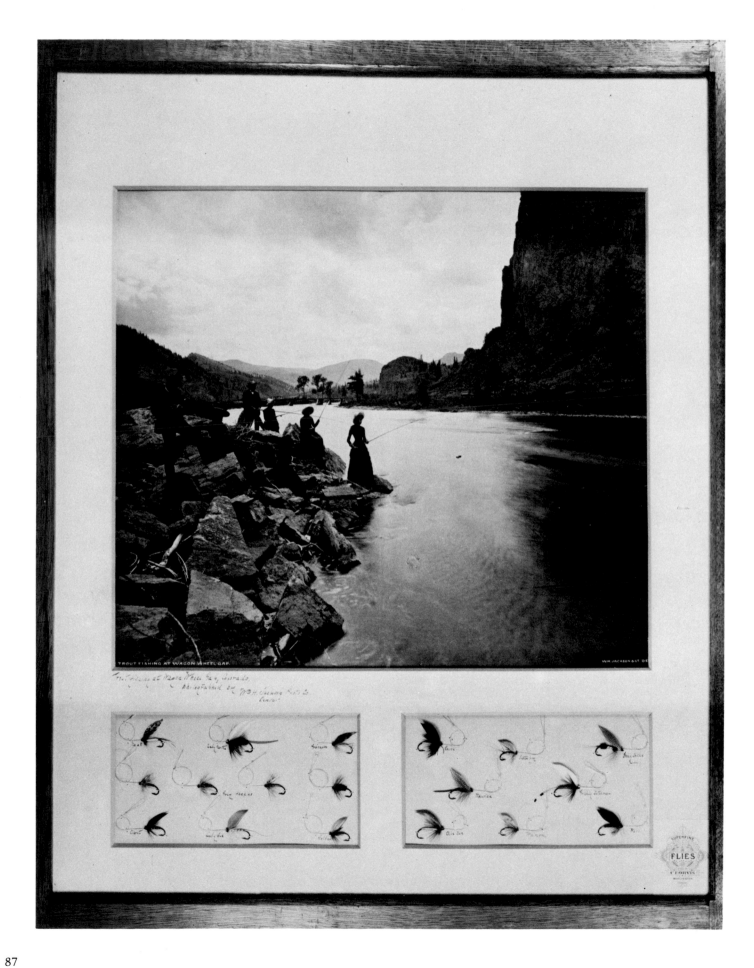

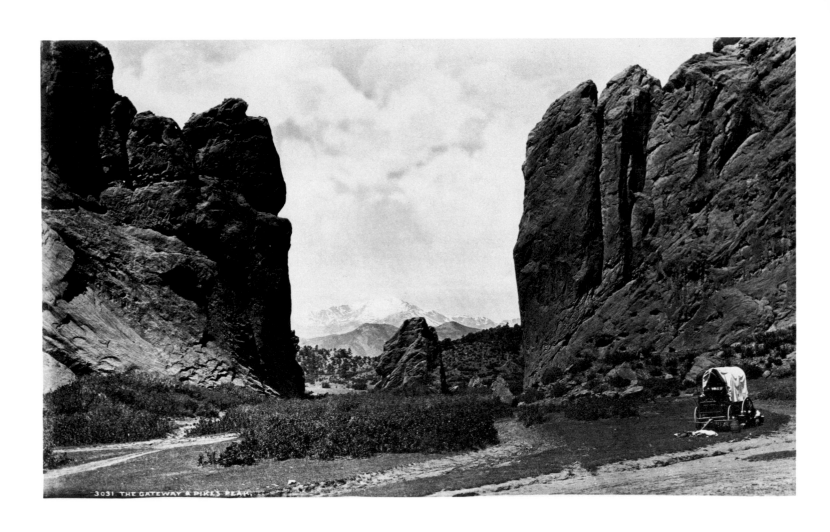

3031 THE GATEWAY & PIKE'S PEAK.

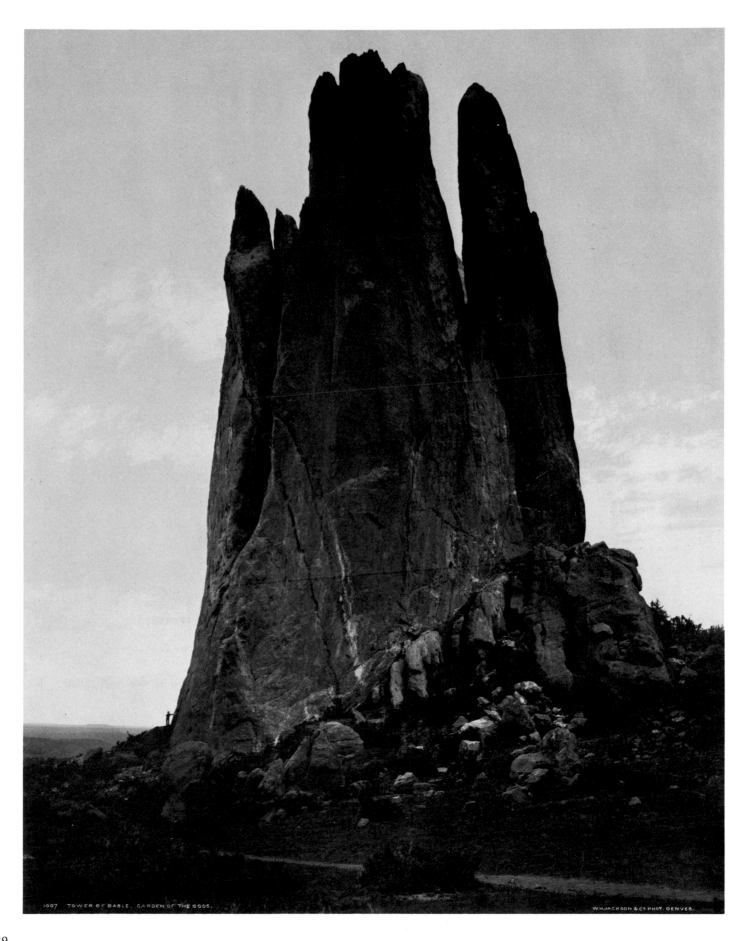

1007 TOWER OF BABLE. GARDEN OF THE GODS.

W.H.JACKSON & C? PHOT. DENVER.

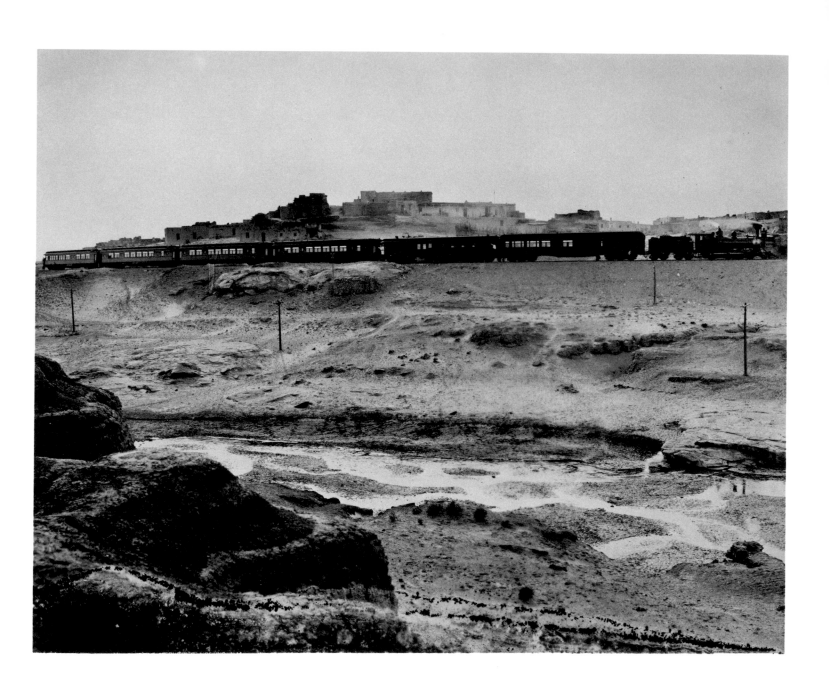

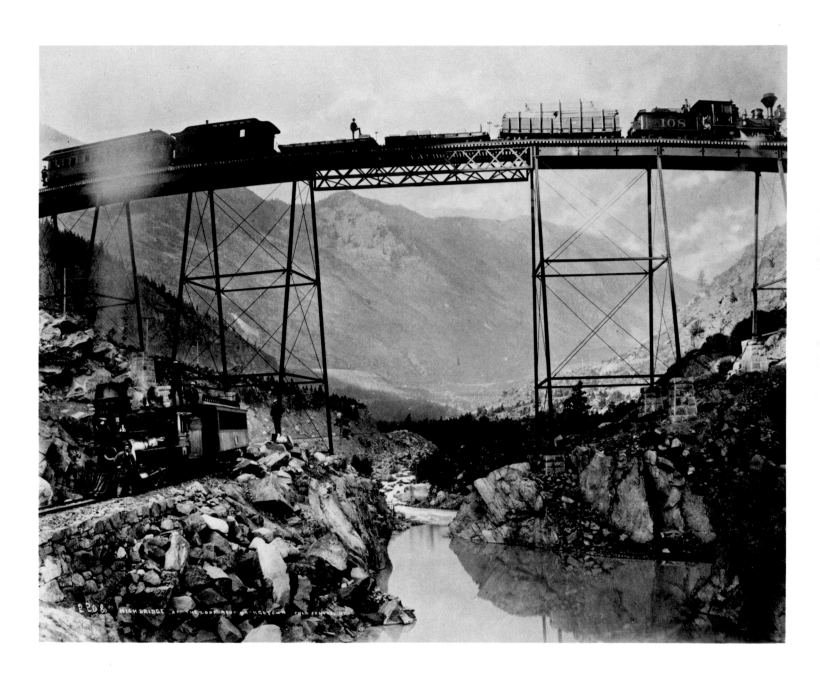

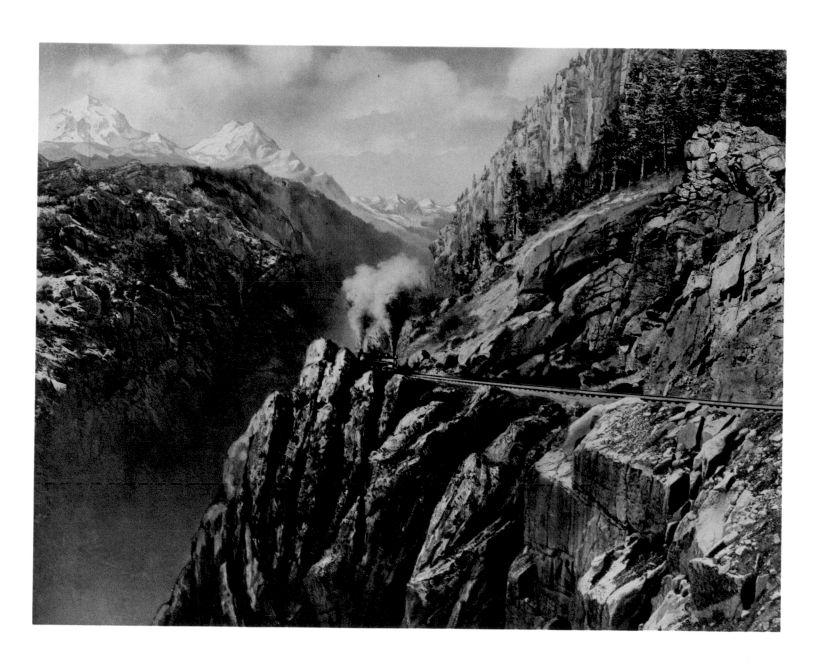

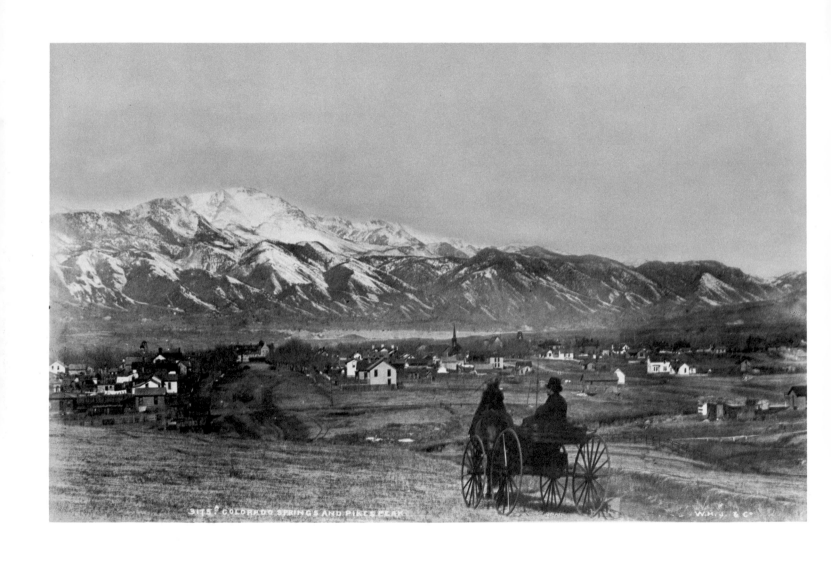

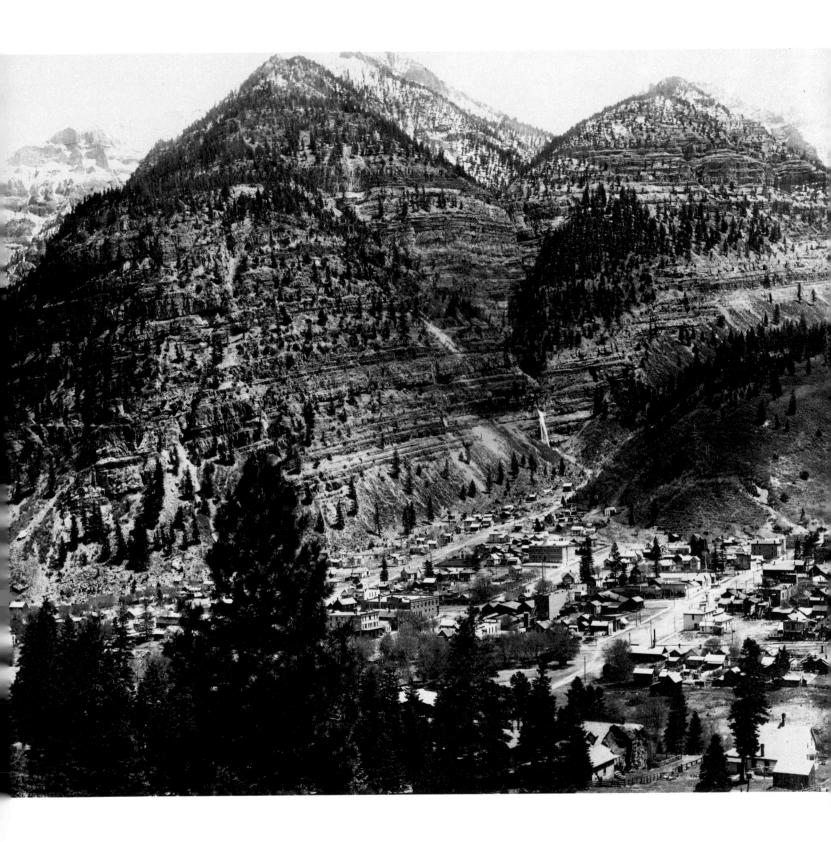

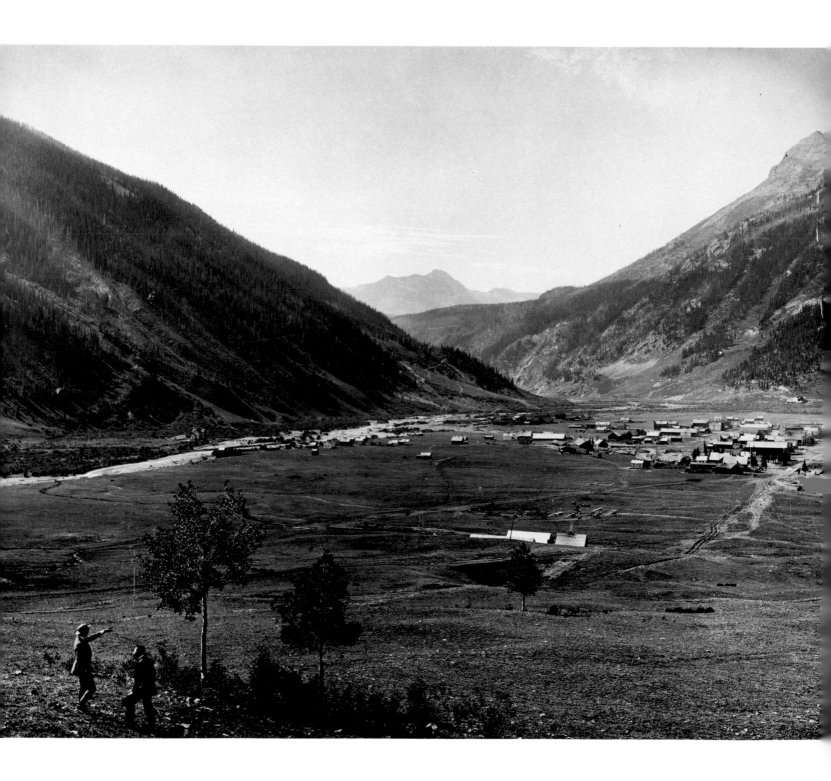

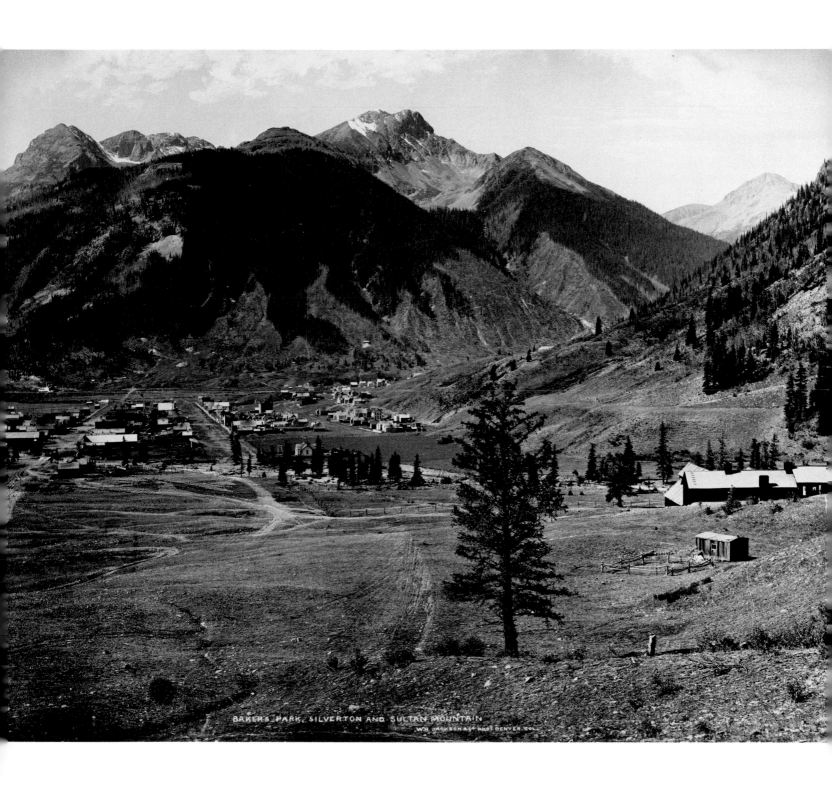

BAKER'S PARK, SILVERTON AND SULTAN MOUNTAIN
WM. JACKSON & CO. PHOT. DENVER. COL.

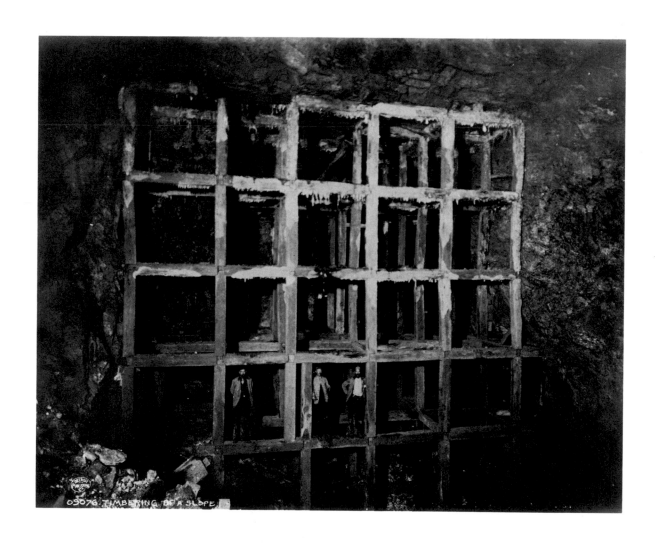

09076 TIMBERING OF A SLOPE.

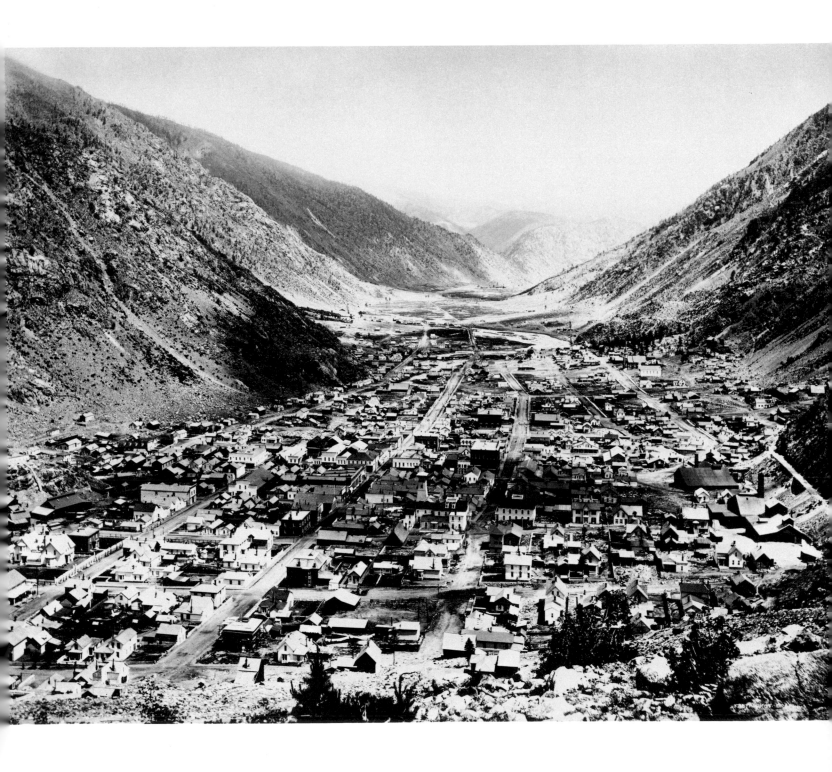

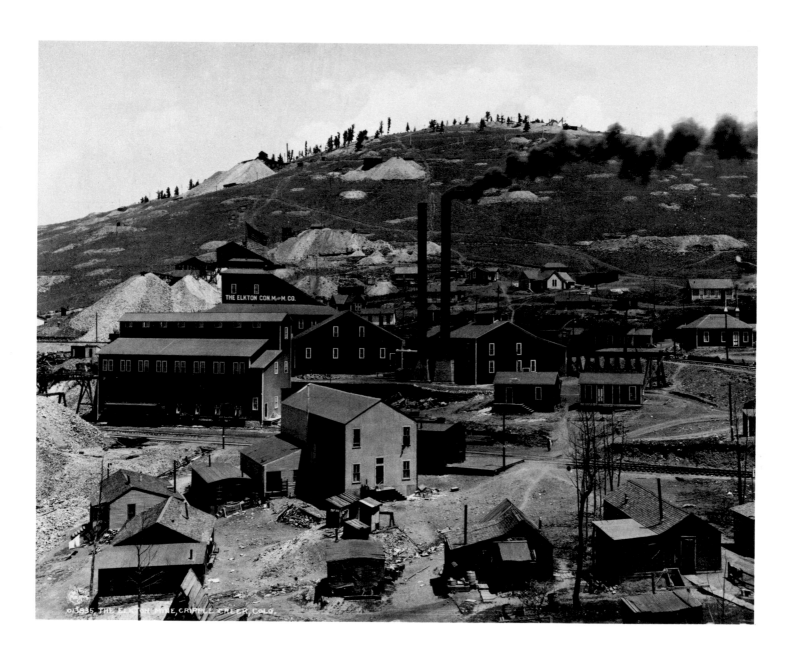

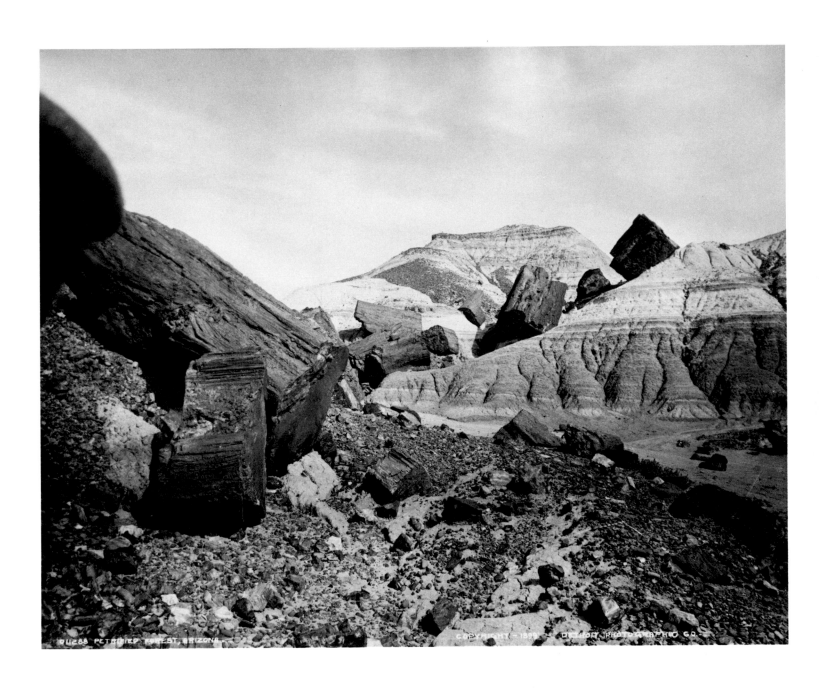

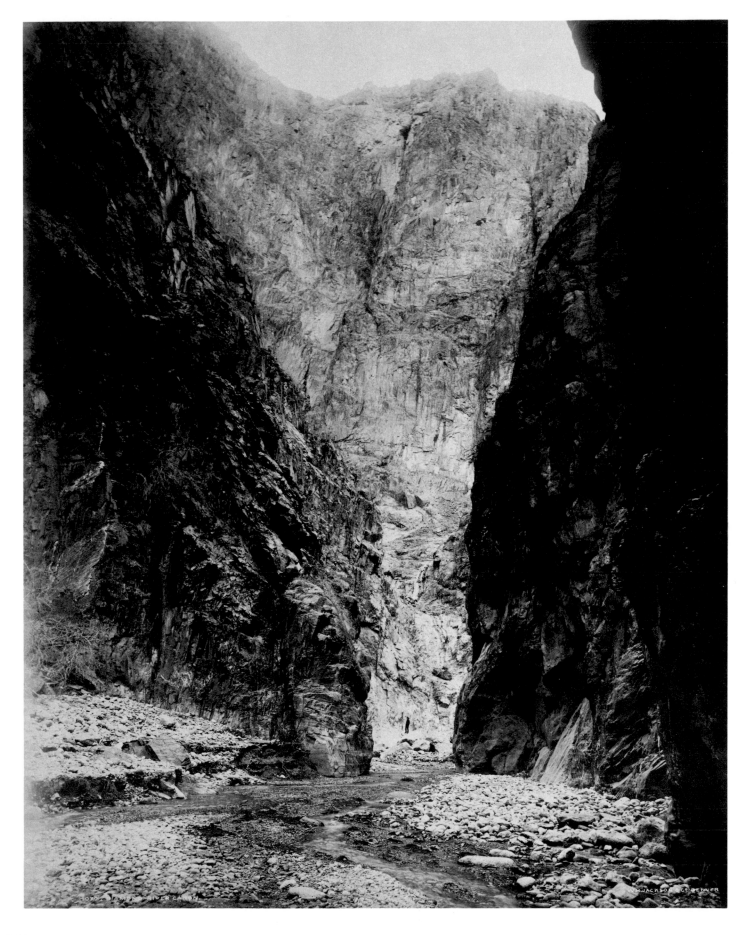

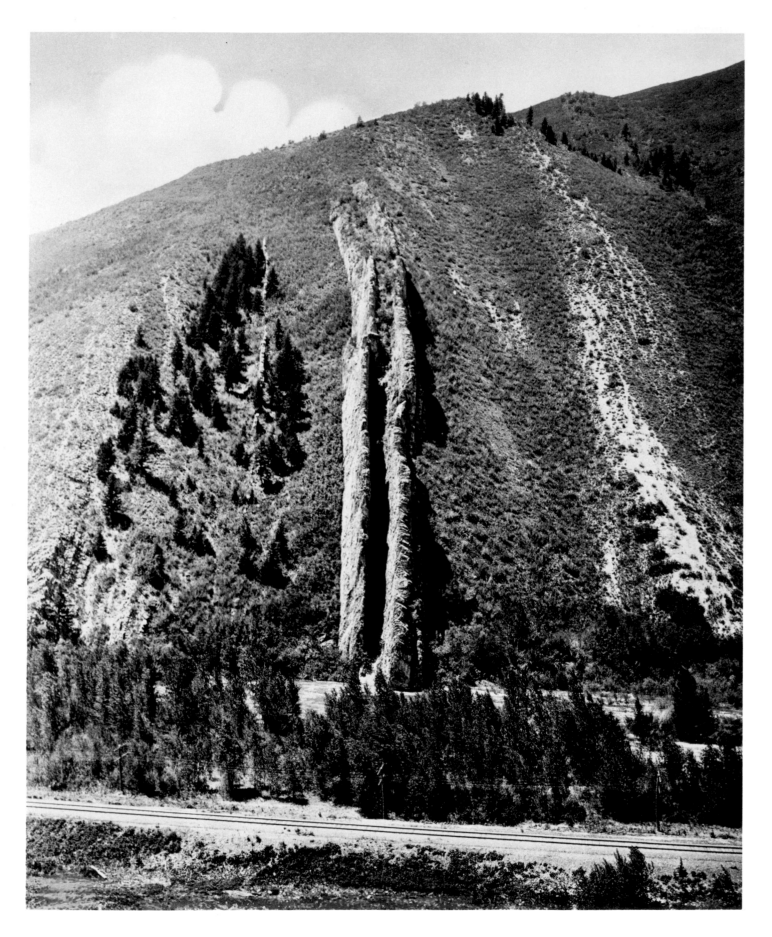

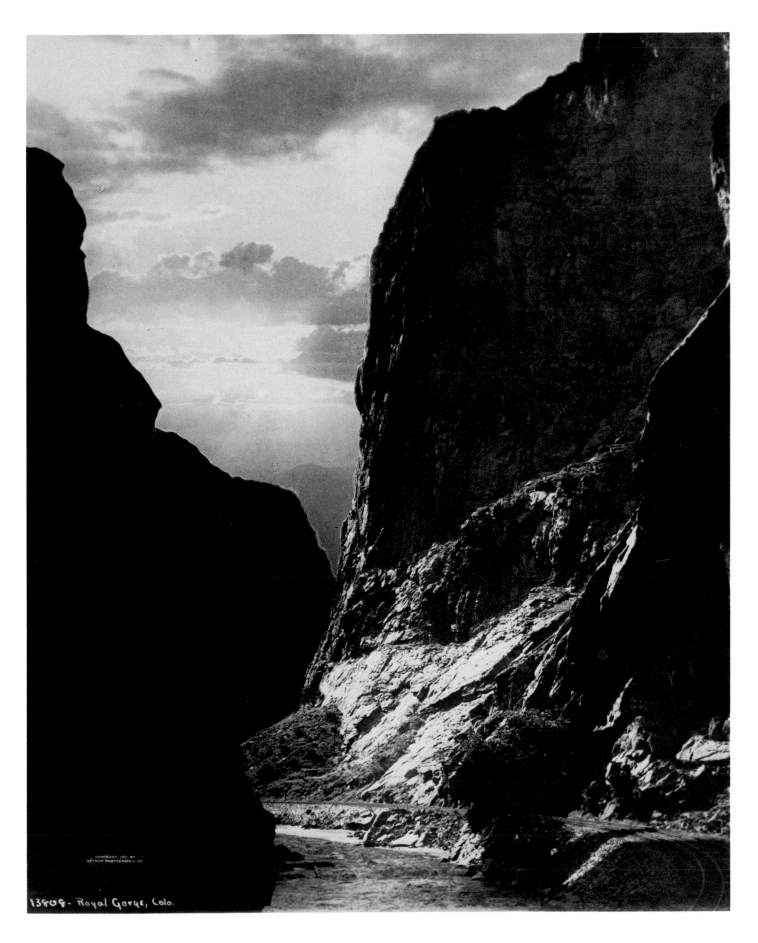

13808 - Royal Gorge, Colo.

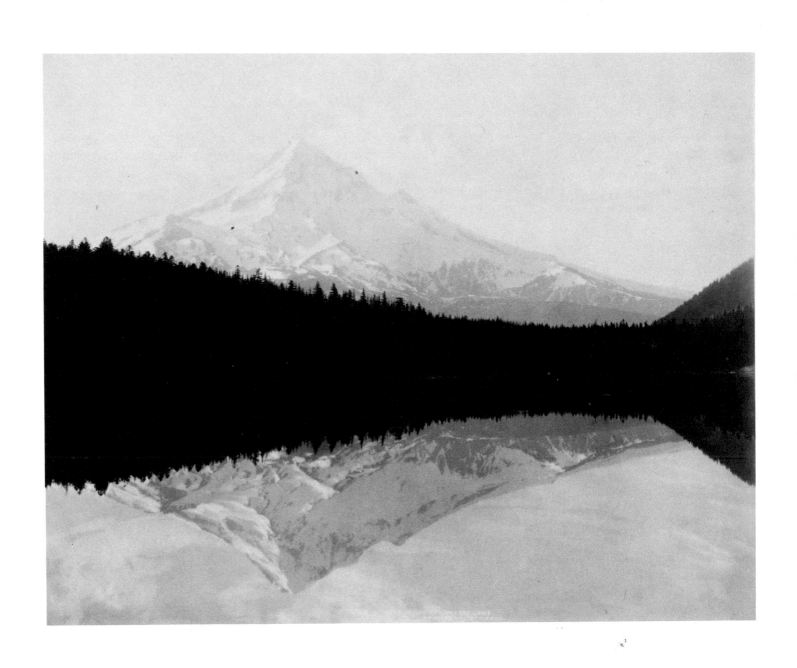

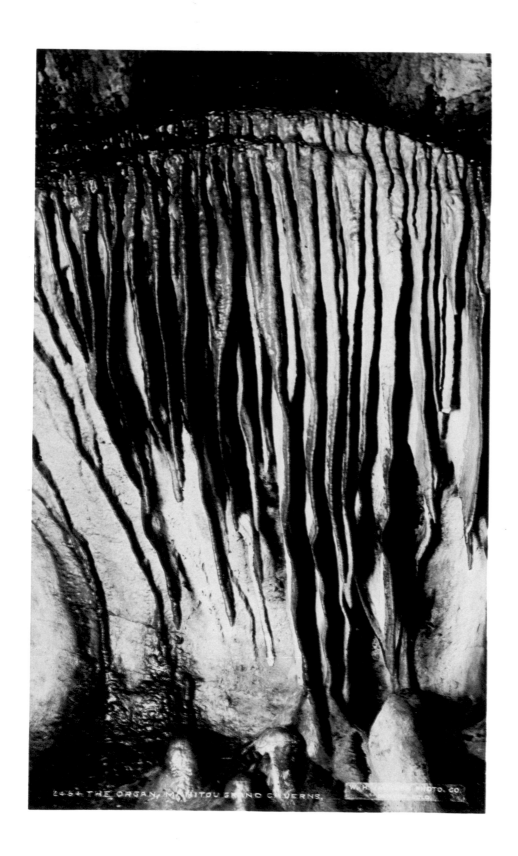

2464 THE ORGAN, MANITOU GRAND CAVERNS.

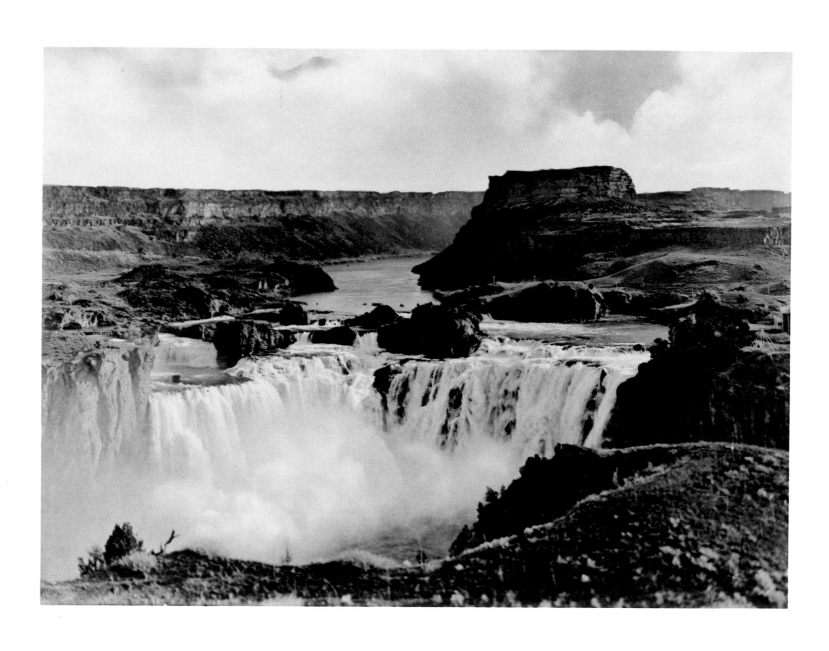

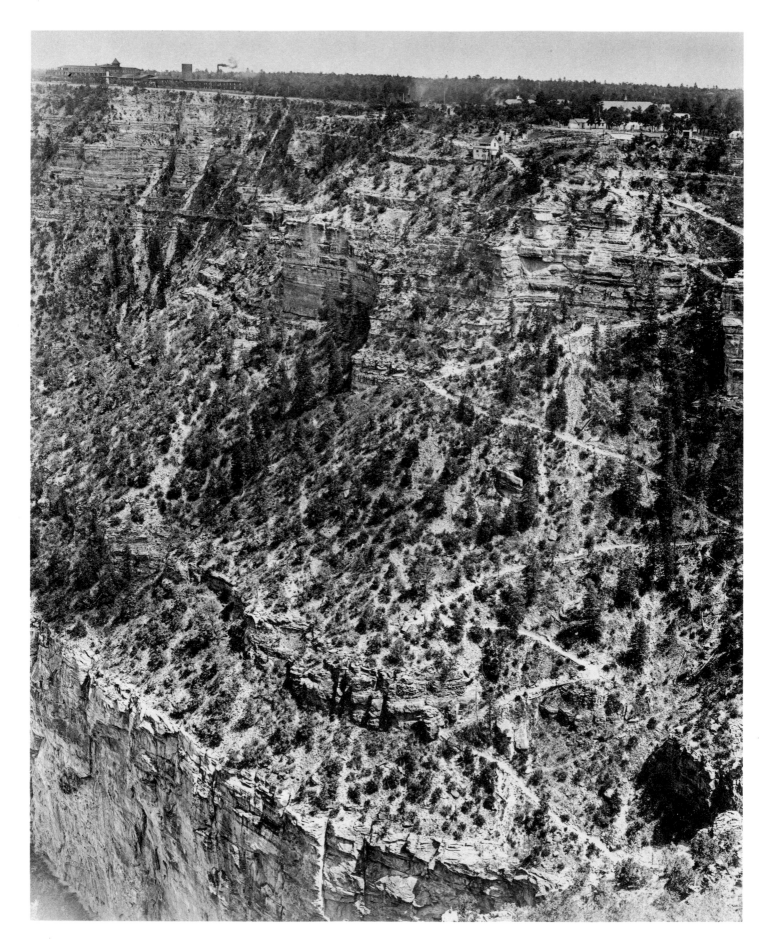

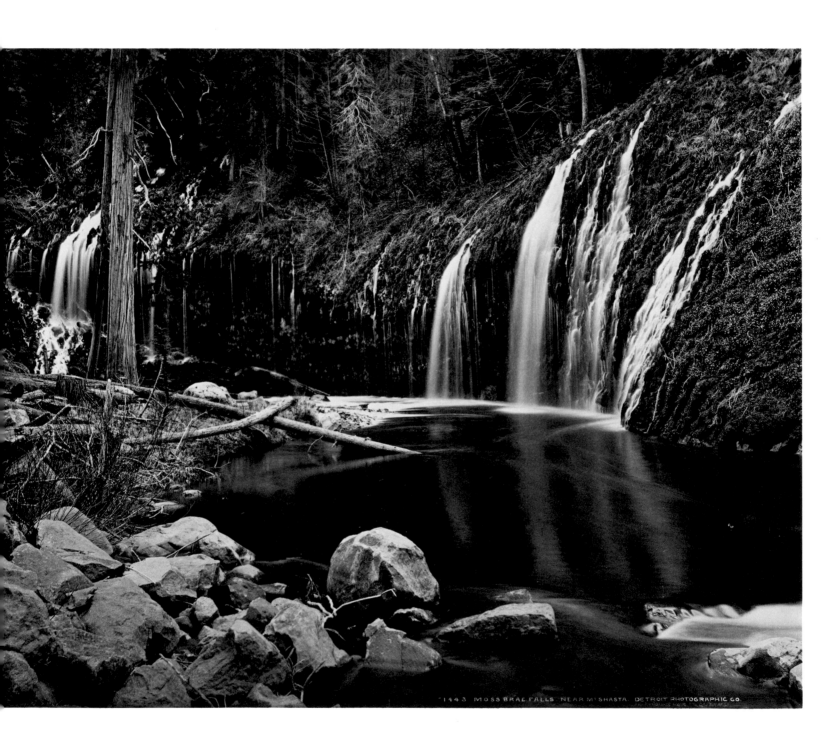

"1443 MOSS BRAE FALLS NEAR MT SHASTA. DETROIT PHOTOGRAPHIC CO.

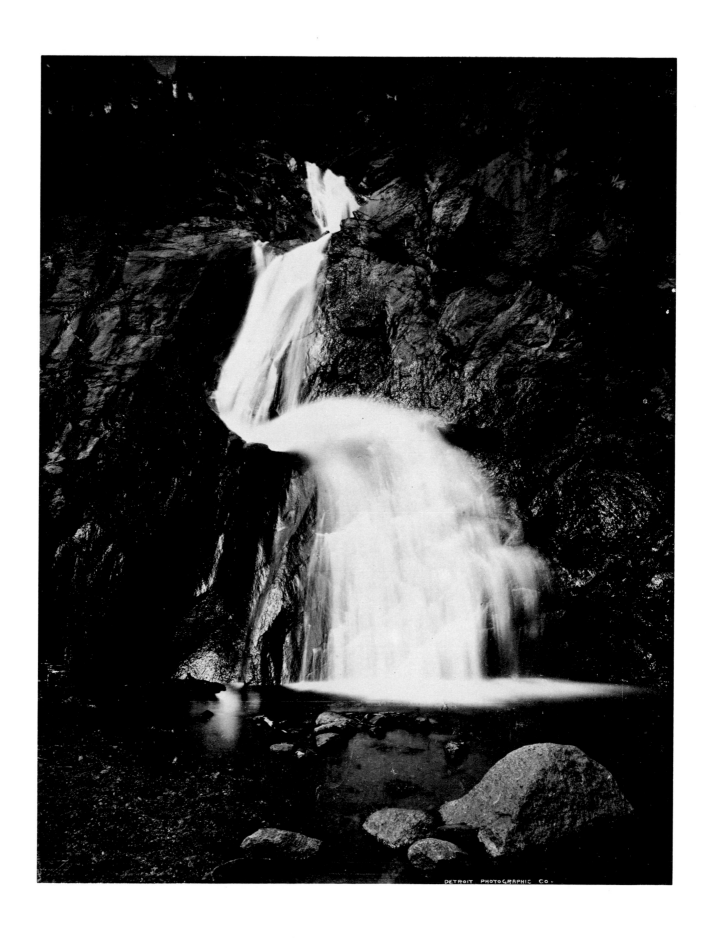

DETROIT PHOTOGRAPHIC CO.

117

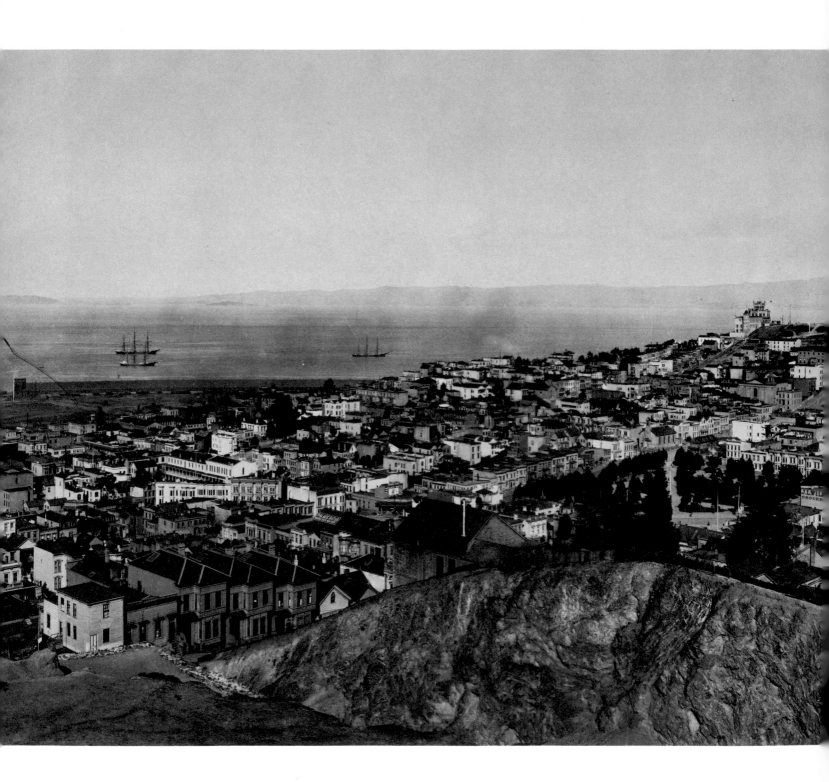

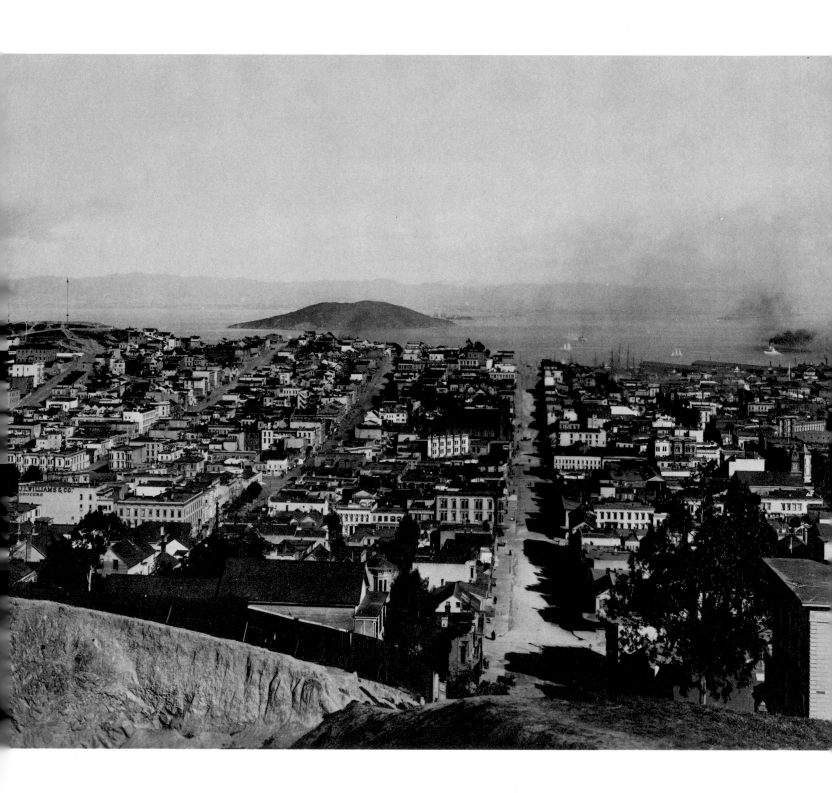

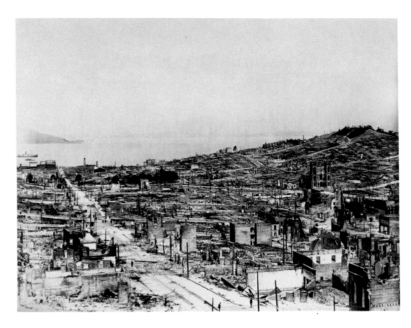

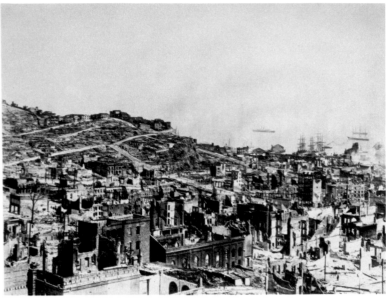

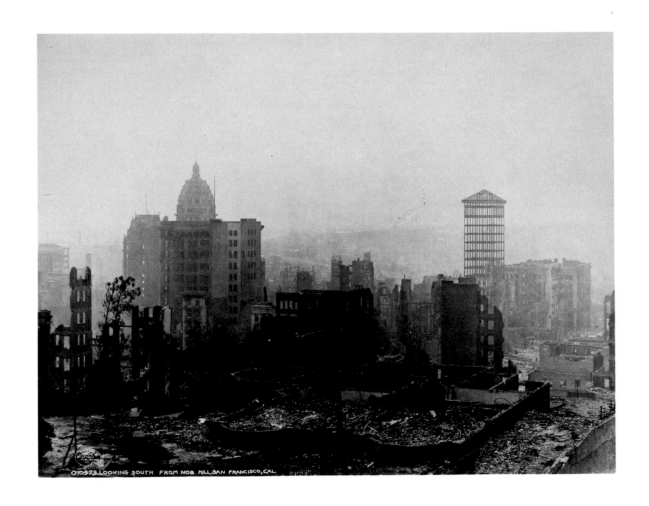

010979 LOOKING SOUTH FROM NOB HILL, SAN FRANCISCO, CAL.

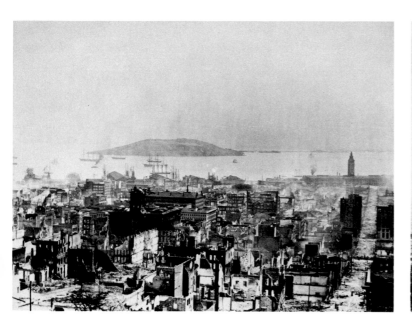

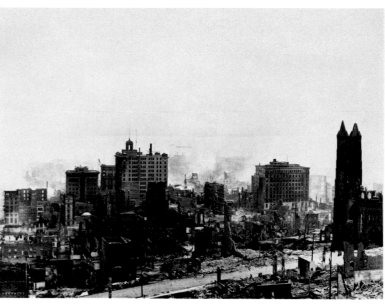

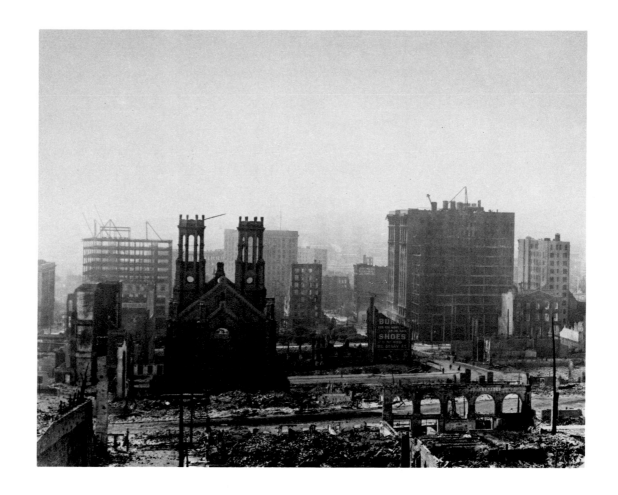

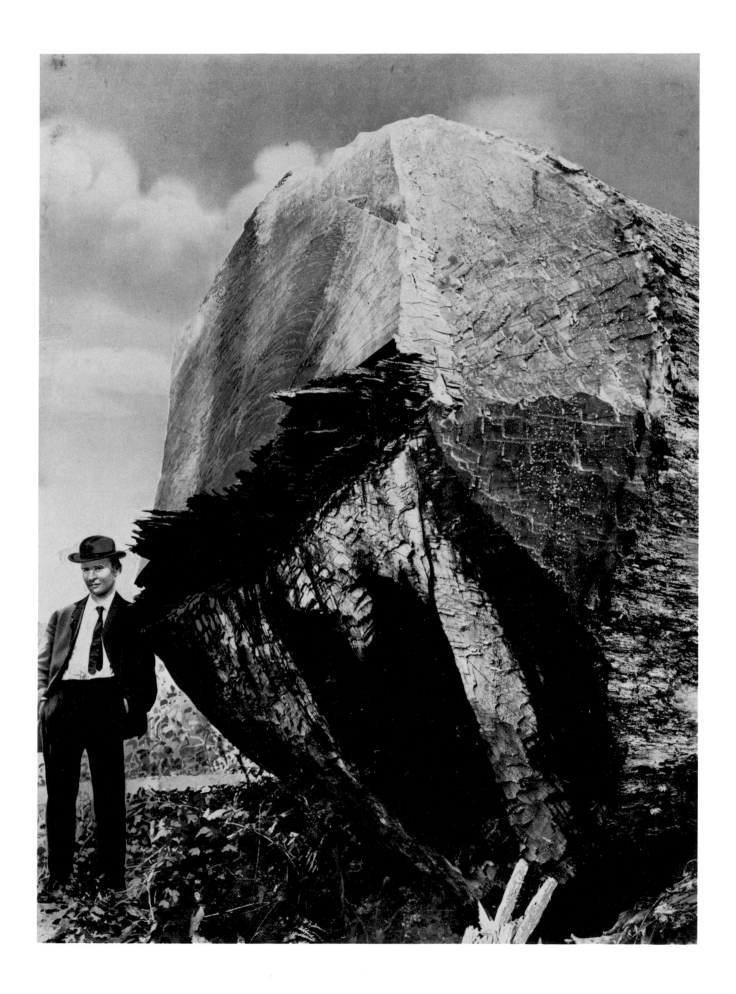

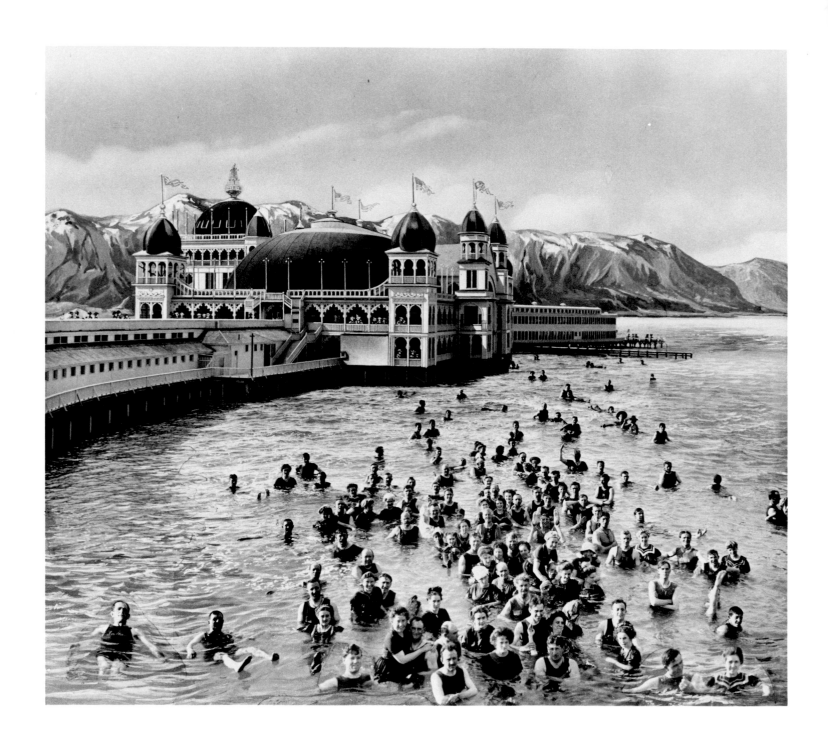

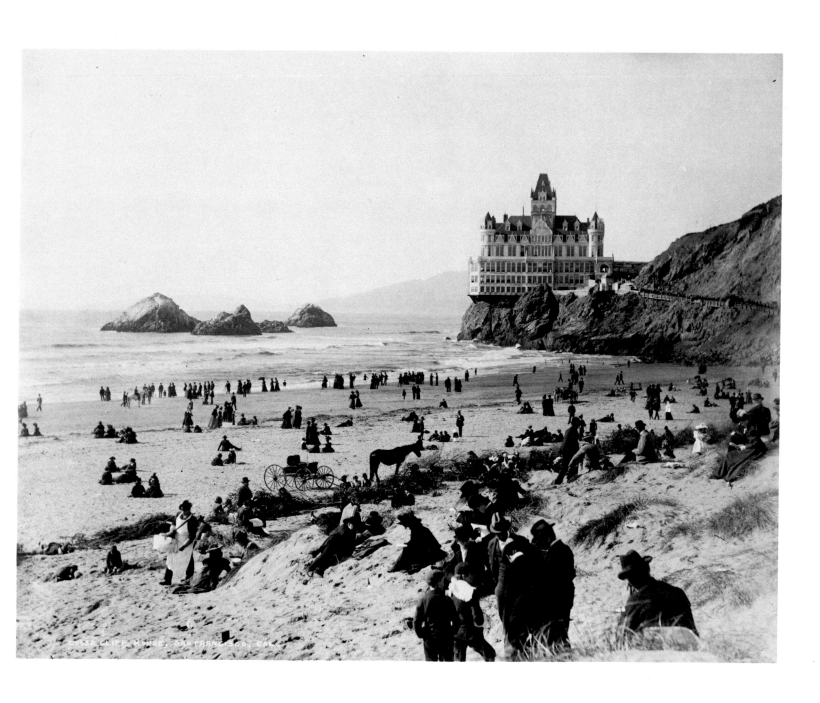

GREAT CLIFF HOUSE, SAN FRANCISCO, CAL.

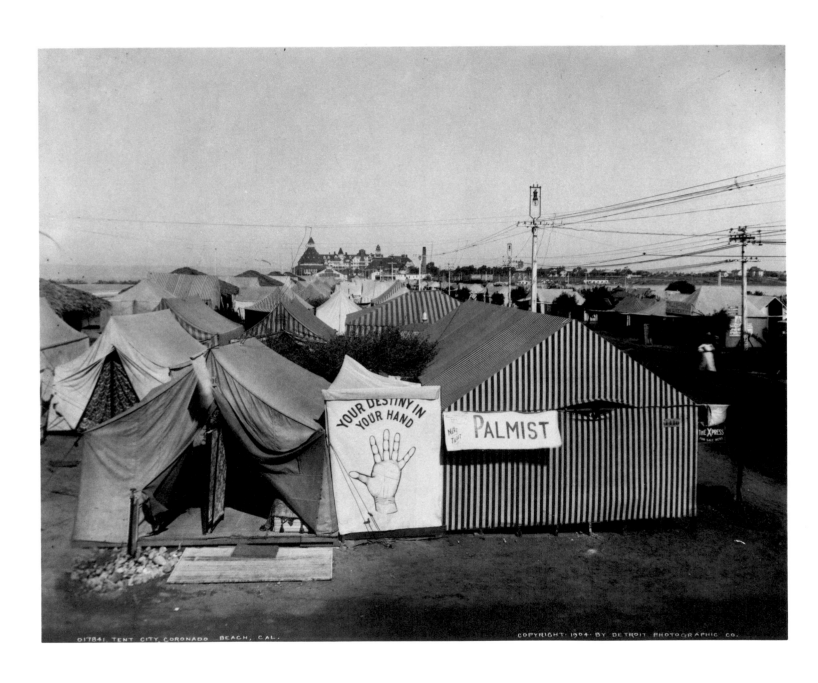

017841. TENT CITY, CORONADO BEACH, CAL.

COPYRIGHT 1904 BY DETROIT PHOTOGRAPHIC CO.

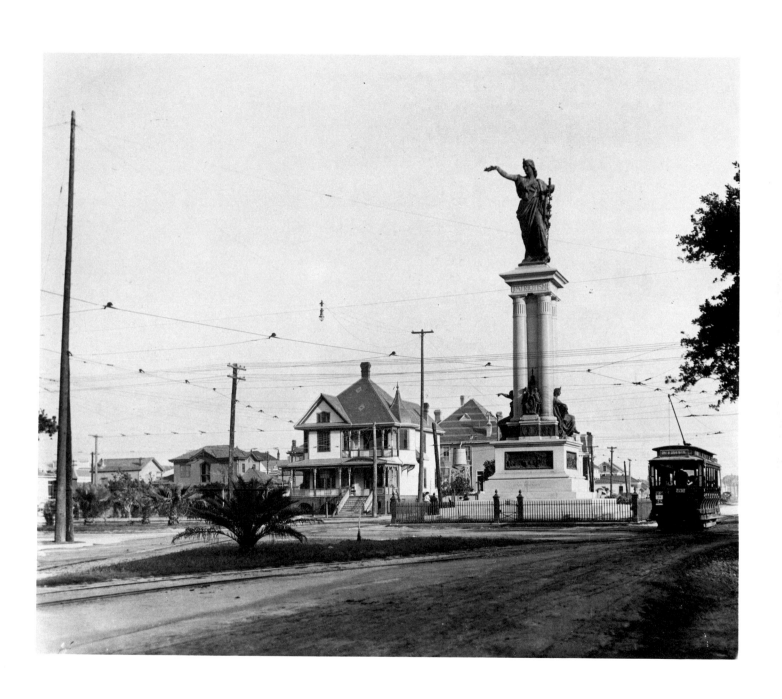

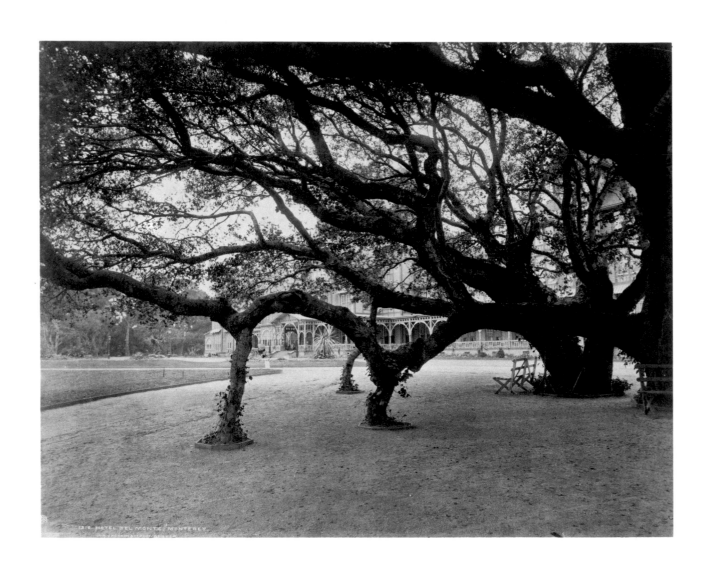

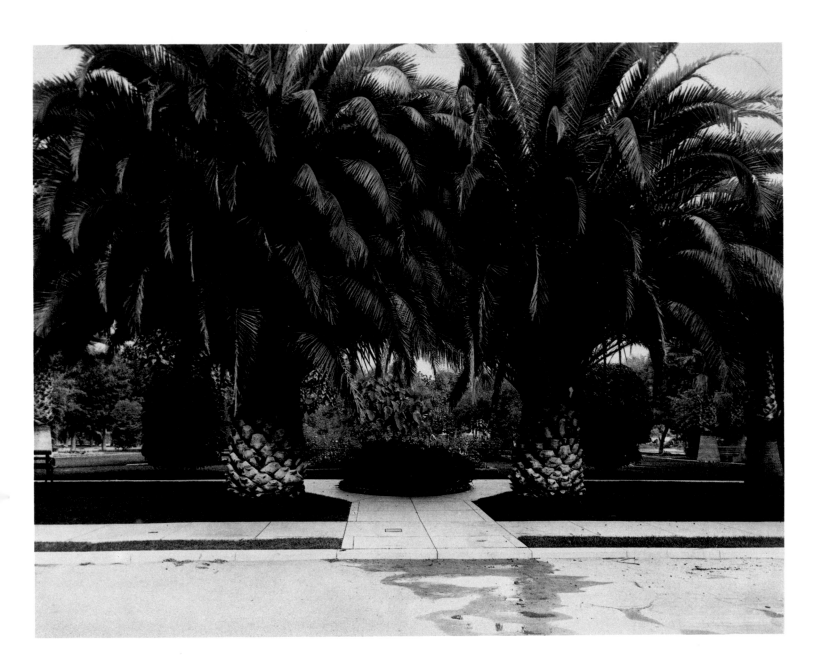

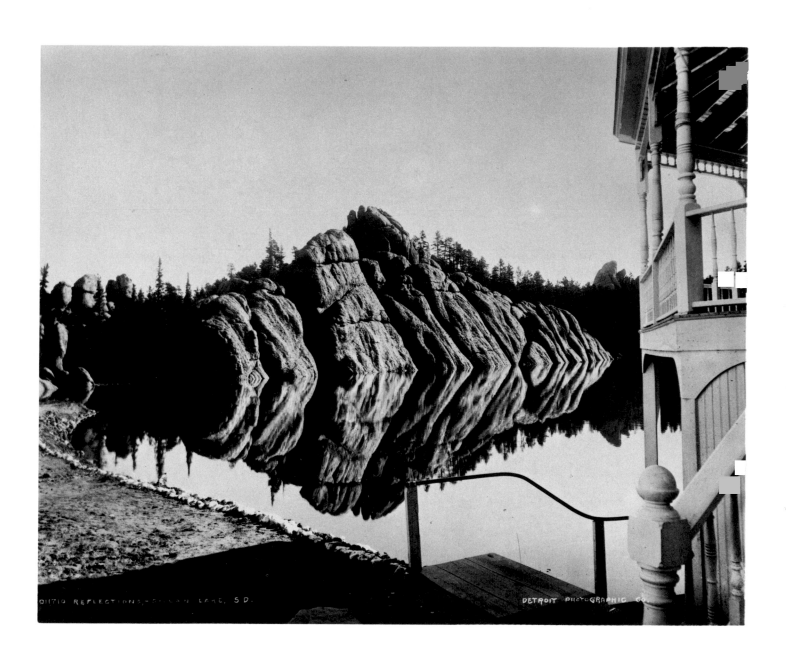

ONTARIO REFLECTIONS—SYLVAN LAKE, S.D. DETROIT PHOTOGRAPHIC CO.

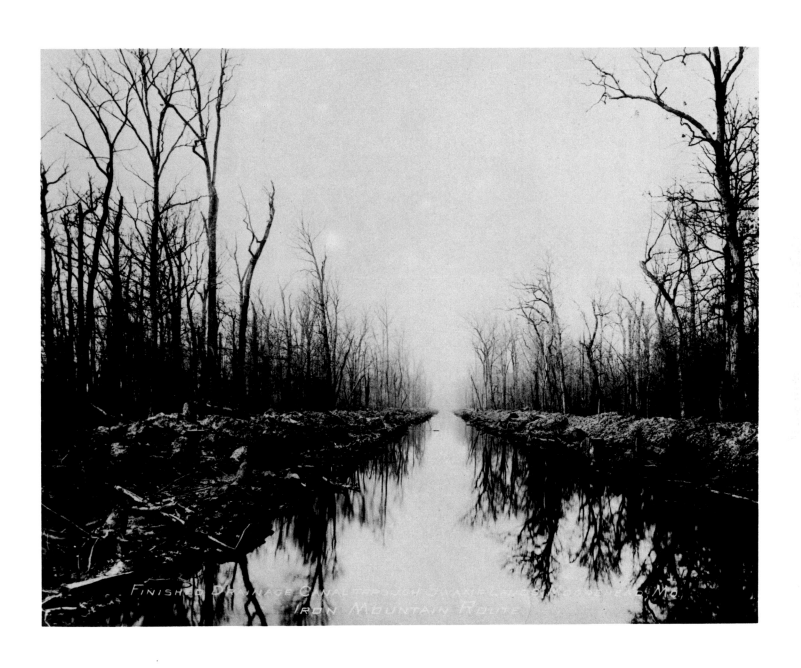

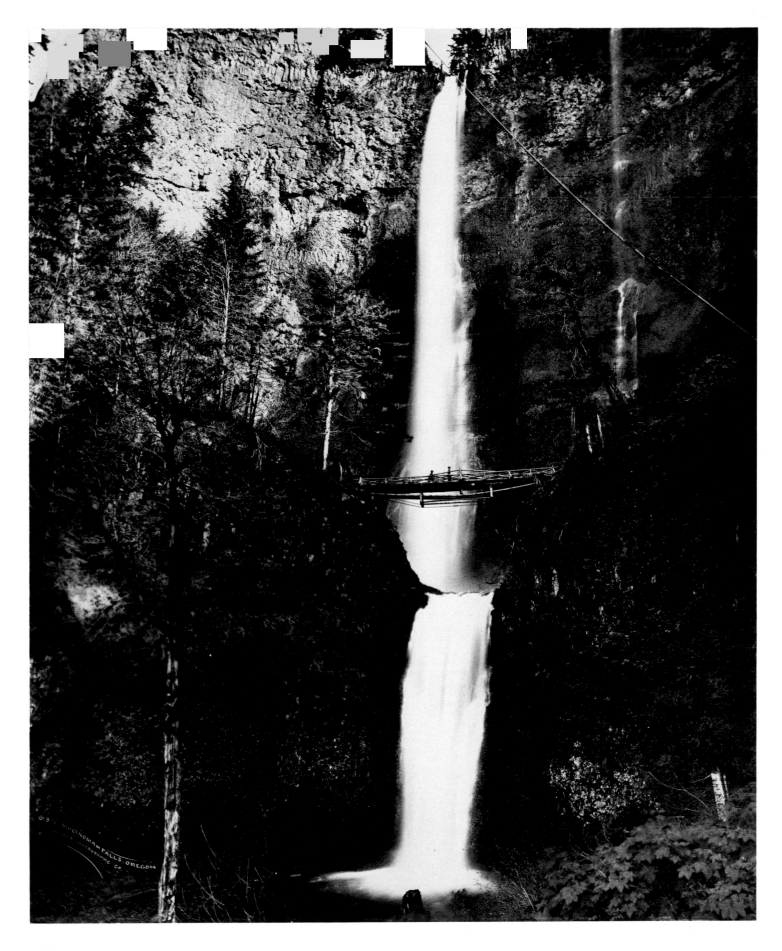

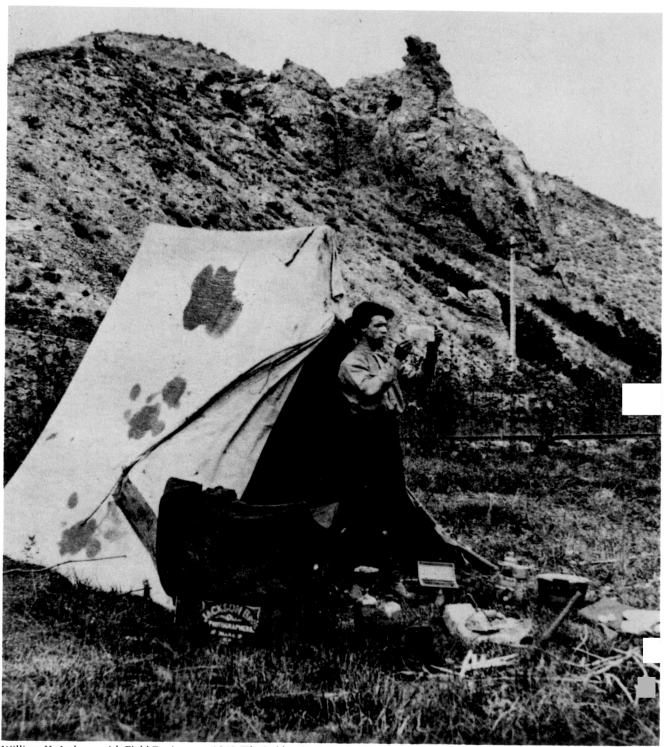

William H. Jackson with Field Equipment, 1869 *(The Smithsonian Institution)*

CHRONOLOGY *by Diana E. Edkins*

1843 April 4. Born in Keesville, New York. First of seven children.

1844 Family moved to Georgia.

1853 Family moved to Troy, New York. Received first schooling. Learned watercolor painting from his mother and Chapman's *American Drawing Book.* From his autobiography:

> *I can hardly remember the time when I didn't draw pictures. It was something without beginning . . . and is still without end.*
>
> *Time Exposure,* p, 6.

1855 Earned $2 a week painting window screens and political posters.

1856 First "big" ($10) commission: painting backdrops for local theatre.

1857 First employment in a photographic portrait studio.

1858 Graduated from Old Fourth Ward School, Troy, New York. Employed as retoucher and colorist by C.C. Schoonmaker, Troy's leading photographer.

> *I warmed up the prints with watercolor,*
>
> *New York Times Magazine,* April 17, 1940, p. 4.

1860 Employed by Frank Mowry, photographer, Rutland, Vermont.

1862 August 18. Enlisted in Twelfth Vermont Infantry, Company K. Military service uneventful. Appointed staff artist by commanding officer; sketched camp life and countryside.

1863 Mustered out of army before end of July. Returned to Rutland and job with Mowry.

1864 Artist in F. Styles' Gallery, Burlington, Vermont, at $25 per week. Joined literary society, enjoyed reading poetry, and learned to play the flute.

1866 Following a dispute with his fiancee, Caroline Eastman, broke their engagement and left for New York City.

 Met fellow veteran of the Civil War in New York. With him and a second companion, started West by railroad. Arrived St. Joseph, Missouri, the rail's end, with $22.75 to his name. Traveled by steamboat to Nebraska City, Nebraska. Signed up as bullwhacker on a wagon train bound from Nebraska City to Montana.

 Jackson's dream of silver mining soon vanished. He abandoned the Montana-bound wagon train and at South Pass, Wyoming, joined a Mormon train to Salt Lake City, some 150 miles distant.

 Remained in Salt Lake City several months, then moved on to Los Angeles.

1867 Failed to gain adequate employment in California. Signed up as a vaquero driving, with a party of nine, a string of two hundred wild horses to the railhead of Julesburg, Wyoming, for transportation in cattle cars to Omaha, Nebraska. Started East again; as payment received a suit of clothes, a shave and a haircut.

 Early August. Arrived in Omaha, Nebraska. Became a colorist for Hamilton. In early fall, Jackson bought Hamilton's Gallery with capital sent by his father. Later bought out another photographic gallery owned by Eaton.

> *Mon. 5th (August). Struck for a photograph room the first thing.*
>
> *Tues. 6th. Had a long talk with Hamilton (proprietor of one of the leading galleries). Wants to do one of two things, either to hire me by the week or to give me charge of a gallery of his just vacated & run it on shares, doing coloring at the same time.*
>
> *Wed. 7th. It's a marvel to me now that I am my own master once more how I could stand & endure what I have during the last three months. . . . Called on Hamilton & soon clinched a bargain with him. It was that I was to receive $15 for the 1st week, $18 for the 2nd, $20 for the 3rd & $25 for the 4th, & if all satisfactory the last figure to continue as regular salary. . . . I cannot begin to tell how good my new life begins to feel to me. I just laugh aloud to myself sometimes in pure enjoyment.*
>
> *Diaries of William Henry Jackson. . . . 1866-67, 1873, 1874.*

1868 His younger brother, Edward, came from Troy, New York to become William Henry's partner.
They consolidated the galleries and called themselves, "Jackson Brothers, Photographers." Became the
leading portrait gallery in town.

First field work with camera done along the Union Pacific Railroad. Jackson called it,
"Landscape photography or viewing."

*Portrait photography never had a chance for me, so I sought my subjects from the housetops,
and finally the hilltops and about the surrounding country. . . . The opening of the Pacific Railroad
in 1869 rendering easy access a region rich in scenic effects and interest, I determined to photograph it.*
The Philadelphia Photographer, Vol. 12, No. 135, p. 91.

Seldom moving more than half-a-mile a day, Jackson toured the countryside for three months
that summer with his "traveling wagon" which was outfitted with a single tank of water and a sink, and
storage for the chemicals. He covered a radius of 100 miles around Omaha, visiting and
photographing the Pawnee, Otoes, Omahas, Winnebagoes, Poncas, and Osages. Many of the photographs
were the first ever made of these Indian tribes. The negatives formed the foundation of a collection
of 3,000 Indian plates later given to the Bureau of American Ethnology at the Smithsonian Institution
in Washington, D.C.

Jackson's Field Box and Railroad
Trestle *(The Museum of Modern Art)*

1869 May 10. The day of the joining of the rails at Promontory Point, Utah, Jackson married Mollie Greer
in Omaha, Nebraska. Spent a six-day honeymoon on a steamboat going down the Missouri River to
St. Louis, where Mollie returned to Omaha.

May 16. Left St. Louis for Cheyenne, accompanied by Hull, his companion and assistant from
Omaha, on his "first photographic campaign." Carried two cameras: one for 8 by 10-inch negatives,
the other for the smaller stereoscopic pictures then so popular.

June 23. Arrived in Cheyenne, Wyoming and set up a business. Photographed street scenes
monuments and other points of interest to make as many negatives as possible that would be suitable for
publication and sale in Omaha. He said he was "in quest of the picturesque and marvelous." On
the way back home, visited Echo and Weber Canyons for the first time, and photographed Devil's Slide.
Jackson remarked:

*I was more than ever impressed by the scenic possibilities. The wonderful rock formations in
one and the rugged mountain features on the other, all presenting great opportunities for picture
taking. The scenery of Echo and Weber appeared magnificent and must keep one continually
perplexed when I come to views.*

*Returned to Omaha with just about the finest assortment of negatives that had yet come
out of the West.*
Diaries, No. 5, pp. 6, 22.

August. E. & H. T. Anthony & Co., who later published Jackson's series, "Rocky Mountain and Yellowstone Views," requested that Jackson furnish them with 10,000 stereo pictures on this area of the western American landscape.

Met A.J. Russell, the Union Pacific photographer, and made tentative plans to accompany him on a journey to the Uinta Mountains the following summer.

1870 July. Ferdinand Vandiveer Hayden, a surveyor and explorer, visited Jackson's studio to obtain photographs. He was especially interested in those showing the formations of the Green River, Wyoming. (He had also seen the Indian photographs and the ones made for the Union Pacific Railroad.) Hayden became enthusiastic about the scenic features of the region he was to cover during the summer's Survey and suggested Jackson join him as the official photographer. Hayden could not offer Jackson anything beyond keep during the trip, along with the right to whatever negatives he made. Jackson accepted and remained "Official Photographer" for the Hayden Survey for its duration, 1870-1878.

August 7. Broke camp. The Survey party was made up of twenty men: twelve in the party proper and eight teamsters. Among the major contributors were Dr. Ferdinand Vandiveer Hayden, the Chief; Stevenson, Hayden's assistant; R.S. Gifford, the New York landscape painter; John Beaman, the meteorologist; H.D. Schmidt, the naturalist; and W.H. Jackson. Each man was required to carry a Henry rifle and a Remington pistol.

The region surveyed was along the Old Oregon Trail across Wyoming via the North Platte through Devil's Gate, Great Gorge, Sweetwater Region, Split Rock and over the famous South Pass, Uinta Mountains, Henry's Fork, Green River Basin and Brown's Hole. The party returned via Green River by Bridge Pass to Cheyenne and disbanded in Fort Sanders. The very limited time given for preparation, the lateness of the season and the extent of territory to be covered rendered the work extremely arduous. Jackson said of the summer's work:

> Our object primarily was to gather such pictures as would reflect the notable features of the regions we were exploring and then on my own I desired to get rare stereo views and other views for the trade.

The Pioneer Photographer, p. 83.

He made about 371 negatives during that summer, sometimes as many as 17 negatives a day. This was a remarkable achievement for a wet-plate photographer, considering the slow speed of the plates, the uncertainties of the weather and the many changes of location that had to be made to obtain a variety of views. Nearly all the views were taken on side trips; a small detachment visited the "more interesting" portions of the mountains or canyons.

Later. In Washington, D.C., during the final conference that year of the Survey participants, Jackson was made the salaried, official Survey photographer. Made prints from that summer's negatives and prepared for next season's field work.

1871 The general plan for the expedition was to continue the work of 1870 into adjacent territory, especially the rediscovered wonders of Yellowstone. Although public attention had been drawn to the legendary Yellowstone through N.P. Langford's lectures in Washington and his articles in *Scribner's Monthly*, Yellowstone was still *terra incognita*.

June 10. The Survey party set out from Ogden, Utah. The whole expedition to Upper Yellowstone took 40 days and covered 500 miles. Botelers Ranch became the base for supply. It was the first time many of the marvels such as Mammoth Hot Springs, Baronett's Bridge, Tower Falls, Tower Creek, Mount Washburne, Teton Range, Fire-Hole Basin, Upper Geyser Basin, East Fork and Snake River Basins had been seen, described, analyzed and cataloged by scientists, an artist and a photographer. The Survey disbanded in Evanston, Illinois.

The size of the party increased to 35, of which 21 were horsemen. Some of the major contributors to this expedition were Dr. Hayden, again Chief; Stevenson, his assistant; Anton Schonborn, chief topographer; Lieutenant Doane, leader of Jackson's party; John Beaman, meteorologist; Thomas Moran, official artist of the Survey; J.T. Hine, photographer from Chicago (all of whose negatives were lost in the famous fire); J. Crissman, a local photographer who lost his camera over the edge of Yellowstone Canyon; and W.H. Jackson, official photographer.

An 8 x 10 camera outfit was added to his standard equipment of a 6 x 8 and a stereographic camera and the necessary supplies for making prints in the field. Made 15 to 20 negatives a day. Jackson said of the expedition:

> . . . it (Yellowstone) was regarded as a wonderland, of which a small portion only had been explored and everyone was sure that still more marvelous things were yet to be found. It was this expectation that gave the keenest zest to each day's journey. . . . Here was the first really important work for both scientist and picture men. . . a subject never before described or photographed. . . .

Of the way he worked, he said:

> My photographic work naturally kept me separated from the main outfit most of the time during the day. With a pack mule carrying the apparatus and accompanied by two or three companions (Moran was always along) we made many disgressions in search of picture material. . . .

Jackson acknowledged Moran's help, saying:

> He (Moran) was interested in photography and gave unstintingly of his artistic knowledge especially with regard to the problems of composition. He entered in the spirit of the work most heartily dividing his time impartially between his own sketching and assisting in the selection of camera subjects.

Diaries, No. 5, pp. 9-10.

Of particular interest is his description of Mammoth Hot Springs:

> Foot of Mammoth Hot Springs was the really first important work for both scientists and picture men. . . . In this instance, there was such an infinite variety of detail, that one exposure after another could be made with but little variation in the view, requiring but one round trip between the dark box and the camera for each negative made.

Diaries, No. 5, p. 7.

On the way home, Hayden urged him to take a special photographic trip to the Pawnee and Omaha villages in Nebraska. Four hundred negatives resulted from this expedition, ranging from scenic routes, falls, canyons and rock formations, to Indians.

Issued a set of stereographic views, "Yellowstone National Park, Wyoming," His best work called *Yellowstone's Scenic Wonders*, bound in album form and filled with original prints, was distributed to members of the House and Senate. These photographs were instrumental in making Yellowstone the first National Park, through a bill signed by President Grant in March of 1872.

> Within the next few months I was to begin to taste that little fame which comes to every man who succeeds in doing a thing before someone else.

Time Exposure, p. 203.

The importance of Jackson's work to the Survey was stressed by Hayden in each of his annual reports to the Secretary of the Interior. In the report for 1875, he gave a succinct and general history of this accomplishment:

> Photography was first used to any extent by the Government during the war. . . . After the close of the war, the previous good services of photography in the field recommended it to the exploring and surveying expeditions, and it was extensively employed by them. A photographic corps was attached to the Survey in 1870 and it has continued its use ever since. . . .

> The photographic work has been under the direction of Mr. W.H. Jackson, an experienced landscape photographer, who has made an average of 400 negatives each year, ranging in size from the stereoscopic up to plates 20 by 24 inches square. . . .

> From the two thousand or more negatives made during these preceding six years, we must ascertain what return they have made for the time and money expended upon their production, and entirely aside, too, from their aesthetic qualities and the pleasure which lovers of the beautiful and picturesque may derive from them. They have done very much, in the first place, to secure truthfulness in the representation of mountain and other scenery. Twenty years ago, hardly more than caricatures existed, as a general rule, of the leading features of overland exploration. Mountains were represented with angles of sixty degrees inclination, covered with great glaciers, and modeled upon the type of any other than the Rocky Mountains, the angular lines of a sandstone mesa, represented with all the peculiarities of volcanic upheaval, or of massive granite, or an ancient ruin with clean-cut, perfectly squared and jointed masonry, that would be creditable

to modern times. The truthful representations of photography render such careless work so apparent that it would not be tolerated at the present day. . . .

In ethnography, it gives us faithful portraits of the varied families of our great Indian population, representing with unquestioned accuracy the peculiar types of each; their manners of living, dressing, occupations, and mythical inscriptions. In archaeology, how important it is that the uncompromising lens portrays the at present almost inaccessible ancient ruins of the Southwestern Territories! These photographs can be sent all over the world and practically answer the purpose of a personal inspection. . . .

Ninth Annual Report of the United States Geological and Geographical Survey of the Territories . . . for the Year 1875, 1877, pp. **21-23.**

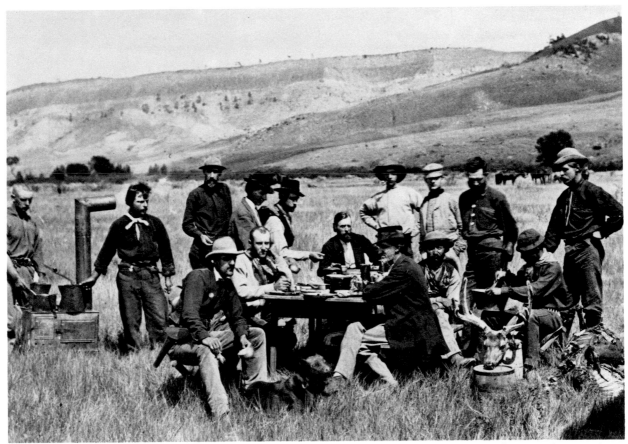

U.S.G.S. Survey Team, 1870. Camp at Red Buttes, Wyoming. F. V. Hayden seated in center; W. H. Jackson standing at right *(National Archives)*

1872 July 20. Set out from Ogden. Again the Survey was to explore virgin territory, this time the Tetons from the west. The expedition divided into two parties, 30 men in each party, and covered the areas of Henry's Fork, the Teton Basin, and Fire-Hole Geyser Basin. Hayden's party retraced the 1871 route. Jackson joined Stevenson's command, which covered the park from the southwest. Moran was again a member of the expedition.

Added an 11 x 14 camera to standard equipment. Worked with Moran. Again, Tower Creek was a high point of the expedition; Jackson worked there for two days attempting to capture a view of the stream plunging into a gorge 130 feet below.

October 8. Sold Omaha studio and moved to Washington, D.C. with Mollie. Rented some rooms near the Survey headquarters. Spent winter cataloging and printing negatives made the previous summer.

Mollie and infant died during childbirth.

1873 Stereo views of Yellowstone published by E. & H.T. Anthony & Co.

March. Made a life member of the National Photographic Association. Hayden's activities shifted to the Colorado Rockies, partly because of Indian troubles to the north. Surveyed the Rockies along Estes Park, Gray's and Tory's Peaks, Pike's Peak, the Arkansas River and finished at the Mount of the Holy Cross. Highlights of the exhibition were Long's Peak, Castle Rock, Garden of the Gods (made eight negatives in one morning), Ute Falls, Hoosier Pass, Twin Lakes, Sawatch Range and La Plata Peaks. Their major goal was to locate and photograph for the first time the fabled Mount of the Holy Cross. (This 14,000-foot peak facing the rising sun had become legendary because, under certain weather conditions, snow filled the fissures at it's summit to outline a perfect cross.)

May 29. Set out from Long's Peak. The photographic division was outfitted as a separate unit. Took along 400 glass plates for 9 x 14, 4 x 7, and stereoscopic cameras. Introduced the use of panoramic views:

Panoramas are to be judged by their intent to display structure of regions which few have visited. There is plenty of sublimity in scenes, vast amphitheaters and deep gorges; yet are not precisely picturesque in the proper sense.

Descriptive Catalogue, 1875, p. 4 ph.

One panoramic view included the entire Colorado range from Long's Peak to Pike's Peak, a distance of over 100 miles. His views from Mount Lincoln in the South Park extend over a radius of 50 miles, sweeping within the circle a great number of peaks.

Spent most of the summer plagued with mechanical problems. Often a laborious ascent of thousands of feet with the entire pack outfit had to be repeated two or even three days in succession, because of broken plates, bad exposures and storms. Did, however, obtain great panoramas of the most notable summits, e.g., Mount Lincoln, La Plata, and Mount Elbert.

August 18. Photographic division joined rest of the party, including Hayden and Holmes, to seek the Mount of the Holy Cross.

There had been so much controversy about this reputed cross that the survey considered it quite as essential to show the actual presence by photography, as it was to locate it topographically.

"How the Mountain of the Holy Cross was Photographed for the First Time." Lecture at Red Cliff, Colorado, March 17, 1923.

The ruggedness of the territory was generally known, although not yet delineated statistically. The Survey was guided by the somewhat vague advice of mountain men that the best vantage point for sighting the Mount would be the summit of Notch Mountain, northeast of the Mount of the Holy Cross and at approximately the same elevation. The party found the going difficult for the trail was steep and overgrown with thick brush. Pack animals could not be used for the last 1,500 feet of the climb. The next morning, they broke into two groups: Gardner, Hayden, Whitney and Holmes intending to climb the Mount of the Holy Cross, while Jackson's party, still carrying over 100 pounds of equipment, hacked its way up the other side of the canyon to the top of Notch Mountain. Tom Cooper carried the camera, Coulter, another packer, the plate boxes, and Jackson, the chemicals.

On this day, as usual, I pushed ahead, and thus it was that I became the first member of the Survey to sight the cross. Near the top of the ridge I emerged above the timberline and the clouds, and suddenly, as I clambered over a vast mass of jagged rocks, I discovered the great shining cross before me, tilted against the mountainside.

Time Exposure, p. 217.

The weather closed in before pictures could be taken, so Jackson and his aides retreated to the timber, shivered throughout the night and climbed the mountain again at the crack of dawn.

August 24. The next morning, Jackson photographed the Mount of the Holy Cross for the first time. He later said of this experience:

I have exposed and developed eight plates ranging from stereos to 11 x 14. The morning was perfect for photography and as I had only one standpoint, was all through before noon. I photographed it again in 1880 and 1891 after I had gone into business for myself in Denver. All were never as good as the first one I had taken in 1873.

Jackson's letter to Mr. Dawson, January 30, 1922,
Colorado Public Library, Western History Division.

He processed the negatives on the spot; for wash water, he melted snow. Jackson related that two 11 x 14 and four 5 x 8 and stereoscopic negatives were made. After photographing the Mount of the Holy Cross, Jackson's work ended for the season.

September 5. Returned to Denver. During this Survey, Jackson had secured 300 negatives of scenery, 100 of them being various panoramic views with from four to six plates used for each panorama. Many Rocky Mountain views were sold to magazines, building his professional reputation. The American people were thrilled at the news of the "discovery" of the Holy Cross. Jackson's photographs of this "Mount" became as legendary as the mountain itself. They were in the greatest demand. Jackson won seven medals for the photographs he exhibited at the Philadelphia Centennial Exposition in 1876.

Jackson considered reopening his studio, but Hayden persuaded him to wait.

Photographs of the Yellowstone National Park and Views in Montana and Wyoming Territories published by the U.S. Government with a selection of 37 of the most representative photographs of the years' work.

October 8. Jackson married Emilie Painter. After a honeymoon in New York City, they rented rooms in Washington, D.C., at a comfortable boardinghouse close to the Survey headquarters.

1874 January 24. A popular periodical of the day remarked:

> *The expeditions of Professor Hayden and the current literature have made the Yellowstone*
> *region as famous as the land of the Arabian Nights.*
>
> *Frank Leslie's Illustrated Newspaper,* Vol. 37, No. 956, January 24, 1875, p. 325.

July 21. Appropriations of funds for Survey delayed. Set out from Denver to photograph Los Piños Ute Indian reservation in southwest Colorado. The photographic division again outfitted as a separate unit. Took only a compact 5 x 8 camera serviceable for both single and stereoscopic pictures.

August 18-23. Arrived at Los Piños Creek, an encampment of 70 tepees of the Ute Indians. Met Chief Ouray. He and his family were to sit for Jackson. Medicine man declared the "box" was bad medicine. Peah, a young chief, and Ouray both sat for Jackson. They were the only ones.

August 24. Left Los Piños for Rio Grande, passing Cunningham Pass.

August 27, Arrived at Chemise ranch. Met Tom Cooper, a miner and old acquaintance from Omaha. Cooper told him about the ruins of the cities of Animas of the Mancos. "The information had been vague and indefinite."

September 7. With Cooper and another miner, John Moss, prepared for a side trip of six days to investigate the cliff ruins of the Mesa Verde, McElmo Canyon and Hovenweep. Pictures of the "Lost Cities" were published sometime later, as an album of 56 photographs called the *U.S.G.S. Rocky Mountains, Natural Surroundings: 1870-74.*

> *The discovery of the first cliff dwelling that came anywhere near our expectations was*
> *made unexpectedly, just enough to sustain interest in making further discoveries. . . . The most*
> *outstanding feature for the world was that these cities had died.*
>
> *The Pioneer Photographer,* p. 232.

1875 June 6. Set out for Mesa Verde a second time with E. A. Barker, a naturalist, Harry Lee, a guide, and Henry Holmes. Took a two-week side trip to Uncompahgre Peak area and Lake City.

Late July. Journeyed westward to Hovenweep, McElmo, and Laguna Pueblo. Found ruins along the Rio San Juan, at Canyon de Chelly, Sierra Abajo and Sierra La Sal.

> *Would examine the surface of the monumental rocks and ridges. Would then go out with*
> *the small camera first, then the large one.*
>
> Jackson, "A Notice of the Ancient Ruins in Arizona and
> Utah Lying About the Rio San Juan," U.S.G.S. *Bulletin,*
> p. 25.

Added Anthony's Novel Camera, which used 20 x 24-inch plates, to his equipment. Used this mammoth camera in a series of photographs to illustrate prominent points around the Rocky Mountains.

> *They are the largest plates ever used in field photography in this country. They convey an*
> *impression of the real grandeur and the magnitude of mountain scenery that the smaller views*
> *cannot possibly impart.*
>
> *U.S.G.S. Catalogue, 1869-1875,* Miscellaneous Publications, No. 5, Preface.

These views excited the photographic world.

An examination of these pictures fills us with admiration for this magnificent scenery of our own country, which is scarcely excelled by that of any other, and for the wonderfully successful work of this mammoth size, each picture of which is a study in its composition, its lighting, and general grandeur of effect produced by its breadth and perspective. Amazement that such work could be executed in the wild regions of the Rocky Mountains, from almost inaccessible positions, whence everything had to be carried on pack-mules, and much of the work done under circumstances of the greatest disadvantage. Most photographers consider the manipulation of 20 x 24 plates formidable enough under the most favorable conditions, as the chances of failure and all the difficulties attendant upon the negative process are greatly increased, when the plates used can be measured by feet instead of inches; but Mr. Jackson has proved himself a master, not only of the principles of art which govern such work, but of every circumstance or condition which may in any way affect his success in producing the grandest results photography is capable of.

The Philadelphia Photographer, April, 1876.

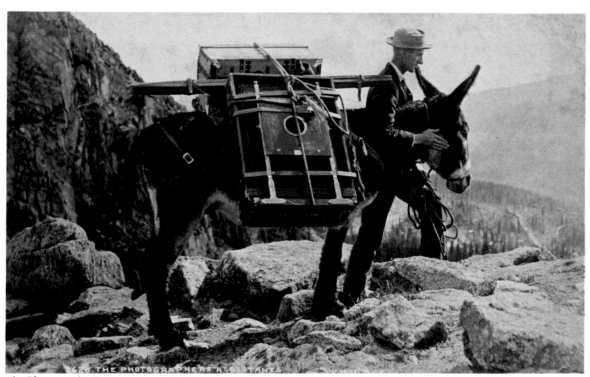

The Photographer's Assistants, 1873 *(Newhall Collection)*

August 3. Holmes and Jackson in San Miguel country. Saw no ruins of interest until Montezuma, where they sketched and photographed. First time that Jackson ever expressed a wish for photography to capture the colors of the natural foliage. Jackson also discovered, photographed and sketched ancient Indian cliff dwellings in the Southwest. He was becoming something of an archaeologist. For the *Bulletin* of the U.S. Geological Survey, he wrote a scholarly "Notice of the Ancient Ruins in Arizona and Utah Lying About the Rio San Juan."

August 21. Started due north up Epsom Creek; found numerous ruins.

September 3. Low provisions caused an early return.

Fall. Spent most of this time making clay models for a three-dimensional panorama of cliff dwellings for the 1876 Centennial Exposition in Philadelphia.

1876　February 2. Son, Clarence Seymour, born.

Descriptive Catalogue of Photographs of North American Indians of Over 1,000 Negatives Made During a Period of Twenty-Five Years, published in Washington by the Department of the Interior. Over

seventy tribes depicted; primarily comprised of Jackson's photographs but also included the work of Shindler, Hiller and others.

Assigned to organize the Survey's elaborate exhibit at the Centennial Exposition in Philadelphia. Displayed his three-dimensional scale model made the previous fall of the Mesa Verde ruins. Also included were large window transparencies, painted in color, of both scenic and geological interest. Another section was devoted to an exhibition of Indian portraits and artifacts, photographs of Yellowstone and stereoscopic views of Yosemite. Hayden felt that the exhibit was of such importance that Jackson should be in daily attendance to explain the displays and answer visitors' questions. Remained at the Exposition until its close in the fall. Thus no field work was done that year.

With the preparation and installation of the Centennial exhibit completed, I spent hours studying other photographic exhibits. I put most of my time in some experimental work in photography. One of my undertakings was the construction of a rotating panoramic camera. I wished for an instrument that would take in the entire horizon with one continuous sweep instead of making separate plates and then joining them together. I used coated paper with a substratum of rubber on collodion emulsion. Made a circular base corresponding to a piece of a tripod.

Quoted on the same pages is a description of Jackson's own work in the exhibition:

. . . The grandest examples of government photography are on the north side of the building, and consist of a large number of transparencies by William Henry Jackson, of Washington. . . . Some of these plates are at least 28 x 36 inches, and yet as perfect in every detail as one of stereo size. An examination of these pictures will convey an idea of the magnificent scenery there is in our own country.

Diary, 1876, pp. 3-4, New York Public Library Manuscripts Division.

1877 Survey was to be a continuation of work done in the '74-'75 season in the old ruins in the San Juan Basin and into regions farther south. Arranged an expedition to a section of the country entirely outside the regular Survey work. Accompanied by Reverend Sheldon Jackson, a missionary, toured the Presbyterian missions established in various pueblos between Santa Fe and the Moqui (Hopi) villages west of the Rio Grande.

Wet-plate material became impractical because of weight, bulk and slow speed. The trip gave Jackson an opportunity to test the new dry films. From England, Jackson imported a supply of 400, 8 x 10 exposures of L. Warnerke's "sensitive negative tissue" supplied in bands and a special "roll holder," which made up the equipment for this Survey.

Started out from Santa Fe and went on to Laguna, Pueblo of Acoma, the Zuni region and Fort Defiance ("there was to be a great assemblage of Navajos and Moqui Indian agencies for annuity distributions, ten thousand Indians"). Two-day trip to Canyon de Chelly, the Hopi villages, "The Seven Cities of Tusayan," and the Chaco Canyon Ruins. At the end of the season, found that deferred development had ruined the films.

Pictureless, yet success from the point of view of an archaeologist.

Diaries, 1876-1878, pp. 20-21.

The Survey was a success for important discoveries were made at Pueblo Alta, one of the principal ruins of Chaco Canyon.

Two publications were completed: *Report on the Ancient Ruins Examined in 1874-1875 and 1877;* and *United States Geological Survey: Report of the Territory of Wyoming and Idaho, Part I and II.*

Prior to 1878.

An attempt was made by me to publish a volume of reproductions of my survey photographs by the collotype process by E. Bierstadt. A fire destroyed many of the negatives and plates before the work was completed.

Letter from Jackson to Mr. Ellison, June 20, 1924,
Denver Public Library, Western History Division.

1878 Appropriations for the Surveys became increasingly difficult to obtain each succeeding year. This, the last expedition of the Hayden Survey, was an exploration of the Wind River Mountains, the Tetons and Yellowstone. His third trip to the Yellowstone, Hayden followed generally the route he had taken in 1872. Jackson carried 11 x 14, 5 x 8 plates and a small tent-darkroom; used only dry plates.

August. Started out from Cheyenne and continued on to the Wind River Mountains. Tried out dry plates at Fremont's Peak. Snow plagued them continuously. On to Upper Yellowstone and the Tetons. Trip ended at Bell Springs on October 17. Jackson remarked:

The physical handicaps with the equipment this year seemed particularly prevalent. Chemicals were more than usually erratic in their behavior. Weather conditions were unfavorable especially bad for distant views. . . . Early mornings were the best times for working for the afternoons were windy, cold and rainy.

Diaries, 1878, pp. 34-44.

November 23. Daughter, Louise, born.

1879 Early. Congress ordered a consolidation and curtailment of Survey activities and all branches were joined. Jackson discontinued his work for the government and moved to Denver. Opened a studio at 413 Larimer Street, called "The Jackson Photographic Co." Retained all equipment used on the Surveys. The studio served as headquarters for the promotion of his own pictures, so hired a printer, a mounter, a receptionist, and two assistants: Frank Smart, son of a Washington photographer, and Hosier. This marked the beginning of his "Denver Period."

Summer. Devoted his time to taking views of Leadville, Colorado, his first independent trip since the Surveys. The results of the summer's work:

. . . differed little from the Hayden Survey, except in the use of a wagon rather than a pack mule. . . . Scattered over the hill were miner's shacks, derricks, ore dumps and a few stunted pine trees. I photographed them all. At the end of each day the treasure seekers slopped through the mud of Hawson Avenue to the Clarendon or the Texas, and to half a hundred other saloons, brothels and gambling dives, in search of such pleasures as they could pay for. I photographed them, too. My first summer as a commercial landscape photographer in ten years was instructive and not profitable.

Time Exposure, pp. 256-257.

1880 Spring. Sent for his family from Washington, D.C.

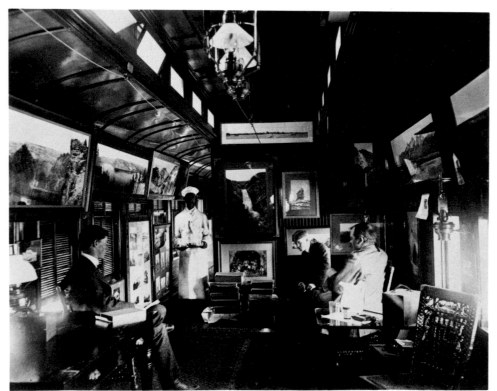

Interior of Photographic Railroad Car *(State Historical Society of Colorado)*

1881 Early. Formed partnership with Albert E. Rinehart, Denver portrait photographer. Firm named "Jackson and Rinehart." This was to last until 1884, when Rinehart opened a studio directly across the street from Jackson. Changed permanently from wet-plate to dry-plate process; 18 x 22 became the largest format he would work with.

Made arrangements with the booksellers, Chain and Hardy, to finance a number of his photographic projects.

To help stimulate travel along their routes, the railroads hired Jackson to take photographs. Received the first job from General W. J. Palmer of the Denver & Rio Grande Railway Company for a series of pictures to be used for promotional purposes. Given a special train with a flat car to serve as a photographic platform.

After this year, industrial photography became a lucrative business with important commissions from railroads like the Colorado Midland, Denver South Park, Pacific, and Colorado Central. (This collection eventually totaled some 30,000 negatives, and was compiled over a period of 15 years. The pictures were made as he traveled in specially-equipped cars provided by the various lines: D&R, G.W., New York Central, B&O, Sante Fe, Southern Pacific, Mexican Central and others.)

1882 June 7. Daugher, Hallie, Born.

From this time on, Jackson made photographic enlargements. During the summers, he constantly traveled to add more negatives.

1883 Moran and Jackson made a tour of the Grand Canyon trying to retrace a trip made previously. Their party included Ernest Ingersoll and Karst.

First trip to Mexico commissioned by the Mexican Central Railway. Jackson began using magnesium on field trips for pictures of caves and other dimly-lit interiors.

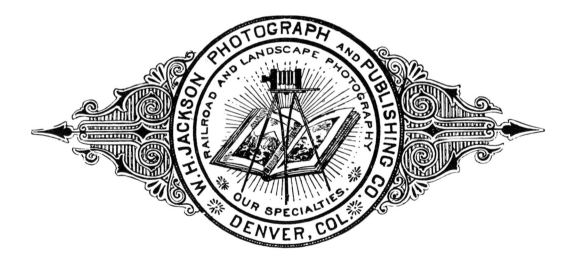

1884 Used 18 x 22-inch dry plates in the Southwest ruins. Returned to Mexico to photograph and climb Mount Popocatapetal; other trips to Mexico were made in following years.

1883 Incorporated as W.H. Jackson Photograph and Publishing Co., Inc. Louis Charles McClure began
84 working in the studio, specializing in architectural photography. Chamberlain also worked as an assistant.

1885 Moved the studio to Arapahoe Street and built a house on Clarkson Street. Entertained extensively.

Published albums of documentary views of Mexico and Colorado. These included approximately 600 photographs which were later combined with the files of the Detroit Publishing Company. From 1885-1902, he extended his activities to Canada, Yellowstone, New York, Arizona, Virginia, California, Louisiana and Florida.

Constantly experimented with new photographic processes all during his career.

1889 Following a trip to California:

*In this trip he has exposed 750 plates varying in size from 5 x 7 to 18 x 22. . . . Among them
are several panoramic views, one Hotel del Monte. It is of extraordinary size of 18 x 76 inches. . . .
By making four or more negatives from one point and printing them in panorama by blending
one print into the other, Mr. Jackson has overcome the difficulty and presents a picture
which, even to the eye of the expert, hides the method of its construction.*

A.J. Treat, *Wilson's Photographic Journal*, Vol. 1, No. 26 (1889), p. 378.

Also discussed at length in this article are Jackson's panoramic photographs of Yosemite
taken on the trip. The author expressed the following:

*It has long been my belief that views can be made on 'well-worn roads' to equal, and even
excel, work done by those who have been over the ground many times before. . . . Yet, Mr. Jackson
was the first to show the fine group of trees and rocks to the left and make the headland and the
bit of water on the right the termination of the arrangement. . . . I am not alone in saying that Mr.
Jackson's panoramic pictures of Yosemite are the first photographs that give one an idea of the
grandeur of this Nature's Masterpiece.*

Jackson took part in the "Berlin Exhibition." In his review of the show, Alfred Stieglitz said
of Jackson's work:

*Jackson, Denver, carried off the highest honors with his immense landscape pictures of the
Colorado region. Germans are not accustomed to work of such size and naturally gazed at it
with wonder.*

American Amateur Photographer, Vol. 1, No. 5 (November, 1889) p. 202.

1891 Returned to Mesa Verde to photograph the by then much publicized great cliff dwellings; from this
time until its realization in 1906, he consistently advocated the creation of Mesa Verde National Park.

1892 Summer. Two trips: one to the Grand Canyon of the Colorado for a week and the other to
Yellowstone for twelve days. The Grand Canyon party consisted of Moran, Jackson, Paul Higgins of
Chicago and Sam Taylor, Jackson's assistant. The Yellowstone party included Nead, Gilchrist, Williams,
Moran, Jackson, Crosby and two other men.

The highlight of the trips was Moran again accompanying Jackson, including the sidetrips
to Devil's Tower, Bighorn and the mountains of Wyoming. The relation between the artists was still
as close as it had been in 1871. Both shared a love for spectacular scenery and each helped
shape the other's vision. Moran's impressions follow:

*Jackson's negatives are turning out splendidly, and they will furnish me with material for
innumerable pictures. Jackson and I are concocting a scheme for publication of six subjects of
grand size for the Holy Cross, Yellowstone, Shasta and others.*

Letter from Moran to Mary, his wife, June 11, 1892,
Home Thoughts, p. 97. (The result is probably the album of
24 prints at the Library of Congress dated 1892-1894.)

Jackson photographed the great sweep of the Canyon embracing a view of 125 miles.
*His photographs will be nearly seven feet long and thirty inches high. The following day we spent at
various points along the Canyon edge and he made 100 negatives altogether.*

Letter from Moran to Mary, June 5, 1892, *Home Thoughts*, p. 91.

The sizes of the photographs taken were 18 x 22, 8 x 10 and 5 x 8 (the 5 x 8 plates were
taken over by the Detroit Publishing Co.).

*Regarding my 1892 trip to Devil's Tower, planned a great display (for) showing (at) the
Chicago Exposition in '93 and for that purpose organized an expedition to visit and photograph
the principal scenic features of the state, with myself, of course, as photographer, Thomas
Moran as painter, and Crosby, my partner in my Denver business.*

Letter from Jackson to F. Fryxell, March 24, 1936, quoted in *Home Thoughts*, p. 146.

Fall. Major Joseph Pangborn, an ex-journalist who was then publicity representative for the
Baltimore & Ohio Railroad, asked Jackson to take pictures along the railroad's route. "We'll provide
a private car and ten dollars a photograph." Pictures were to be displayed in a special exhibition
at the Columbia Exposition in 1893. Jackson entered over a hundred landscapes in the exhibition.

1893 One of the most important assignments undertaken by The William Henry Jackson Photograph and Publishing Company, was as official photographer to the World's Columbian Exposition. He was to record the entire event and be awarded a bronze medal by the Centennial Commission in recognition of his achievements. The "Lost Cities" exhibit was sent on to the American Museum of Natural History. It did much to arouse scientific interest in the archaeology of the Southwest.

With the close of the exposition, Jackson assembled a special album composed of 100, 11 x 14 views which he sold for $1,000 each. He sold a duplicate set of negatives to Harry Tammen of the *Denver Post* for $1,000. He received another $5,000 for the right to produce them in a collection called *The White City (as it was. . .)*, published by Tammen in 1894.

August 23. Jackson, accompanied by friends, celebrated the 20th anniversary of photographing the Mount of the Holy Cross by again visiting Notch Mountain.

1894 Spring. Independently published the *Catalog of Standard and Panoramic Photographs* out of Denver, Colorado. Hundreds of views were listed. The standard views were 17 x 21 unmounted, and sold for $1.50 each. These could also be purchased mounted on 22 x 26-inch cards which sold for $2 each. For mounting on 25 x 30-inch extra-fine cards with an india tint border, he charged 50¢ more and platinotype mounts with an embossed center sold for $1.50 extra. The panoramic photographs came in either 17 x 38 inches or 21 x 32 inches; unmounted, they sold for $5, mounted, $6, and colored, $12.

May 21. Books now proved of great importance to Jackson. The *Denver Times* reviewed his newly-published book called *Wonder-Places . . . The Most Perfect Pictures of Magnificent Scenes in the Rocky Mountains . . . The Masterworks of the World's Greatest Photographic Artist*. It contained 32 photographic "gems" of Jackson's landscapes, 21 of which were views of Colorado.

> Wonder-Places *is the curious but accurately descriptive title of a really remarkable work. It is a book without words, entirely novel in conception, finding no exemplar in the field of literature, and comparable only to Mendelssohn's 'Song Without Words.'*
>
> *As the great tone-poet gives us immortal songs, the soul of melody without the body of language, so the artist who made the marvelous photographs produced in this sumptuous book of* Wonder-Places *has given us the soul of nature without the cumbrous body of description. W.H. Jackson is, without dispute, the greatest scenic photographer in America, and ranks with the greatest in the world. In the course of his artistic career he has made at least 30,000 negatives of scenery in all sections of the North American Continent, and the 36 (some are copies of drawings) pictures reproduced in* Wonder-Places *are the ones chosen by him as the masterpieces of his artistic life.*
>
> <div align="right">Denver Times, May 21, 1894, p. 6, col. 4.</div>

Summer. Prepared for the world tour he was to take with Pangborn for the World Transportation Commission. (This group was formed to study public transportation throughout the world and to supply material for a transportation museum in Chicago.) Jackson was to be the official photographer. The Commission also included Edward Winchell, the artist; Clement Street, a mechanical expert; and Harry Stevenson, Pangborn's secretary.

September. Pangborn wrote that the Commission would leave soon after delay in raising funds was settled. Jackson had contacted magazines and received a commission — *Harper's Weekly* agreed to pay $100 a page if Jackson would provide landscapes and pictures of the everyday life of people.

Late September. The World Transportation Commission set sail. Three weeks were spent in London preparing to go through the Suez Canal to Ceylon and India.

November 1. Marseilles via Paris.

November 9.

> *On way through Marseilles Pangborn put on aires of a millionaire. Then the style we travel in being that of magnates of some kind.*
>
> <div align="right">Letter to wife, November 9, 1895, New York Public Library Manuscripts Division.</div>

November 10-21. Coast of Africa between Tunis and Tangiers.

November 22. Cairo via Gibraltar by steamer.

December 10. Up the Nile to Memphis and back.

December 14. Photographed around the Suez Canal entrance.

1895 January 19. Arrived in Bombay. Jackson felt it was one of the most enchanting cities he had ever seen. Negatives piled up rapidly.

January 26. Sent off to *Harper's* all (over 100) of the Ceylon pictures.

February. Made glass color-plates of Mamalpur. Two large Jackson panoramas were exhibited in the Calcutta Photographic Exhibit at the Government Photolithographic Works. The panorama of Ouray, Colorado, won a bronze medal.

April 4. Arrested in Singapore for photographing Fort Palmer, although he claimed not knowing what it was. Soldiers confiscated his camera and locked him in a room. After discussing case with the magistrate, Jackson was immediately released.

During the next five months, the Commission traveled through Australia, New Zealand, East Indies, China and Japan. Jackson left Pangborn on an independent venture to Korea. He visited Seoul with an English-speaking guide selected by Dr. Horace Allen, Secretary of the U.S. Legislature.

Throughout this trip, Jackson was hailed as the "Great American Ambassador."

October 8. The Commission disembarked at Vladivostok, Russia. The Amur River was frozen, forcing them to change their plans.

December 5. Left via the trans-Siberian route.

1896 January 22. The long train trip ended at Krasnoyarsk.

January 28. Reached Moscow.

March 3. Jackson, Winchell and Stevenson went to Bremerhaven, Germany, and boarded a liner for New York. The Commission ultimately failed, for it accomplished no real work. The tour "became a handsome junket with goodwill as our stock in trade."

Jackson's photographs appeared regularly in *Harper's Weekly* for more than a year. The most famous of these illustrated an article entitled, "On the Siberian Czarist Prison Camps."

1897 The panic of 1893 had left the Jackson firm in financial difficulties. Improvements in halftone engravings enabled picture magazines to cut into the old "view" market. The Denver studio suffered greatly. A program manager suggested that Jackson give illustrated talks on the countries he had visited. This lecture program extended throughout the area of Colorado. It was called "One Hundred Minutes in Strange Lands" and was illustrated with 125 slides projected on screens by stereopticons. The lecture tour was a failure.

William A. Livingstone, head of the Photochrom Company of Detroit under the supervision of the Detroit Publishing Company, offered Jackson $5,000 in cash and $25,000 in stock as a salaried director of the Photochrom firm. Through this transaction, Jackson became part owner of the Detroit Publishing Company and its chief cameraman. The company specialized in photographic views; seven million prints were sold annually. Photo-Chromo was a Swiss-developed photolithographic process which made it possible to produce multiple copies of color prints from two or more photoengraved relief blocks.

What became of the negatives of Jackson's firm in Denver is in dispute.

All these negatives passed into the hands of my successors when I left there in 1898.

> Letter from Jackson to G.G. Gilchrist, January 27, 1938,
> Denver Public Library, Western History Division.

Yet in another letter, he writes:

Leaving Denver, I turned the collection over to the Detroit Publishing Company. . . . The photographs became an important feature of the business of the company.

> Letter from Jackson to Mr. Ellison, February 24, 1938,
> Denver Public Library, Western History Division.

Early Fall. Jackson packed up and left for Detroit.

I had two things to contribute to the Detroit Publishing Company; 1) the most complete set of Western negatives yet assembled by one man and 2) the experience and reputation.

> *Time Exposure*, p. 323.

His wife remained in Denver working as a colorist in his old studio.

1898 Summer. Jackson went to Omaha to make a pictorial of the Trans-Mississippi Exposition, then on to the Black Hills to do promotional work for the Chicago & Northwestern Railroad.

Fall. Beginning of intensive indoor work in the production of color prints in sizes ranging from post card to the largest suitable for printing. The retail salesrooms were in Detroit, New York, Los Angeles, London, and Zurich. Their 342-page catalog was distributed world-wide.

1899 Jackson covered over 20,000 miles in five months, doing scenic photography of Yellowstone and the Rockies in order to accumulate new pictures for the Photochrom Company.

1900 Became president of the Colorado Camera Club.

In the summer, traveled throughout Colorado.

Winter. Photographed along the Atlantic coast from Virginia to Florida. Took his first voyage to Cuba and Nassau for more pictures.

1901 Summer spent in the Colorado Rockies and then on to photograph the Texas Panhandle.

1902 Pinnacle of prosperity for the Photochrom Company. They decided to send out a traveling display of their work to be housed in a private car of the Santa Fe Railway. Jackson toured the Southwest aboard the "California Special," giving informal talks and answering questions.

1903 Spring. E.H. Husher, superintendent of the Photochrom Company, resigned. Thus, at sixty, Jackson became the manager of 40 artisans and a dozen traveling salesmen.

1905 Published albums of views: *West Indies, Bahama Islands,* and *Venezuela* from the years 1900 to 1905

1912 Jackson's mother died. He was greatly disturbed by her death.

1917 His wife, Emilie, died at the age of seventy-five. Jackson remarked years later, "The hardest blow had been losing Emilie."

1923 *One thing leads to another. My revived interest in western travel and exploration has brought about my election as a non-resident member of the Explorers Club of New York.*

Letter from Jackson to Mr. Thomas Dawson, April 23, 1923, Denver Public Library, Western History Division.

1924 Early in the year, the Photochrom Company collapsed. It owed Jackson over $6,000 in back salary. Sold his interest in the firm to Robert L. Livingstone. (With the death of Livingstone, Henry Ford purchased the collection.)

October 14. Retired from the Detroit Publishing Company.

November 16.

I am painting now more than writing. I have been doing some Indian subjects for a gentleman interested in ethnographic letters and at present am working on a picture of a large encampment of Shoshones in South Pass from photographs that I made in 1870.

Letters from Jackson to Mr. Ellison, Denver Public Library, Western History Division.

Lived on the pension he received as a Civil War veteran. At first, resided with his daughter and her family; later, moved to the Annapolis Hotel.

1929 *Pioneer Photographer* published.

Accepted post of Research Secretary for the Oregon Trail Memorial Association. To take this position, he had to move to New York City. The Association was headed by a friend and coauthor of the *Pioneer Photographer,* Dr. Howard Driggs. At the Association, Jackson handled correspondence, addressed meetings and accumulated data. He spent the remaining years of his life in this post. The job gave him time to travel extensively on his vacations. Lost savings in crash.

1936 The Department of the Interior hired Jackson to supervise and help execute a series of mural paintings for its new building in Washington, and so he took to the field again.

The four large (30 x 60-feet each) oil paintings in the series were to commemorate the early days of the Geological Surveys. They represented (1) the Hayden Survey with a picture, "Old Faithful Geyser in Background"; (2) The King Survey of the Fortieth Parallel, entitled "Encampment in Carson Valley with the Sierra Nevada in the Distance"; (3) The Wheeler Survey of 1873 by "The Party Before the Pueblo of Zuni with Thunder Mountain on the Horizon"; and (4) Powell Survey of the Colorado River, "With the Party at Work Along the Canyon Floor."

Jackson's collection of 40,000 negatives were sold to and stored in the Edison Institute in Dearborn, Michigan.

*Mr. Wyer of the Denver Public Library has purchased the original proof print albums of all
Rocky Mountain subjects and has been exhibiting them. In all the Denver Public Library purchased
2,000 photographs from Jackson's personal collection of Colorado and the Rocky Mountain Empire.*

Letter from Jackson to Mr. Ellison, April 10, 1936,
p. 2, Denver Public Library, Western History Division.

1937 January 13. Because of lack of funds, worked for the National Park Service and executed some 30 paintings of scenic interest.

June. Received a medal in recognition of his services to the nation from the University of Colorado. Dr. Goody Koontz said of Jackson:

*. . . a pioneer in the preservation and representation of the beauties of untamed nature of our
great West.*

Manuscripts filed on Jackson, Colorado Historical Society.

1938 Made an honorary fellow in the Royal Photographic Society of Great Britain.

Participated as a technical advisor in the filming of the motion picture, *Gone With the Wind.*

1939 Completed a series of 50 watercolors recording the history of the Oregon Trail for the Association's publication. These were based on recollections and pencil sketches Jackson had made during his journey over the trail in 1866.

Made an honorary member of the American Alpine Club.

1940 Jackson's autobiography, *Time Exposure,* published.

1941 Received an honorary Doctor of Law Degree from the University of Wyoming, at Laramie, Wyoming.

1942 March 3 - April 5. Jackson was one of 22 photographers represented in The Museum of Modern Art's exhibition "Photographs of the Civil War and the American Frontier."

June 30. Died, in his 99th year, at the Midtown Hospital in New York City, from injuries received in a fall. Left one son and two daughters, seven grandchildren and four great grandchildren.

*Jackson, who for 79 of his 99 years viewed the world through three eyes, two of his
own, the other the searching, ever-improving eye of the camera, is dead.*

The Herald Tribune, July 1, 1942.

His photographs live on—a legacy to his nation.

EPILOG

1946 The Union Pacific Railroad's Jackson files were donated to the Colorado Historical Society.

1949 January. After long negotiation, the trustees of the Ford Foundation, and the Edison Institute in Dearborn, Michigan, turned over the entire Jackson collection of 53,879 glass negatives, made during the years of 1880 through 1920, to the Colorado Historical Society. These photographs dealt with all the subjects Jackson had worked with west of the Mississippi. The transaction was made possible by Mr. Swan, Mr. Brayer, and Mr. Clarence Jackson, his son.

All the negatives made during that same period, but pertaining to the East and foreign countries, were given to the Library of Congress. These plates had been part of the Detroit Publishing Company's collection. Paul Vanderbilt has said:

*The most important collection acquired by the Library of Congress is doubtless the lot of
30,000 original glass-plate negatives made in Eastern United States by William Henry Jackson.
The later work is less well-known because he has omitted detailed discussion of this phase of his
career from his published autobiographies.*

The Library of Congress Quarterly Journal of Current
Acquisitions, Vol. 7, No. 1 (November, 1949), pp. 45-46.

The original Hayden Survey negatives were deposited in Washington, D.C. (National Archives, Department of the Interior), although the Photographic Division of the United States Geological Survey Library at the Denver Federal Center has duplicate negatives.

1956 The original sample books of Colorado towns and scenery, used by Jackson while in business in Denver, were placed in the Western History Department of the Denver Public Library. Five excellent examples of the large 20 x 24 wet-plate negatives are also located there.

BIBLIOGRAPHY *by Diana E. Edkins*

BOOKS, ALBUMS AND MANUSCRIPTS BY JACKSON

> Wonder-Places *is a book without words, entirely novel in conception, finding no exemplar in the field of literature, and comparable only to Mendelssohn's 'Song Without Words.'*
> The Denver Times *(May 21, 1894), p. 6, col. 4.*

Album of Documentary Views of Mexico, 1884-1885. Privately printed, n.d. 600 photographs in four albums from the files of the Detroit Publishing Co.

Album of Views of Canadian Cities and Countryside 1890-1905. Privately printed, n.d. 150 photographs from the files of the Detroit Publishing Co.

Albums of Views of the West Indies, Bahama Islands and Venezuela, 1900-1905. Privately printed, n.d. 200 photographs in two albums from the files of the Detroit Publishing Co.

Among the Rockies: Pictures of Magnificent Scenes in the Rocky Mountains. The Master-Works of the World's Greatest Photographic Artist from Thousands of Negatives as the Gems of the Collection. Denver, Colorado: Great Divide Publishing Co., 17 illustrations. Also Denver, Colorado: H. H. Tammen Curio Co., 1900, 17 illustrations.

The Cañons of Colorado. Denver, Colorado: F.S. Thayer, 1900, 16 illustrations.

Catalogue of Standard and Panoramic Photographs. Denver, Colorado: W. H. Jackson Photograph & Publishing Co., 1894.

Catalogue of Stereoscopic Photographs. Washington, D.C.: Cunningham & McIntosh, 1871, 11 pages.

Correspondence with Mr. Thomas F. Dawson, November 20, 1920-April 23, 1923. Manuscript, Colorado Historical Society.

Correspondence with R.S. Ellison, 1924-1940. Manuscript, Denver Public Library, Western History Division. 112 items in all.

Correspondence with Mr. G.G. Gilchrist, July 14, 1934-June, 1942. Manuscript, Colorado Historical Society.

Denver & Rio Grande Railroad Co., Rocky Mountain Scenery. A brief description of prominent places of interest along the line of the Denver & Rio Grande Railroad. New York: Press of the American Bank Note Co., 1888(?), 80 pages including illustrations.

Diaries of William Henry Jackson, Frontier Photographer, to California and Return, 1866-1867, and with the Hayden Surveys to the Central Rockies, 1873, and to the Utes and Cliff Dwellings, 1874. Edited, with introduction and notes by LeRoy R. Hafen and Ann W. Hafen. Glendale California: A.H. Clarke, 1959, 345 pages.

Diaries: May 14, 1866-December 16, 1866, and December 19, 1866-August 11, 1867. Manuscript, Colorado Historical Society.

Diaries: 1867, 1869, 1870-1873, 1876-1878. Plus letters to his wife, Emilie, October 4, 1894-April 39, 1895, and May 9, 1895-February 17, 1896. Manuscript, New York Public Library Manuscripts Division.

Drawings of the Oregon Trail. New York (?), 1929-1930, 6 mounted plates.

Grand Cañon of the Arkansas. Denver, Colorado: W.H. Jackson, 188-(?), 12 illustrations.

Jackson's Famous Pictures of the World's Fair. . . . Chicago, Illinois: The White City Art Co., 1895, 80 plates.

Niagara Falls, New York. Detroit Publishing Co., 1900. Nine color photoreproductions, mounted in a 17 by 25-inch album.

The Pioneer Photographer: Rocky Mountain Adventures With a Camera, with Howard Driggs. Yonkers-on-Hudson, New York: World Book Co., 1929.

Portraits of American Indians: 1876. Washington, D.C.: Privately printed, 1876. Selected from the collection of Survey photographs representing 70 different tribes. Professor F.V. Hayden, in charge. 616 mounted photographs.

Time Exposure. New York: G.P. Putnam's Sons, 1940. Reprint, *Time Exposure: The Autobiography of William Henry Jackson.* New York: Cooper Square Publishers, 1970.

U.S. Geological Survey: Rocky Mountains, Natural Surroundings, 1870-1874. Privately printed, n.d. Album of 56 photographs.

The White City (as it was. . .). Chicago, Illinois: The White City Art Co., 1894. Pictures of the World Centennial Exposition, 1893.

Wonder-Places: The Most Perfect Pictures of Magnificent Scenes in the Rocky Mountains. The Master-Works of the World's Greatest Photographic Artist, William Henry Jackson. Denver, Colorado and Chicago, Illinois: Great Divide Publishing Co., 1894, 21 plates.

> *An unthinking public may imagine that the employment of photography in connection with the work of the Survey is more ornamental than useful. . . and that the sole business is merely to please the eye and not for practical and scientific use. . . .*
>
> *Photographs have done very much in the first place to secure truthfulness in the representation of mountain and other scenery. Twenty years ago, hardly more than caricatures existed, as a general rule, of the leading features of overland explorations. . . .*
>
> Record Group 57. M623, Roll 21, 1869-1879, no date, no name, p. 1.

Catalogue of the Photographs of the U.S. Geological and Geographical Surveys of the Territories. William Henry Jackson, photographer, 1875, 51 pages. List of titles only. In 1874, a larger *Descriptive Catalogue* was issued, followed in 1875 by a 2nd edition; illustrated.

Descriptive Catalogue of Photographs of North American Indians of Over 1,000 Negatives Made During a Period of Twenty-Five Years. (Department of the Interior, U.S.G.S., F. Hayden). Miscellaneous Publications. No. 9, 1876.

Descriptive Catalogue of the Photographs of the U.S. Geological and Geographical Surveys of the Territories for the Years 1869 to 1873, Inclusive. 2nd edition. Miscellaneous Publications, No. 5, 1875.

Descriptive Catalogue of the Photographs of the U.S. Geological and Geographical Surveys of the Territories for the Years 1869 to 1875, Inclusive. 1876, 83 pages. Hayden, geologist in charge, with full descriptions of the photographs.

Holmes, William Henry, "A Notice of the Ancient Ruins of Southwestern Colorado, Examined During the Summer of 1875." *U.S. Geological and Geographical Survey Bulletin,* Vol. 2, No. 1 (1876), pp. 3-24. Illustrated with photographs by Jackson.

Jackson, William Henry, "A Notice of the Ancient Ruins in Arizona and Utah Lying About the Rio San Juan." *U.S. Geological and Geographical Survey Bulletin,* Vol. 1, No. 3 (1875), pp. 25-45. Illustrated with photographs by Jackson.

———, *Photographs of the Yellowstone National Park and Views in Montana and Wyoming Territories.* 37 mounted photographs, each plate accompanied by guard sheet with descriptive letter press.

———, "Report on the Ancient Ruins Examined in 1875 and 1877." *U.S. Geological and Geographical Survey Bulletin,* Vol. 1 (1877), pp. 411-450. Illustrated with photographs by Jackson.

———, *Views of the Yellowstone.* (Department of the Interior: U.S.G.S.), 1871, 81 mounted photographs. This is the album which was presented to Congress as proof of the wonders of Yellowstone.

———, *United States Geological Survey: Report on the Territory of Wyoming and Idaho, Part I and II.* 1877.

UNPUBLISHED GOVERNMENT DOCUMENTS IN THE NATIONAL ARCHIVES: THE HAYDEN SURVEY

Record Group 57. Records of the United States Geological Survey. This is the most valuable collection of material on the Hayden Survey. It contains much correspondence sent to Hayden from members of his survey and from other individuals.

Record Group 48. Records of the Office of the Secretary of the Interior. It is divided into two sections: The Patents and Miscellaneous Division, and The Lands and Railroads Division. The amount of the Hayden material is small, consisting of some correspondence between Hayden and the Secretary of the Interior and some correspondence from scientists.

JACKSON PHOTOGRAPHS IN OTHER SOURCES

> *Now that through the intrepidity and restless spirit of American enterprise this vast and hitherto unexplored region is becoming gradually more known, we stand almost overpowered in the presence of its stupendous resources, as well as in that of some of its singular and sublime geographical features.*
>
> *Frank Leslie's Illustrated Newspaper,* Vol. 36, No. 934 (August 23, 1873), p. 383.

Buckman, George R., *Colorado Springs and Its Famous Scenic Environs.* Privately printed, Colorado Springs, 1893. Photographs by W.H. Jackson.

Bunce, O.B. and William Cullen Bryant, *Picturesque America: Or, the Land We Live In.* Vols. 1 & 2. A delineation by pen and pencil of the mountains, rivers, lakes, forests, waterfalls, shores, canyons,

valleys, and other picturesque features of our country. New York: Apelleton & Co., 1872-1874. Illustrated with photographs by W.H. Jackson which were also models for the etchings which Thomas Moran executed to illustrate the articles.

Centennial State, 1876-1882: A Memorial Offering of the Business Men and Pioneers of Denver, Colorado. Denver, Colorado: Rebanks Wilson & Co., 1882. Forty-three photographs of Denver, Colorado, by W.H. Jackson.

The City of Denver, Its Resources and Their Development: A Souvenir of the Denver Times. Denver, Colorado: Carson, Hurst & Harper, Art Printers, 1892. Photographs by W.H. Jackson.

Driggs, Howard Roscoe, *The Old West Speaks.* Englewood Cliffs, New Jersey: Prentice Hall, 1956, 220 pages. Bibliography: pp. 203-205. Watercolors by W.H. Jackson.

——, *Westward America.* New York: G.P. Putnam's Sons, 1942. With reproductions of 40 watercolors by W.H. Jackson.

Ingersoll, Ernest, *Knocking About the Rockies.* New York: Harper & Brothers, 1883, pp. 3-220

McClurg, Virginia Donaghe (text), *Picturesque Colorado.* Series No. 1, Denver, Colorado: Frank S. Thayer. 1887. Photographs by W.H. Jackson; phototype illustrations by Gutekunst.

Thayer, William Makepiece. *Marvels of the West: A Vivid Portrayal of the Stupendous Marvels in the Vast Wonderland West of the Missouri River.* Norwich, Connecticut: Henry Bill Publishing Co., 1888 and 1891, 715 pages. 350 engravings and maps many of which are from photographs by W.H. Jackson and T.O. Sullivan, but not credited.

ARTICLES BY JACKSON

Scenes of amazing grandeur lured me. I was eager to get in picture form some of these scenes and some suggestion of the activities connected with this mighty national enterprise.

The Pioneer Photographer, p. 60.

"Across Korea on Horseback." *Harper's Weekly,* Vol. 42 (January 15, 1898), pp. 59-61.

"A Visit to the Los Piños Indian Agency in 1874." *Colorado Magazine,* Vol. 15, No. 6 (November, 1938), pp. 201-209. Extract from the 1874 diary of W.H. Jackson.

"Famous American Mountain Paintings, I With Moran in the Yellowstone, A Story of Exploration, Photography and Art." *Appalachia,* New Series, Vol. 2, No. 12 (December, 1936), pp. 149-158.

"Field Work." *The Philadelphia Photographer,* Vol. 12, No. 135 (March, 1875), pp. 91-93. Extremely important.

"First Official Visit to the Cliff Dwellings." *Colorado Magazine,* Vol. 1, No. 4 (May, 1924), pp. 152-160.

"How the Mountain of the Holy Cross Was Photographed for the First Time, August 24, 1873." *Red Cliff, Colorado* (March 17, 1923).

"Landscape Photography with Large Plates." *Anthony's Photographic Bulletin* (1898), pp. 315-316.

"Letter to Mr. Barker." *Anthony's Photographic Bulletin,* Vol. 5, No. 12 (December, 1874), p. 419.

Letter to the Editor: "The Pocket Camera." *The Photographic Times,* Vol. 6, No. 64 (April, 1876), p. 75.

"Mountaineering Photography, Old Style." *The American Alpine Journal,* Vol. 4, No. 1, Issue 12 (1940), pp. 214-218.

"On the Siberian Czarist Prison Camps." *Harper's Weekly*

"Photographing the Colorado Rockies Fifty Years Ago." *Colorado Magazine,* Vol. 3, No. 1 (March, 1926), pp. 11-22.

"Who First Photographed the Rockies?" *The Trail,* Vol. 18, No. 9 (February, 1926), pp. 12-16.

BOOKS ON JACKSON

We were up with the sun every morning. Everyone was discovering some new or more wonderful viewpoint. It was a most entrancing thought that we were in the presence of one of the grandest views in the world and one never before photographed.

The Pioneer Photographer, p. 111.

Forsee, Alysea, *William Henry Jackson: Pioneer Photographer of the West.* New York: Viking Press, 1964. Illustrated with photographs by Jackson.

Jackson, Clarence S., *Pageant of the Pioneers: The Veritable Art of William Henry Jackson, Picture Maker of the Old West.* Minden, Nebraska: Harold Warp Pioneer Village, 1958.

——, *Picture Maker of the Old West: William Henry Jackson.* New York: Charles Scribner's Sons, 1947.

Jackson, Clarence S. and Marshall, Lawrence, *Quest of the Snowy Cross.* Denver, Colorado: University of Denver Press, 1952.

Miller, Helen Markley, *Lens on the West: The Story of William Henry Jackson*. Garden City, New York: Doubleday, 1966, 52 illustrations, drawings and photographs by Jackson. Chronology: pp. 186-189.

ARTICLES ON JACKSON

> *The photographic work was this year (1873) again in the charge of Mr. W.H. Jackson, who*
> *has approved in previous campaigns his skill as a workman, his enterprise and persistence*
> *as an explorer, and his good judgment in the selection of his subjects.*
> *American Journal of Science and Arts,* Third Series, Vol. 6, No. 36 (December, 1873), p. 463.

"Admirable Lantern Exhibition" (Editor's Table). *The Philadelphia Photographer,* Vol. 10, No. 109 (January, 1873), p. 32.

Anthony & Co., E. & H. T. "Government Photography in America." *Anthony's Photographic Bulletin,* Vol. 5, No. 11 (November, 1874), p. 366.

"Bakers' Park: The Photographer Turning His Camera on the Grand Old Peaks." *Rocky Mountain News,* Vol. 16 (July 29, 1875), p. 4, col. 4.

Borland, H., "Camera Historian William Henry Jackson, Pioneer Photographer of the West." *The New York Times,* Mp. 4 (April 7, 1940).

Bradley, Prof. Frank H., "Explorations of 1872: U.S. Geological Survey of the Territories under Dr. Ferdinand V. Hayden: Snake River Division." *The American Journal of Science and Arts,* Third Series, Vol. 6, No. 33 (September, 1873), pp. 194-206.

"The Cañons of the Colorado." *The New York Daily Graphic* (October 11, 1875), p. 780.

"Correspondence — The Return of Mr. William Henry Jackson." *Anthony's Photographic Bulletin,* Vol. 7, No. 1 (January, 1876), p. 31.

Detzer, K., "Portrait of a Pioneer: Father of the Picture Postcard and Discoverer of Yellowstone National Park." *Reader's Digest,* Vol. 34 (June, 1939), pp. 29-32.

Ellison, Robert S., "William Henry Jackson: Pioneer of the Yellowstone, Casper, Wyoming." *The Midwest Review,* Vol. 16, No. 9 (September, 1925), pp. 1-6.

Fryxell, Fritiof, "Mount of the Holy Cross." *Trail and Timberline* (January, 1934), pp. 7-8.

——, "William Henry Jackson: Photographer, Artist, Explorer." *American Annual of Photography,* Vol. 53 (1939), pp. 208-220.

"Gift of William Henry Jackson and Timothy O'Sullivan Photographs." *Image,* Vol. 2, No. 5 (1962). A gift of 364 photographs of the American West was presented to George Eastman House by the Department of Geological Sciences of Harvard University. Jackson's work was represented by 140 photographs.

Greenleaf, C.J., "William Henry Jackson—Photographer." *The Photo-Era,* Vol. 65, No. 3 (September, 1930), pp. 135-138.

Hayden, Ferdinand V., "The Survey of the Territories, The Hayden Expedition." *The New York Tribune,* Scientific Series, Extra No. 14 (December 30, 1873), p. 3.

——, "The Yellowstone Region." *Science Record 1873,* pp. 515-529. Engravings from W.H. Jackson photographs.

"The Hayden Survey: A Visit to the Offices of the Surveying Corps." A Government Correspondent. *The New York Times,* Vol. 24, No. 7367 (April 27, 1875), p. 1.

"The Hayden Survey: Beyond the Settlements." A Government Correspondent. *The New York Times,* Vol. 24, No. 7445 (July 27, 1875), p. 1.

"His Adventures of 97 Years Old Told by Pioneer Photographer." *Newsweek,* Vol. 16, No. 5 (July 29, 1940), p. 41.

Holmes, William H., "First Ascent of the Mountain of the Holy Cross: 1873." *Ohio Archaelogical and Historical Quarterly,* Vol. 36 (1927), pp. 517-527.

Howe, Hartley, "William Henry Jackson: Frontier Lensman." *U.S. Camera Annual,* Vol. 1 (1941), pp. 65-92, including 31 illustrations.

"Interesting American Scenery." *The Philadelphia Photographer,* Vol. 13, No. 148 (April, 1876), pp. 120-122.

"Interview with Fred Mazzulla and Herbert Davis with Louis Charles McClure: His Life (William Henry Jackson) as a Colorado Photographer." Taped interview, Denver Public Library, Western History Division, 1956.

Ives, Ronald L., "The Wild West Is Painted: Pioneer Photographer-Painter Portrays Historic Scenes for the New Interior Department Museum." *The Science Newsletter,* Vol. 33 (March 19, 1938), pp. 186-190.

Jackson, Clarence S., "First With a Camera: W.H. Jackson Blazed the Trail for Photographers in Three Famous Scenic Areas of Mountain Empire." *Rocky Mountain Empire Magazine* (April 10, 1949), p. 5.

Mumey, Dr. Nolie, "William Henry Jackson: A Tribute." *The Westerners*, Denver, Colorado: Denver Posse, Brand Book, Vol. 3 (1947), pp. 257-280. Notes by Jesse Nusbaum.

Nevins, A., "Pioneer in Photography." *The Saturday Review of Literature*, Vol. 22, No. 7 (September 7, 1940), p. 7.

Norton, Frank H., "Photographic Exhibition." *Frank Leslie's Historical Register of the United States Centennial Exposition, 1876*. New York: Frank Leslie Publishing House (1877), pp. 164-165.

Obituary: "In Memoriam: William Henry Jackson." *The American Alpine Journal*, Vol. 5, No. 1, Issue 15 (1943), pp. 135-136.

Obituary: "William Henry Jackson, Pioneer Photographer of the West Dies: His Third Eye Saw Wonder West." *The Denver Post* (July 1, 1942), pp. 1, 8.

Obituary: "William Henry Jackson Dies: Photographer 99." *The New York Times* (July 1, 1942).

Obituary. *The Photographic Journal*, Vol. 82, No. 340 (November, 1942), p. 386.

Obituary. *Time*, Vol. 40 (July 13, 1942), p. 51).

Racanicchi, Piero, "William Henry Jackson." *Popular Photography Italiana*, No. 51 (September, 1961), pp. 43-54, 32 illustrations.

"Scattered Photography in the Great Exhibition: Government Buildings." *The Philadelphia Photographer*, Vol. 13, No. 154 (October, 1876), pp. 292-295.

Selmeier, Lewis W., "First Camera on the Yellowstone." *Montana—The Magazine of Working History* (Summer, 1972), pp. 43-52.

"Stereoscopic Views of the West." *The Philadelphia Photographer*, Vol. 10, No. 110 (February, 1873), p. 64.

Stieglitz, Alfred, "The Berlin Exhibition." *The American Amateur Photographer*, Vol. 13, No. 5 (November, 1889), pp. 202-204.

Treat, A.J., "A Celebrated Photographer and His Work." *Wilson's Photographic Magazine*, Vol. 1 (1889), pp. 378, 379.

"William Henry Jackson—Landscape Photographer." *Wilson's Photographic Magazine*, Vol. 30, No. 437 (May, 1893), pp. 228-231. First time a Jackson photograph was used as an illustration in a photographic magazine, "The Lower Terraces, Mammoth Hot Springs, Yellowstone National Park," p. 229.

"U.S. Geological Survey of the Territories." (Editor's Table) *The Philadelphia Photographer*, Vol. 12, No. 133 (January, 1875), p. 30.

"U.S. Geological Survey of the Territories, Ferdinand V. Hayden, Geologist in Charge. Photographs of 1873." *The American Journal of Science and Arts*, Third Series, Vol. 6, No. 36 (December, 1873), pp. 463-466.

Vanderbilt, Paul, "William Henry Jackson in the East." *U.S. Camera*, Vol. 12, No. 5 (May, 1949), pp. 44-47.

GENERAL WORKS ON NINETEENTH-CENTURY PHOTOGRAPHY AND THE AMERICAN WEST—BOOKS

> *The photographs were of immense value. Description might exaggerate, but the camera told the truth and in this case the truth was more remarkable than the exaggeration.*
>
> Hiram Chittenden, *Guide to the Yellowstone National Park*. 1917.

Andrews, Ralph Warren, *Picture Gallery Pioneers: 1850-1875*. Seattle, Washington: Superior Publishing Co., 1964, 192 pages. 17 photographs by Jackson, pp. 25-36.

Bartlett, Richard A., *Great Surveys of the American West*. Norman, Oklahoma: University of Oklahoma Press, 1962, 408 pages, illustrations, maps. Bibliography: pp 377-390.

Chittenden, Hiram Martin, *Yellowstone National Park: Historical and Descriptive*. Stanford, California: Stanford University Press, 1933. 286 pages.

—— *The Yellowstone National Park*. Reprint of above entry, edited and with an introduction by Richard Bartlett. Norman, Oklahoma: University of Oklahoma Press, 1964, 208 pages, maps. Bibliography: pp. 196-199.

Goetzmann, William H., *Exploration and Empire: The Explorer and the Scientist in the Winning of the American West*. New York: Alfred A. Knopf, 1966, 656 pages, illustrations, maps. "A note on the sources": pp. 649-656.

Harber, Opal Murray, "The Photographers of Colorado Accompanying the Expeditions and Surveys Before 1876: The Most Noted Photographer, William Henry Jackson." In "The Early Photographers of Colorado: 1853-1876," unpublished MA thesis for the University of Denver, 1956.

Hayden, Ferdinand V., *The Rocky Mountain Album*. 1872 advertisement for this work (never seen personally). Speculated to have 60-100 instructive views of Western scenery by William Henry Jackson and to have been an edition of 500.

——, *Scenes and Incidents Connected with the United States Geological Survey of the Territories,* 1871. (Again, never seen personally.) To have been photographically illustrated with 19 camp views, 6 x 8, and 28 vignettes by William Henry Jackson in an edition of 150.

——, *The Yellowstone National Park, and the Mountain Regions of Portions of Idaho, Nevada, Colorado and Utah Described by Hayden.* Boston: L. Prang and Co., 1876, 15 mounted plates. Illustrated with chromo-lithographic reproductions of watercolor sketches by Thomas Moran.

Horan, James David, *The Great American West: A Pictorial History from Coronado to the Last Frontier.* New York: Crown Publishers, 1959, 288 pages. Bibliography: pp. 281-283. 12 Jackson photographs: pp. 27, 83, 88, 150, 151, 213, 247.

Linquist-Cock, Elizabeth, "The Influence of Photography on American Landscape Painting: 1839-1880." Unpublished Ph.D. dissertation, NYU, 1967.

Moran, Thomas, *Home Thoughts from Afar: Letters of Thomas Moran to Mary Nimmo Moran.* Edited by Amy O. Bassford with an introduction and notes by Fritioff Fryxell, East Hampton, N.Y.: East Hampton Free Library, 1967.

Nash, Roderick, *Wilderness and the American Mind.* New Haven: Yale University Press, 1967.

Newhall, Beaumont, *The History of Photography from 1839 to the Present Day.* New York: The Museum of Modern Art, 1949, 238 pages, including 146 illustrations. One Jackson photograph: p. 81.

Shearer, F.E. (ed.), *The Pacific Tourist: An Illustrated Guide to the Pacific Railroad and California and Pleasure Resorts Across the Continent.* New York: Adams & Bishop Publishers, 1879.

Shepard Paul. *Man in the Landscape: A Historic View of the Esthetics of Nature.* New York: Ballantine Books, 1972.

Taft, Robert, *Photography and the American Scene; A Social History; 1839-1889.* New York: Dover Publications, 1938, 1964, 546 pates, illustrations, ports. Thirteen Jackson photographs: pp. 298-301, 303, 304. Jackson quoted: pp. 288, 309, 310.

Truettner, William H. *National Parks and the American Landscape.* Catalog of the National Collection of Fine Arts, Smithsonian Institution, 1972.

Williams, Henry T. (ed.), *The Pacific Tourist: A Complete Traveler's Guide.* New York: Henry T. Williams, 1877, with specific contributions by Ferdinand V. Hayden, Clarence King, etc. Illustrations by Thomas Moran, A.C. Warren and F. Schell; engravings by Meeder and Chubb; engravings after photographs by William Henry Jackson and Timothy O'Sullivan.

GENERAL WORKS ON NINETEENTH-CENTURY
PHOTOGRAPHY AND THE AMERICAN WEST—ARTICLES

The scenery along the Yellowstone River may be said to be broken up into the pastoral,
the grand, the sublime and the appalling.
 Frank Leslie's Illustrated Newspaper, Vol. 36, No. 924 (June 14, 1873), p. 223.

Bartlett, Richard A., "The Hayden Survey in Colorado." *Colorado Quarterly,* Vol. 4, No. 1 (Summer, 1955), pp. 73-88.

Born, Wolfgang, "The Panoramic Landscape as an American Art Form." *Art in America,* Vol. 36, No. 1 (January 1948), pp. 3-10.

Bradley, Frank, "Explorations in 1872: United States Geographical Survey of the Territories under Dr. F.V. Hayden; Snake River Division." *American Journal of Science and Arts,* Third Series, Vol. 6, No. 33 (September, 1873), pp. 194-206.

Gardner, James T., "Hayden and Gardner's Survey of the Territories, Under the Direction of the Department of the Interior." *American Journal of Science and Arts,* Third Series, Vol. 6, No. 34 (October, 1873), pp. 297-300.

Hayden, Ferdinand V., "The Hot Springs and Geysers of the Yellowstone and Fire-Hole Rivers." *American Journal of Science and Arts,* Third Series, Vol. 3. No. 15 (March, 1872), pp. 161-176.

——, "The Wonders of the Yellowstone." *Scribner's Monthly,* Vol. 2, No. 2 (June, 1871), pp.

——, "The Wonders of the West—11: More About the Yellowstone." *Scribner's Monthly,* Vol. 3, No. 4 (February, 1872), pp. 388-396.

Jackson, Turrentine W., "The Creation of Yellowstone National Park." *Mississippi Valley Historical Review.* Vol. 29 (June, 1942), pp. 187-206.

Langford, Nathaniel P., "Ascent of Mt. Hayden." *Scribner's Monthly,* Vol. 6, No. 2 (June, 1873), pp. 129-157.

—— "The Wonders of the Yellowstone." *Scribner's Monthly,* Vol. 2, No. 1 (May, 1871), pp. 1-17; Vol 2, No. 2 (June, 1871), pp. 113-128.

Muir, John, "The Grand Canon of the Colorado." *The Century Magazine*, Vol. 65, No. 1 (November, 1902), pp. 107-116.

Pike, Donald G., "Four Surveyors Challenge the Rocky Mountain West." *The American West*, Vol. 9, No. 3 (May 1972), pp. 4-13.

"Photographic Hall; Major Scientific Reports from the Western Expeditions, the Centennial Exposition, 1876." *The Scientific American Supplement*, No. 10 (March 4, 1876), p. 308.

Samson, John, "Photographs from the High Rockies." *Harper's New Monthly Magazine*, Vol. 39, No. 232 (September, 1869), pp. 465-475.

Taft, Robert, "Old Photographs—A Review of American Photography in the Period, 1839-1880." *Transactions, Kansas Academy of Science*, Vol. 36 (1933), pp. 36-40.

Toll, Roger W., "The Hayden Survey in Colorado in 1873 and 1874." *Colorado Magazine*, Vol. 6, No. 4 (July, 1929), pp. 146-156.

Vogel, Herman Wilhelm, "Photographs at the Centennial Exhibition." *The Scientific American Supplement*, No. 40 (September 30, 1876), p. 625.

MAJOR COLLECTIONS OF ORIGINAL WILLIAM HENRY JACKSON PHOTOGRAPHS

AMERICAN ANTIQUARIAN SOCIETY, WORCESTER, MASSACHUSETTS

Contains 142 photographs, primarily from the Geological Survey years.

AMON CARTER MUSEUM OF WESTERN ART, FORTH WORTH, TEXAS

Contains one of the most comprehensive as well as prime collections: approximately 1,030 original prints, ranging in size from stereo to the 20- x 24-inch format. Also includes souvenir albums, photos of Jackson himself, carte-de-visites, and chromolithographs. Their largest single holding of prints in series are 550 of the Bureau of American Ethnology Indian photographs, 150 stereo cards, and 110 original photographs in albums.

BEINECKE LIBRARY, WESTERN AMERICANA COLLECTION, YALE UNIVERSITY, NEW HAVEN, CONNECTICUT

Contains a rich, well-rounded source of all USGS materials, especially by Jackson and O'Sullivan. Includes assorted catalogs from all periods of Jackson's carreer; published albums and later travel albums; all the Geological Survey albums containing original mounted photographs; the 1871 and 1873 albums; and a personal album entitled "Photographs of Indians."

BOSTON PUBLIC LIBRARY, BOSTON, MASSACHUSETTS

Contains a good representative body of large-sized photographs, for the most part undated and divided by subject matter: 13 views of Mexico, 21 Indian photos, an important collection of four early works (*ca.* 1870) made at Omaha, Nebraska; 20 works from the USGS period; and 40 works representing the period between the Surveys and the Detroit Publishing Company.

CARPENTER CENTER, HARVARD UNIVERSITY, CAMBRIDGE, MASSACHUSETTS

Contains a selection of 47 photographs, primarily of the Surveys.

DENVER PUBLIC LIBRARY, WESTERN COLLECTION, DENVER, COLORADO

Contains 301 photographs of the Western States and Colorado. Strong in Indian photographs, mounted Geological Survey photographs and original Colorado Sample Books. Includes an unusual selection of color photographs and five original (20 x 24) glass plates.

THE INTERNATIONAL MUSEUM OF PHOTOGRAPHY AT GEORGE EASTMAN HOUSE, ROCHESTER, NEW YORK

Contains one of the largest major assemblages of work: over 400 prints in various sizes; 184 stereo views; 37 plates of the 1873 Geological Survey; the album of views of Mexico and the western United States. Just acquired is the fascinating Henry Gannett album containing 448 photographs of Wyoming, Colorado, Idaho and Utah; a personal selection of photos taken during all the Survey years and compiled for the geologist of the Surveys, Henry Gannett.

LIBRARY OF CONGRESS, WASHINGTON, D.C.

Contains thousands of original photographs and negatives (20,000 photos and 30,000 glass plate negatives) from the Detroit Publishing Company collection, both by Jackson and by others working for him during this partnership, that were partially received as copyrights deposits from 1894 to 1914. Also includes a large collection of prints and stereographs made for the Geological Surveys of 1869-75. Numerous albums from the files of the Detroit Publishing Company, documenting cities of Mexico, Canada, West Indies, Bahama Islands, Venezuela, Arizona, Florida and Colorado, taken between the years 1884 to 1905.

STATE HISTORICAL SOCIETY OF COLORADO, DENVER, COLORADO

Contains the collection of photographs, albums and glass plate negatives that came to the Society in 1948 from the Edison Institute in Dearborn, Michigan, through the cooperation of the Ford Foundation. The 52,000 nagatives in the original collection were divided between those taken east and those taken west of the Mississippi River. Includes 7,000 negatives ranging in size from 18 x 22 to 5 x 7, concerning Colorado from the primitive wilderness of the early 1870's to the relative prosperity of the turn of the century, given to the State Historical Society. The Eastern and foreign materials were given to the Library of Congress. There is a catalog available, published in 1974, of plates of Jackson's Colorado Negatives. Other materials in the collection are 57 albums from the Detroit Publishing Company, of various sizes (5 x 7, 5 x 9, 8 x 10, 11 x 14, 16 x 20 and 20 x 24). In addition, there are a number of other original prints for which no glass plates exist; 40 large arge prints from 16 x 20 to 20 x 24; and 12 mural prints about six feet long.

WESTERN AMERICANA COLLECTION, PRINCETON UNIVERSITY LIBRARY, PRINCETON, NEW JERSEY

Contains 72 individual prints, 31 of which are Indian portraits, many with catalog numbers and captions from Jackson's *Descriptive Catalogue of Photographs of North American Indians*, 1877. The majority of works are from the later Survey period (1874) and concentrate on the geographical areas of New Mexico and Arizona.

Editing and Design: Liliane De Cock
Composition and Printing: Morgan Press Incorporated
Paper: Warren's Lustro Offset Enamel
Binding: A. Horowitz & Son